PosterAnnual2003

CEO & Creative Director: B. Martin Pedersen

Editor: Michael Porciello

Art Director: Lauren Prigozen
Design & Production: Luis Diaz, Jennifer Kinon and Andrea Vélez

Photographer: Alfredo Parraga

Published by Graphis Inc.

This book is dedicated to
Raymond Savignac

(opposite) Call for Entries for Mohawk Paper by Vanderbyl Design, page 29 and (next page) Poster for One Sound Studio Inc. by Highwood Communications Ltd., page 207

Contents Inhalt Sommaire

Remarks: We extend our heartfelt thanks to Contributors throughout the world who have made it possible to publish a wide and international spectrum of the best work in this field. Entry instructions for all Graphis Books may be requested from: **Graphis Inc.**, 307 Fifth Avenue, Tenth Floor, New York, New York 10016, or visit our Web site at www.graphis.com.

Anmerkungen: Unser Dank gilt den Einsendern aus aller Welt, die es uns ermöglicht haben, ein breites, internationales Spektrum der besten Arbeiten zu veröffentlichen. Teilnahmebedingungen für die Graphis-Bücher sind erhältlich bei: **Graphis Inc.**, 307 Fifth Avenue, Tenth Floor, New York, New York 10016. Besuchen Sie uns im World Wide Web, www.graphis.com.

Remerciements: Nous remercions les participants du monde entier qui ont rendu possible la publication de cet ouvrage offrant un panorama complet des meilleurs travaux. Les modalités d'inscription peuvent être obtenues auprès de: **Graphis Inc.**, 307 Fifth Avenue, Tenth Floor, New York, New York 10016. Rendez-nous visite sur notre site web: www.graphis.com.

LRS: Somerset College

Hommage à Raymond Savignac

Savignac: Images sans paroles, Text by Alain Weill Je me souviens encore de l'affiche ASPRO que j'ai vue dans le métro à Paris dans les années 1960. Je me souviens d'avoir vu travailler Savignac au musée des Arts Décoratifs. C'est à lui que j'ai commandé l'affiche de l'ouverture du Musée de la Publicité que j'ai dirigé tout comme celle du Festival de Chaumont que j'ai fondé en 1989. Je me souviens des expositions que j'ai montées à partir de ma collection — j'ai été un des premiers à m'intéresser à ses œuvres. Je me souviens de mes dernières visites à Trouville où il s'était retiré. Il avait gardé l'esprit vif et surtout, ce qui m'impressionnait pour un homme de plus de 90 ans, que sa main ne tremblait jamais quand il signant des épreuves d'artistes. Je suis fier que, quand il me dédicaçait une œuvre, il marquait toujours, "pour Alain Weill, vieux complice"…

Disparu l'automne dernier (le 31 Octobre 2002) à la veille de se quatre-vingt-quinze ans, Raymond Savignac était le doyen des affichistes et l'un des derniers survivants d'une profession aujourd'hui disparue. C'était aussi un personnage extraordinaire, parfaitement atypique, dont le parcours de graphiste publicitaire fut exemplaire.

Fils de modeste bistrotiers auvergnats, Savignac grandit dans les quartiers populaires de Paris. Il n'a pas de vocation particulière et, comme il aimait à le dire avec son humour décapant, son rêve était à l'époque de devenir coureur cycliste. Il commença à dessiner, essayant de caser ici ou là des dessins de presse. De petit boulot en petit boulot, il finit par douter de ses chances dans un métier déjà fort encombré. Ne sachant plus à qui s'adresser, il finit par aller voir Cassandre dans son bureau de l'Alliance Graphique, bien décidé à se plier au verdict du maître : miracle, celui-ci l'encourage et lui propose même de devenir son assistant. Nous sommes en 1933, Savignac a 26 ans et pendant 4 ans, avant le départ de Cassandre pour l'Amérique, il sera son collaborateur, signant aussi ses premières affiches. Le plus grand affichiste de la période Art Déco (le père de l'affiche Dubo, Dubon, Dubonnet) avait-il soupçonné que ce jeune homme qu'il avait choisi deviendrait le plus grand affichiste de l'après-guerre? Ce passage de témoin est en tout cas intéressant d'autant que les deux personnalités ont très peu en commun et que la technique de Cassandre, notamment à l'aérographe, est un cauchemar pour Savignac qui a toujours avoué ne l'avoir jamais bien maîtrisé…Reprennent à partir de 1937 les petits travaux pour survivre.

C'est en fait en 1949, alors qu'il a plus de 40 ans, que commence vraiment la carrière de Savignac. « Je suis né à 41 ans des pis de la Vache Monsavon », écrira t-il — et c'est vrai. Lors d'une exposition de maquettes, qu'il organise avec son camarade Bernard Villemot, un projet, pourtant précédemment refusé par Eugène Schueller, patron de L'Oréal, le séduit. Avec Monsavon, Savignac connaît une gloire instantanée.

Il faut dire qu'entre temps, il a trouvé son style qui va bien avec l'air du temps. Son humour, ses couleurs vives, correspondent à ce que le public veut voir après les années de grisaille de l'occupation. Cette nouvelle approche de la publicité, il la baptise « gag visuel » : grand admirateur du cinéma muet comique américain (Charlot en tête) Savignac cherche pour toutes ses commandes, une idée drôle, instantanément compréhensible sans paroles, qui transmette avec humour le message de l'annonceur. Et de ses idées, Savignac en a trouvé des centaines, souvent fulgurantes. Quelques exemples, dans le désordre : pour Bic, écriture souple, un homme caoutchouc fait des nœuds avec son corps, pour la nouvelle bille Bic, c'est un écolier qui a pour tête une bille ; la tête de la vache Maggi hume avec délectation son arrière-train qui cuit pour donner le bouillon ; pour les voyages à demi-tarif S.N.C.F, c'est un couple dont il ne représente que la moitié de chaque corps; pour Aspro, une têtedouloureuse qui est traversée, comme un tunnel, par des automobiles. Savignac crée aussi des personnages à partir du produit à vendre : pour la fête des pères, offrez une cravate, c'est avec une cravate qu'il fait la tête d'un homme auquel il n'a plus qu'à ajouter un œil et une pipe ; pour le pain de mie Jacquet, il donne à une tranche de pain forme humaine. Il n'y a pas de limites à son imagination : ainsi, contre le projet d'autoroute rive gauche à Paris qui devait passer devant Notre Dame, ce sont les tours de la cathédrale, noyées sous ce flot de voitures, qui deviennent des bras pour appeler au secours. Savignac est un peu comme un marionnettiste qui, selon les circonstances, sort ses cartons tout un monde de personnages qu'il a en réserve ; avec des préférences qu'il aime réutiliser : la vache (qui lui a porté bonheur), le coq gaulois (chaque fois qu'il veut représenter la France), la

mouette pour Trouville (où il habitait ces dernières années), les écoliers rieurs, souvent dans le costume marin qu'il portait dans son enfance, jusqu'à sa propre image qu'il utilise dès 1964 pour la banque CIC où il se représente dans un rocking-chair. Dans tous les cas, même s'il n'y arrive pas toujours, Savignac cherche le raccourci, à épurer toujours plus son dessin qui n'est jamais encombré par un élément, un détail ou un trait inutile. Cette primauté qu'il donne à l'idée triomphera—alors qu'il avait connu une éclipse à la fin des années 1970 avec l'arrivée en force des agences de publicité qu'en fervent individualiste, il déteste cordialement—quand Jacques Séguéla l'appelle, au début des années 1980 pour concevoir les campagnes Citroën. Alors que la marque n'avait plus de concept fort et s'égarait dans la description de ses divers modèles, il lui reconstitue, en quelques affiches une image et un territoire en réutilisant, en majesté, les chevrons, le logo Citroën si familier à tous les Français. Si Savignac est avant tout un humoriste, il est aussi bon de rappeler qu'il sait, quand on le lui demande trouver les mêmes raccourcis pour évoquer le drame : l'affiche pour le film Lancelot du Lac de son ami Robert Bresson en est la démonstration.

Au delà de leur conception, ce qui fait le charme des affiches de Savignac réside aussi dans son dessin et dans sa palette : son dessin faussement enfantin, avec ses couleurs vives, parle immédiatement au grand public, crée avec lui une connivence bon enfant – chacun peut penser qu'il aurait pu trouver l'idée, tellement elle est simple et qu'il aurait pu la dessiner tellement le trait enfantin, peut paraître à la limite du maladroit. Bien sûr, il n'en est rien. J'ai eu le privilège d'observer Savignac au travail, sans qu'il s'en aperçoive. C'était à la fin des années 1970 et il était venu travailler une après-midi entière à la bibliothèque des Arts Décoratifs où j'étais alors conservateur. Il s'était fait confier des images d'oiseaux et je l'ai vu crayonner pendant des heures des centaines d'oiseaux, de plus en plus stylisés avec un trait de plus en plus minimal : j'étais en train d'assister à la naissance de la mouette qu'il déclinerait pour la ville de Trouville où il s'apprêtait à s'installer. Chez lui, ce qui paraît évident ne l'est jamais. Prenez la Vache Monsavon : la manière dont est disposé le rose à l'intérieur de l'animal pour le souligner tout en le colorant ressort du grand art ; elle se détache sur le fond bleu par l'intermédiaire d'un halo noir indispensable à l'effet, mais qui peut échapper au premier coup d'œil: les halos, les doubles cernes et les fonds travaillés font partie intégrante de son système pictural et sont, à y regarder de près, d'une grande subtilité et d'une réelle sophistication.

Reste la lettre qui n'était pas, à l'évidence, son point fort. Dans ce domaine, il n'y a vraiment que sa signature qu'il ait travaillé avec soin et créativité: pour l'avoir vu signer des centaines de fois, j'étais toujours émerveillé de voir avec quel soin—et quelle organisation—il construisait son « g », toujours tracé de la même manière. Pour le gros de ses affiches, il se contentait de placer la lettre où il le souhaitait, la dessinant en gros bâtons assez raides et de peu d'intérêt que souvent les imprimeurs s'employaient à rendre un peu plus banale. Le plaisir de Savignac, c'était le dessin pour illustrer sa pensée foisonnante—rien d'autre. Il n'a pas par exemple succombé à la tentation, qui fut celle de pratiquement tous les autres affichistes de sa génération, de devenir peintre du dimanche, voire peintre tout court, ce qui fut presque toujours fort décevant—Savignac avouant tranquillement son manque d'intérêt pour la chose comme une paresse de bon aloi qui est généralement celle des gros travailleurs.

Il me souvient qu'à un congrès de l'Alliance Graphique Internationale, à Blois, au début des années 1980, j'avais fait une présentation de son œuvre. Dans l'assistance un certain nombre de graphistes, anglo-saxons pour la plupart—s'étaient insurgés, faisant remarquer qu'ils ne pouvaient considérer Savignac comme un graphiste. Il est vrai que ces typographes rigoureux, impeccables metteurs en page, formés à l'école de Brodovitch et de l'école de Bâle étaient aux antipodes de ce que je venais de leur montrer. J'en avais été choqué d'autant que Savignac avait été salué par des commandes dans le monde entier y compris aux Etats-Unis pour le magazine LIFE.

Aujourd'hui, les années ayant passé, je comprends mieux leur réaction : c'est vrai que Savignac n'était pas un 'graphic designer': c'était bien plus et bien au-delà simplement un artiste de la publicité—je n'en connais pas beaucoup d'autres.

(opposite page)"Monsavon au Lait" 1949 and (next page)"Gitanes" 1953 designed by Raymond Savignac

The Wordless Poetry of Monsieur Savignac By Alain Weill

The oldest of France's poster artists and one of the last practitioners of a medium since gone out of fashion, Raymond Savignac was an extraordinary figure—someone completely out of the ordinary who enjoyed a most exemplary career in commercial art. He passed away on October 31, 2002, at the age of 95.

Savignac grew up in a working class neighborhood of Paris. His parents, from France's Auvergne region, ran a modest bistro. Attracted to no occupation in particular, he used to talk about becoming a bicycle racer. After taking up drawing, he managed to get several of his early press drawings accepted here and there. Nevertheless, obliged to round the months off with various odd jobs, he had his doubts about his chances in an already overcrowded profession. As a last resort, he went to see Cassandre at his studio, the Alliance Graphique, determined to abide by the great master's verdict. Miraculously, not only did Cassandre offer him encouragement, but he also invited him to become his personal assistant. It was the year 1933, and Savignac—26 years old at the time—would spend the next four years as Cassandre's assistant and collaborator, signing his own first posters as well. One cannot help but wonder whether Cassandre, the greatest poster artist of the Art Deco period (father of the famous "Dubo, Dubon, Dubonnet" poster), somehow suspected that this young man would become the greatest poster artist of the post-war period. At any rate, the fact that one relayed the other stands out because of the difference in their personalities, not to mention that Savignac was ill at ease with the airbrush technique favored by Cassandre. In 1937, after Cassandre left for the U.S. Savignac found himself again relegated to gaining a living through sundry odd jobs.

It was not until 1949 that his career finally took off. As he put it: "I was born at the age of 41 from the udder of the Monsavon cow." At a poster show that he and fellow poster designer Bernard Villemot put on, Eugène Schueller, the head of L'Oréal, fell in love with the Monsavon cow that he had previously rejected, bringing Savignac overnight fame. By now, Savignac had latched on to a style well suited to the current mood. His humor and bright colors were just what the public craved after the dull years of wartime occupation. He himself called this new approach to advertising "visual gags." As a great admirer of American silent comedies—especially Chaplin—Savignac sought to come up with a funny idea for every project, something that could be understood immediately without words, that would bring across the advertiser's message with a dash of humor. He churned out hundreds of such ideas, one more dazzling than the next. Pell-mell, one thinks of his work for the supple writing quality of the Bic ballpoint (a rubber man ties his body into knots), the new Bic ballpoint pen (a schoolboy with a ballpoint as his head), Maggi beef stock (the head of a cow delights in the smell of its own hindquarters simmering in the pot), half-price travel with the French railroad SNCF (a couple's silhouette split in two), Aspro (an aching head serves as a tunnel for traffic flowing from one ear to the other). Another of his devices was to create figures made of the product being advertised: for "Father's Day, Give a Tie," the head of a man is made from a tie, with the addition of an eye and pipe; for the sandwich bread Jacquet, a slice of bread takes on a human shape.

His imagination was boundless: To protest a highway intended for the Left Bank in Paris and passing in front of Notre Dame, he had the cathedral towers—submerged by a stream of cars—turn into arms spread out in a call for help. One is reminded of a puppeteer with a vast store of characters that he can pull out of a box according to the circumstances, and some of which he pulls out more often than others: the cow figure (which brought him luck), the Gallic rooster (to represent France), the seagull (for Trouville, where he spent his last years), laughing schoolchildren—often dressed in the same sailor suit that he himself wore as a child, and even his own picture, which he resorted to for a 1964 CIC Bank advertisement showing himself in a rocking chair. In every instance, he endeavored—even if not always succeeding—to put matters in a nutshell, to rid his drawings of the last useless element, detail or even line.

Savignac granted full primacy to the idea behind a project.

The success of such an approach was temporarily eclipsed in the late 1970s, with the arrival of the sort of advertising agencies that he, as a fervent individualist, could only abhor. A new turning point came in the early 1980s, at a time when Citroën was casting about for a strong identity encompassing its various models. It took Savignac but a few posters to rebuild Citroën's brand image and stake out its territory. He did so by availing himself once again, and in majestic fashion, of the chevron pattern logo that all of France had always associated with Citroën. Renowned as a humorist, Savignac could upon occasion design just as pithy a solution to dramatic effect, as testified by the startling puddle of blood on the poster promoting his friend Robert Bresson's film Lancelot of the Lake.

Beyond the concept behind each poster, their charm also derived from the quality of drawings and colors themselves. The pseudo-childish lines and bright colors have immediate appeal for the public, ensuring a good-natured kinship based on the feeling that we ourselves could have come up with such an apparently simple idea, and drawn lines so childish as to seem almost clumsy. Which is not at all true, of course. I once was lucky enough to be able to watch Savignac at work without his knowing it: In the late '70s, he spent an afternoon at the Decorative Arts Library, which I headed at the time. He had requested several bird images, and for the next few hours he sketched hundreds of birds in ever more stylized fashion, resorting to fewer and fewer lines. In fact, I was witnessing the birth of the seagull that he would develop to represent the city of Trouville, where he was about to settle. Whatever looks obvious in Savignac's work is never actually so. Take his Monsavon cow, for instance: the manner in which the color pink is applied to the inside of the animal is a highly artistic device that lends emphasis as well as color. What is more, the cow stands out against the blue background thanks to a black halo that is in fact vital, even if it is easily overlooked at first. Generally speaking, Savignac's halos, double shadows and intricate backgrounds are essential components of his pictorial approach and, when scrutinized, testify to a highly nuanced and sophisticated technique.

Then there is the lettering on his posters, which appears to have been his weak point. The only writing to which he seems to have applied himself at all creatively was his signature. Having seen him sign his work hundreds of times, I was always amazed by all the care, and organization he put into drawing the "g" in his name the same way every time. Generally speaking, though, he was satisfied to merely apply letters wherever he wanted them, using thick strokes that were quite stiff and uninteresting, inspiring some printers to seek to render them somewhat less commonplace. Savignac derived pleasure exclusively from creating drawings to illustrate all the thoughts teeming in his mind. Never was he tempted, for instance, to become an amateur painter or even a professional one—a generally desultory career fork followed by a great number of his contemporary fellow poster artists. Savignac had no qualms about admitting his disinterest in the matter, serenely laying claim to the sort of respectable laziness that falls due to any hard worker of his ilk.

I remember presenting Savignac's work in Blois, at an AGI congress during the early 1980s. From the audience, several graphic designers—mostly Anglo-Saxon—rebelled, declaring that they found it difficult to classify Savignac as a graphic designer. Admittedly, the work done by the strictly trained typographers and impeccable layout artists belonging to the Brodovitch and Basel schools was at the opposite extreme of what they were being shown. But their reaction came as a shock to me, especially since another tribute was being paid to Savignac at the time, in the form of commissions pouring in from all around the world, including Life magazine.

Today, over two decades have passed and I understand things a bit better: Truly, Savignac was no "graphic designer," but—above and beyond that—an original advertising artist.

Translated from the French by Margie Mounier

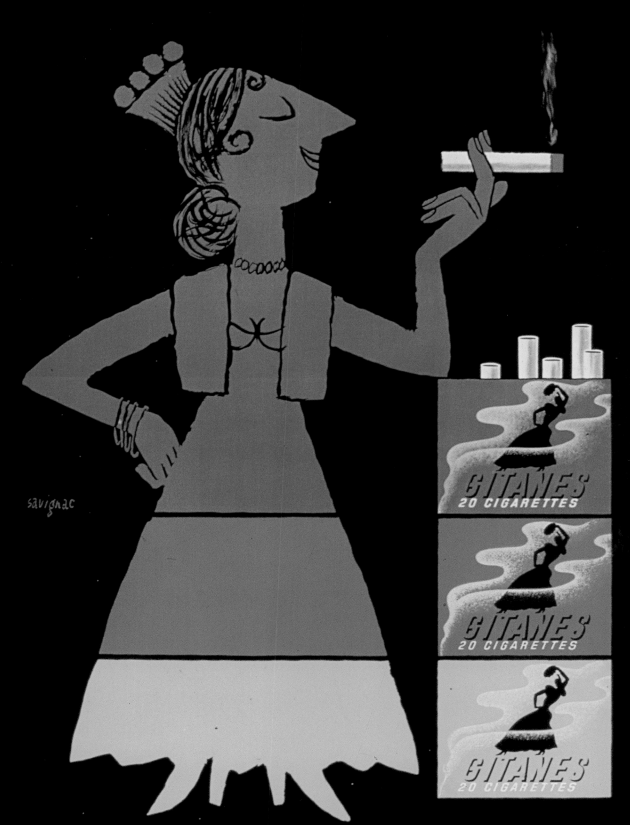

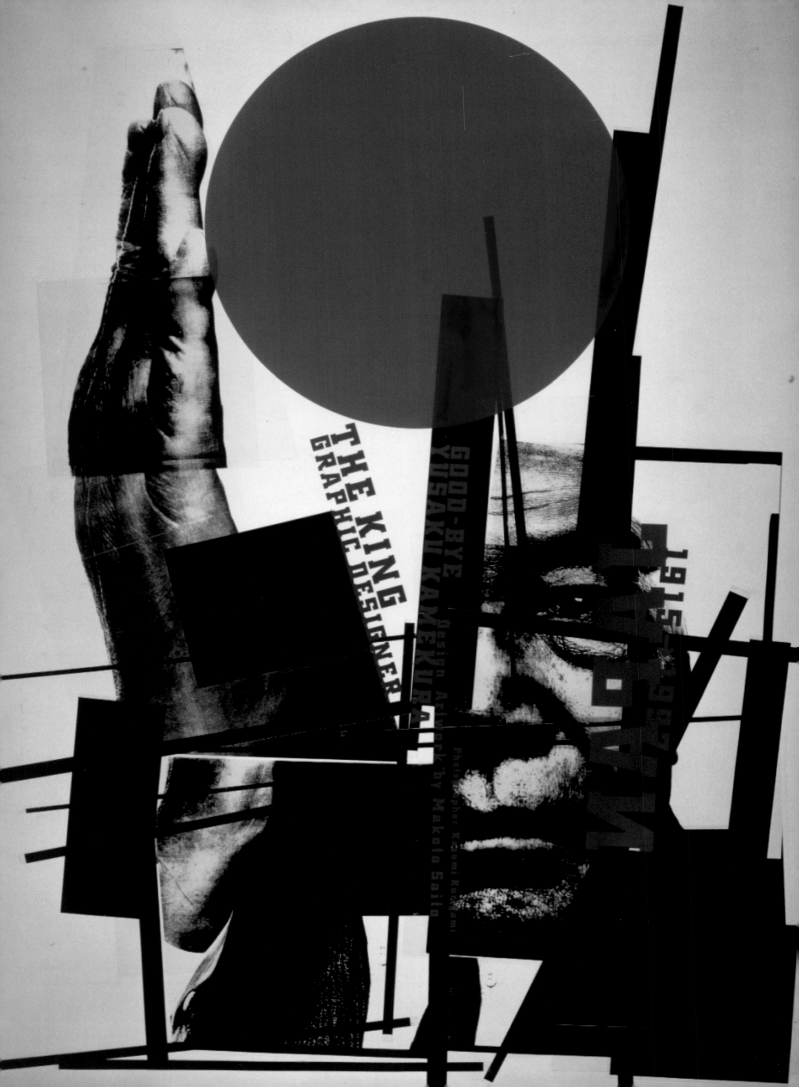

Q&A with Makoto Saito, Japan

Makoto Saito is active in various fields as a graphic designer, commercial art director, creative director and film director, and he is a producer/designer of new products. His debut as a graphic designer in the early 1980s was sensational. His numerous awards include a Gold Prize, Silver Prize and Special Prize (twice) at the International Poster Biennial in Warsaw, Gold Prize (five times) and Silver Prize at the Art Directors Club International Exbition in New York, Grand Prize at the Lahti International Poster Biennial, Silver Prize and Bronze Prize at the International Biennial of the Poster in Mexico, Gold Prize (three consecutive times), Bronze Prize (three times) at The International Poster Triennial in Toyama, Grand Prize at the Tokyo Art Directors Club (1995), Good Design Award from the Chicago Athenaeum (1995, 1998, 1999) and Grand Prizes at other leading poster exhibitions such as in France and Colorado. He and his works are featured in Time magazine and more than 50 other publications around the world. His posters are included in the permanent collections at the Museum of Modern Art in New York, San Francisco Museum of Modern Art, Victoria & Albert Museum in London and at 20 other museums in Chicago, the Netherlands, Germany, Poland, Switzerland and Tokyo. He gave a lecture in April 1996 at the San Francisco Museum of Modern Art under the title "Makoto Saito: The Viewpoint of the Modern Design." He also lectures frequently at both local and international institutions in the United States, France, the Netherlands, Poland, Australia and Hong Kong. He gave a presentation at the AGI conference in Zurich, Switzerland in October, 1999. He held an exhibition and gave a lecture at the Huntington Gallery, Massachusetts College of Art, Boston, USA in November 1999.

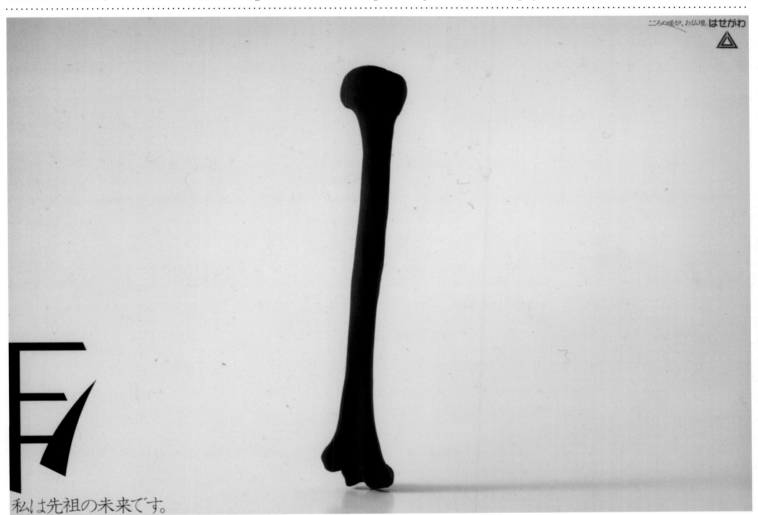

What is your proudest achievement in design so far?
To be able to remove the traditional boundaries between graphic design, advertising and art.

Who are the 3-5 designers you most admire?
Raymond Lowey, Louis Kahn and Stenberg Brothers.

How much does technology influence your work?
It allows my fingers to get into areas that had once been beyond my reach.

What part of your work do you find most demanding?
Maintaining a unique artistic quality.

What interests do you have outside work?
Contemporary art, architecture, space art, and product design.

Have you ever turned down a client—and why?
Yes, I have turned down quite a few of them, because their attitudes and objectives did not match my intentions.

What questions do your clients most often ask?
They hardly ask any questions.

What creative philosophy do you communicate to a student audience? a professional audience? a client?
I tell them why now it's necessary to express what they have not been able to do or what they want to see.

How important is it to win awards?
I think awards are like road markers which indicate whether one is currently going along at the right speed.

Which of your skills would you most like to perfect?
I am not very interested in technical skills. Regarding creative thoughts—they do not have to be new but I would like them to always be fresh.

Where would you like to be five or ten years from now?
I think the limits of human sensibility cannot be figured like 1+1=2. It can be 1+1=1,000. I would like to achieve my goals through more sensuous communications rather than logical communications.

(opposite page) "Sunrise Sunset Yusaku Kamekura," 1999, Client: Toppan Printing Co., Ltd. and (above) "1985 Hasegawa," Client: Hasegawa Co., Ltd. designed by Makoto Saito

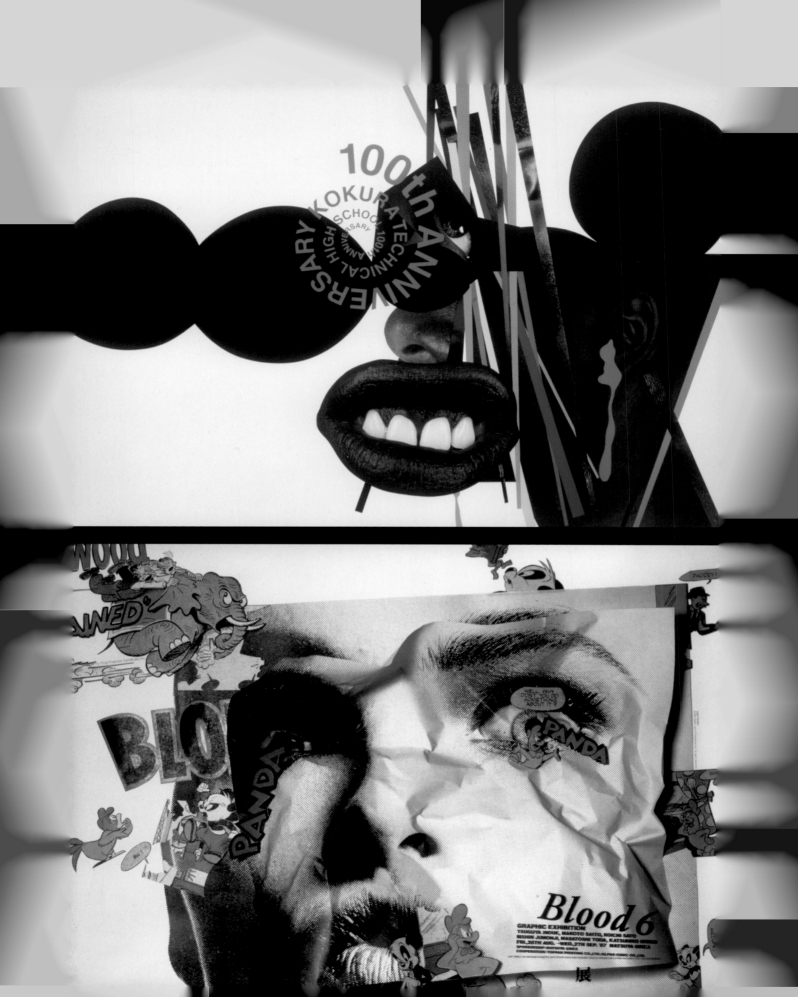

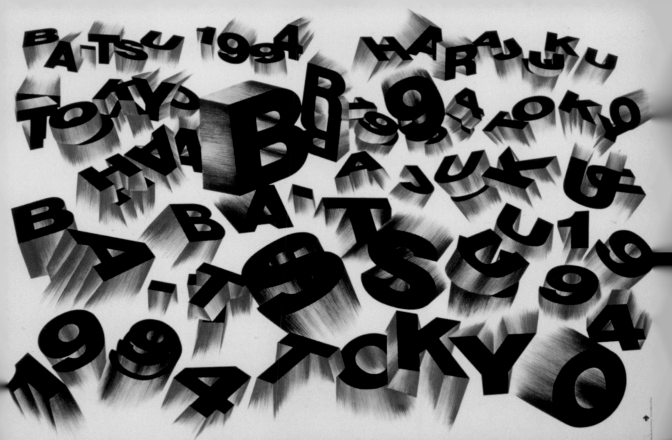
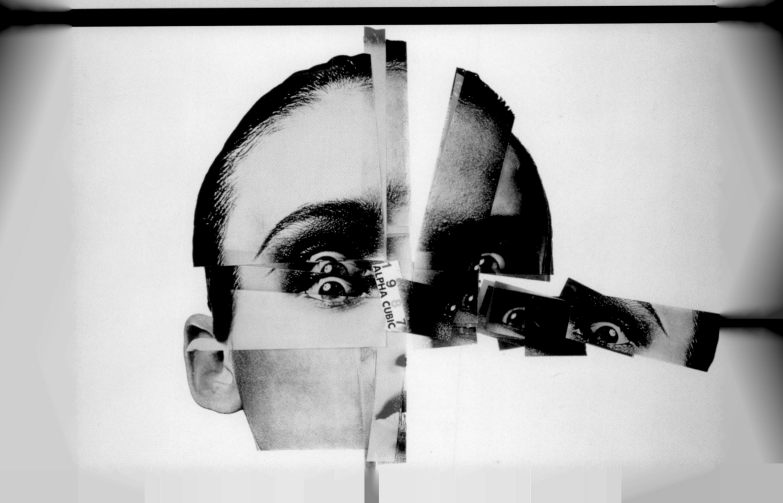

Q&A with Studio Boot, The Netherlands

Studio Boot *has nothing to do with boots other than that you can always walk in. This graphic illustrative design agency, founded in 1993, is a co-operation of Petra Janssen and Edwin Vollebergh. Boot's designs are often strong images with an illustrative use of typography. They are always looking for new solutions. The variety of clients reflects this approach towards graphic design. They love to experiment with old and new techniques and materials—that's why Studio Boot became a household name in the Netherlands. Because they are also living together they can never stop working and thinking about design. Studio Boot is based outside of Amsterdam in the south of the Netherlands where they work for clients such as theaters, publishers, big advertising agencies and shoe sellers. Petra and Edwin both teach design at the Design Academy Eindhoven.*

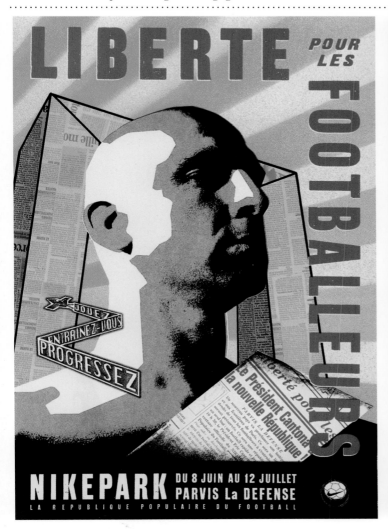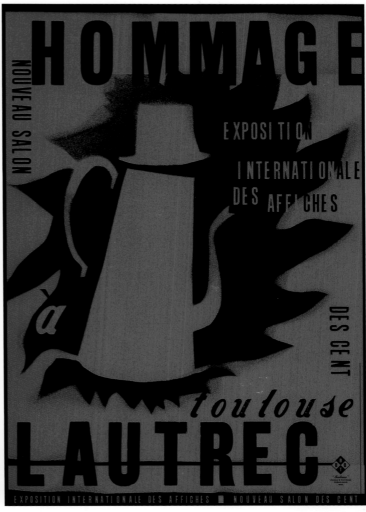

What is your proudest achievement in design so far?
That is difficult to say, but I think for the Dutch PTT—Valentine Postage stamps with a scratchable layer. A new concept presented and produced in a amount of 50 million. A small design with a big audience. (It took three years to develop them.)

Who are the 3-5 designers you most admire?
Stefan Sagmeister, Fiep Westerdorp, Viiane Westwood, Jamie Reed, Swip Stolk

How much does technology influence your work?
We now have to produce much more in very little time.

How do you keep up with current trends in design?
We try not to keep up with trends.

What part of your work do you find most demanding?
Bookkeeping. We have a small studio—just the two of us. So we have to do everything ourselves.

What interests do you have outside work?
Cooking, walking, photography, playing—traveling with our children.

Have you ever turned down a client—and why?
Yes, because we were out of time.

What questions do your clients most often ask?
Please …

What creative philosophy do you communicate to a student audience? a professional audience? a client?
Students: Dare to make something ugly, do not go for the result and the looks. Take risks to develop something special.
Professional: Dare to be different. Dare to make something uglier.
Client: Surprise yourself and trust us.

How involved are you with the design community?
Among our friends are lots of designers.

Do you teach a course on design?
Yes, at the Design Academy in Eindhoven. And we teach the graduate students at the Academie of Art in Den Bosch (our hometown and school where we graduated).

How important is it to win awards?
It's a fantastic podium to get well known internationally or in your own country (and they look good under the table).

Which of your skills would you most like to perfect?
Drawing.

Where would you like to be five or ten years from now?
Working in the same studio; working with inspired clients.

(opposite page) "Childrens Phone," 1993, Theater Poster and (above left) "Cantona," 1998, Client: Nike and (above right) "Hommage à Toulouse Lautrec," 2002 designed by Studio Boot

met: OLAF de KOOIJ

HUGO METSERS de DERDE

ISA III

HOES

SOPHIE

HOUWELING

MARC

MARIE

HUYBREGTS

STICHTING BELGISCH TONEEL

... PRODUKTIE MET REGIESCHOOL AMSTERD...

STADSSCHOUWBURG AMSTERDAM

boven zaal

Geert regie Kimpen

Menelaos

19 T/M 24 APRIL 20.15

AANVANG

dinsdag tot en met zondag

RESERVEREN
020-6242311
020-6271211
AMSTERDAM

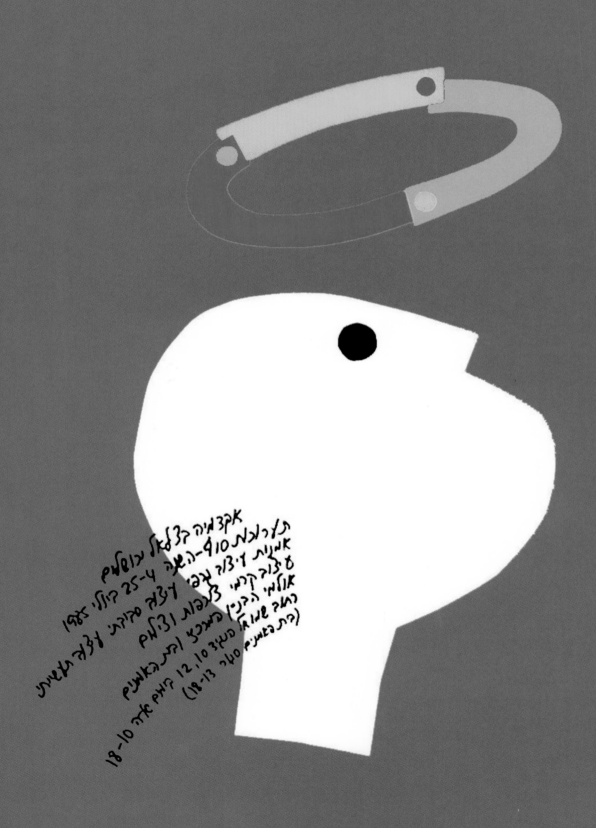

Q&A with Yarom Vardimon, Israel

Prof. Yarom Vardimon: Born in Israel, studied in England at the LCP, Chelsea College of Art and the University of Westminster. Recipient of the ICOGRADA Design Excellence Award Fellow of the International Design Conference, Aspen USA. Honorary Member of the Art Directors Club of New York. Professor of Visual Communications since 1980. Owner of Vardimon Design, Tel Aviv, mainly involved branding, architecture related communication design, packaging and posters. Elected to AGI (Alliance Graphique Internationale) in 1982. Board Member and director of New Media since 2000. Was in charge of the submission of the program for undergraduate studies as well as the Masters Degree program in Israel. Lecturer on Design and Communications, The Creative Workshop—Tel Aviv University School of Architecture. Head of the Design Graduate Program, Shenkar College, Ramat Gan. Past Head of Department of Visual Communications—Bezalel Academy Jerusalem. Chairman, Speaker and Committee Leader at International conferences and symposiums and a visiting lecture in many design colleges in Europe and USA. Past President GDAI, Past Vice President ICOGRADA, judge at many international design competitions, winner of over 90 prizes in design competitions. Works displayed at major international exhibitions and are to be found in international museums and collections as well as in books and publications in Europe, the United States and Japan.

What is your proudest achievement in design so far?
Observing the smiles on the faces of gravely ill children as they were transferred into the newly opened children's hospital—surrounded by a colorful and friendly atrium to the sound of a toy train running above their heads. The design concept worked. The emotions of bystanders erupted. (Hadassah Medical Center, Mother and Child Pavilion, Jerusalem Identity program—I was designer and advisor on conceptual exterior and interior issues, signage and donor recognition.)

Who are the 3-5 designers you most admire?
On a broader definition of design:
Frank Lloyd Wright, Arne Jakobsen, Le Corbusier, Frank Gehry. Incredible total creators, excellent communicators of their own impressive visions; outstanding contributors to culture as well as to the study of the visual language.
A few posters penetrated my brain-cells during my design-cradle-period in a most selective, unexplained way:
The simplicity and flat image of "Hamlet," Begarstaffs, 1894; The torn chain and threatening dog, "Simplicissmus," Heine, 1897; Bernhard's "Stiller" shoe and special signature, 1908; Max Bill's "O" with its unique 'boxed' typography; Cassandre's "Etoile du Nord," 1927, and "La Route Bleue," 1929; Man Ray's "Keeps London Going," 1932; Josef Muller-Brockmann's music posters of the '50s.
At that stage I must have been visually born. These people were in a way my hidden mentors. Then, looking around, I began identifying my conceptual "relatives." I most admire a visually expressed, well defined idea/message, which leaves me with ambiguous, memorable afterthoughts that can last a long time.

How much does technology influence your work?
Immensely. It's a tool for creating options, enhancing dialogue and decision making.

How do you keep up with current trends in design?
Trends are a visitor worth knowing. Get acquainted, be charmed, be adventurous—but never forget yourself.

What part of your work do you find most demanding?
Having professional discussions with impossible clients. The worst being T.A.C.T.—The-Anti-Culture-Type.

What interests do you have outside work?
People.

Have you ever turned down a client—and why?
Many. They did not need a designer.

What questions do your clients most often ask?
"Can't you make it cheaper?"

What creative philosophy do you communicate to a student audience? a professional audience? a client?
Students: "I hear—I forget. I see—I remember. I do—I understand." (Chinese proverb). That creativity is an unpredictable intelligent expression of some hidden knowledge, and that linear thinking is a rational system that can compliment it.
Professionals: That I try to do it my way.
Clients: We are only as good as their brief; creativity means 1+1=3.

How involved are you with the design community?
Past President GDAI; past Vice President ICOGRADA; AGI Director of New Media etc.

Do you enjoy speaking at design conferences?
Enjoy? Looking at a mirror can get scary. But then there are others doing it around you too. So much to learn. Opportunities for crystallizing thoughts, evaluating quality and possibly for repositioning.

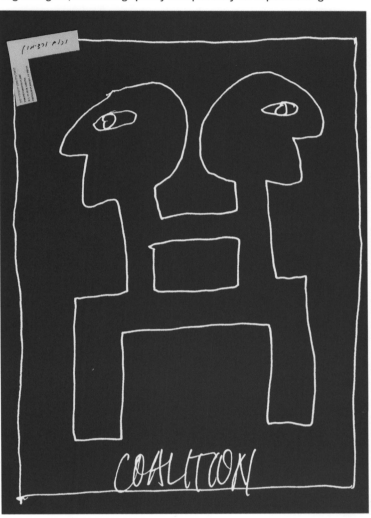

Do you teach a course on design?
Yes, since I was 25 I've taught at Bezalel Academy of Art and Design, Jerusalem; Tel Aviv University School of Architecture; Shenkar College of Engineering and Design.

How important is it to win awards?
Awards recognize the ability of a design to communicate—the designer's skills in the process of solving a problem. They do not affect the quality of the work that was done. They may affect works to come, as well as manifest the importance of design to modern living.

Which of your skills would you most like to perfect?
All of them.

Where would you like to be five or ten years from now?
Here and there.

*(opposite page) "Bezalel Annual Exhibition," 1985, (above) "Coalition"
and (next page) "Ism" designed by Yarom Vardimon*

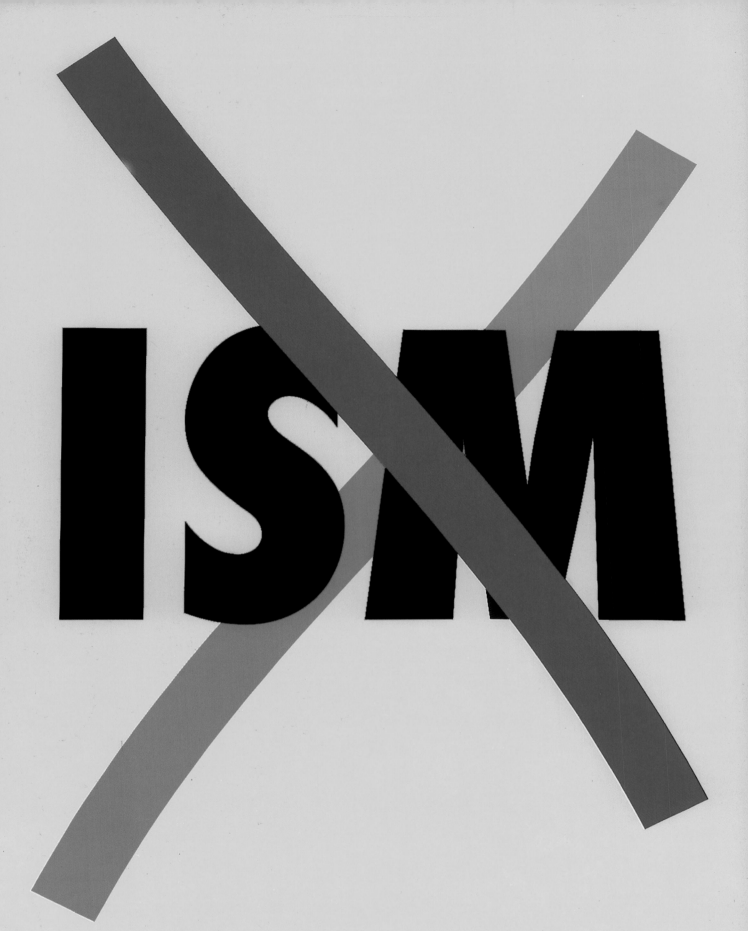

ICU PUBLICATIONS DESIGNED BY YAROM VARDIMON PRINTED IN ISRAEL 1983

Architecture · Interior Design

M2T

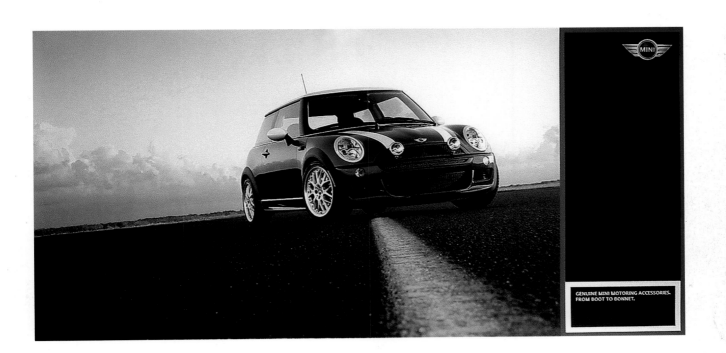

GENUINE MINI MOTORING ACCESSORIES.
FROM BOOT TO BONNET.

Design Firm: 50,000 Feet Inc. Creative Director: Michael Peterson Art Director: Michael Peterson Designer: Michael Peterson Photographers: Eric Perry and Mid Coast Studio Copywriter: Jack Sichterman Client: BMW of North America/Mini

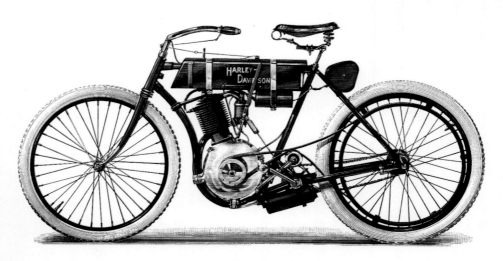

THE HARLEY-DAVIDSON® CORNERSTONE COLLECTION
— CELEBRATING ONE HUNDRED YEARS *of* MOTORCYCLING —

THE 1903 SINGLE

IN LATE 1903 WILLIAM S. HARLEY AND BROTHERS WALTER, WILLIAM AND ARTHUR DAVIDSON built the first Harley-Davidson motorcycle in a tiny backyard shed. Powered by a single-cylinder, 25-cubic-inch engine, the elegant vehicle was a true labor of love, boasting decorative gold tank lettering reportedly hand-painted by the Davidsons' eldest sister, Janet. The 1903 Single

featured a direct leather belt drive, a one-piece cast-iron cylinder, and an innovative loop frame designed specifically for its new powertrain. Although only three were built in the first year of production, the 1903 Single laid the groundwork for a motorcycling dynasty that would produce some of the most beloved vehicles of all time.

©2002, HARLEY-DAVIDSON, INC.

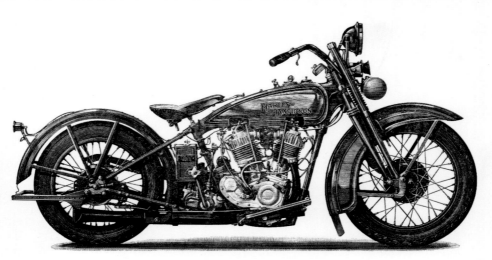

THE HARLEY-DAVIDSON® CORNERSTONE COLLECTION
— CELEBRATING ONE HUNDRED YEARS *of* MOTORCYCLING —

THE 1928 JDH MODEL

IN 1928, HARLEY-DAVIDSON TOOK WHAT IT HAD LEARNED ON THE RACING CIRCUIT and packed it into a new configuration based on the proven, side-valve J Model. The result was the JDH, a responsive V-twin that set new standards in performance and versatility. Known as the "Two-Cam," the 74-cubic-inch JDH was equipped with a second camshaft and domed

metal pistons to boost power output, as well as a throttle-regulated oil pump and front brake — a Harley-Davidson first. While the JDH would disappear with the other J models in 1930, it had paved the way for the development of the Knucklehead engine, a powerplant that would change the course of motorcycling history.

©2002, HARLEY-DAVIDSON, INC.

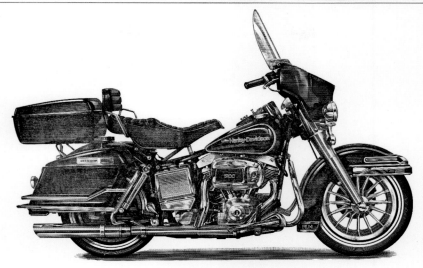

THE HARLEY-DAVIDSON® CORNERSTONE COLLECTION
~ CELEBRATING ONE HUNDRED YEARS of MOTORCYCLING ~

THE 1978 FLH ANNIVERSARY EDITION

ONE OF TWO MODELS RELEASED TO COMMEMORATE HARLEY-DAVIDSON'S 75TH BIRTHDAY, the 1978 FLH Anniversary Edition offered the exclusivity of limited production numbers and custom styling with proven Electra Glide® performance. Featuring vivid black paint, rich gold pinstriping and exclusive 75th Anniversary tank and fender graphics, the striking 1200cc machine also boasted an all-leather seat, gold wheels and a matching cast eagle on its clutch cover. Powered by the venerable Shovelhead engine, the 1978 FLH Anniversary Edition was both a celebration of an important milestone in the Motor Company's history and testament to the enduring power of the Electra Glide pedigree.

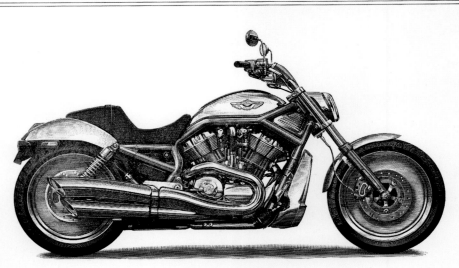

THE HARLEY-DAVIDSON® CORNERSTONE COLLECTION
~ CELEBRATING ONE HUNDRED YEARS of MOTORCYCLING ~

THE 2003 VRSCA V-ROD®

AFTER SEVEN YEARS IN DEVELOPMENT, THE VRSCA V-ROD ROARED ONTO THE MOTORCYCLING SCENE IN LATE 2001, sending shock waves through the industry. Combining a radically new design and blistering performance, the V-Rod is the inaugural member of a new family of Harley-Davidson® motorcycles, as well as the first liquid-cooled production Harley® ever built. Powered by the groundbreaking 1130cc, 115-horsepower Revolution® engine, the V-Rod features bold, anodized aluminum body panels, a hydroformed perimeter frame and dramatic, double S-bend exhaust. Proudly displaying the 100th Anniversary tank emblem, the 2003 V-Rod embodies the promise of the next century of Harley-Davidson® motorcycles.

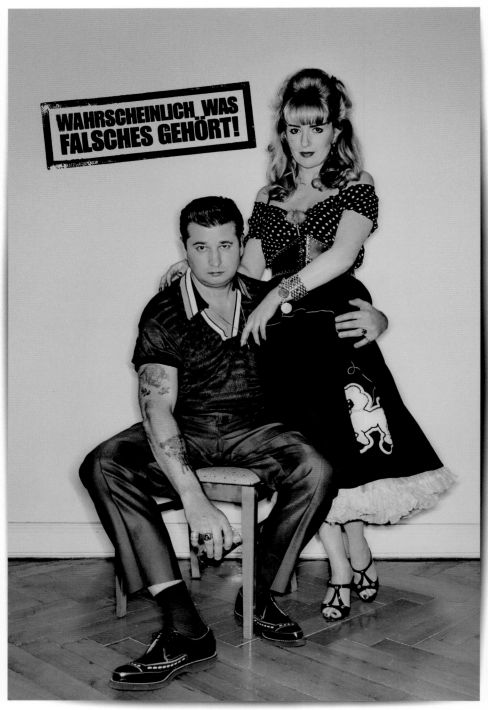

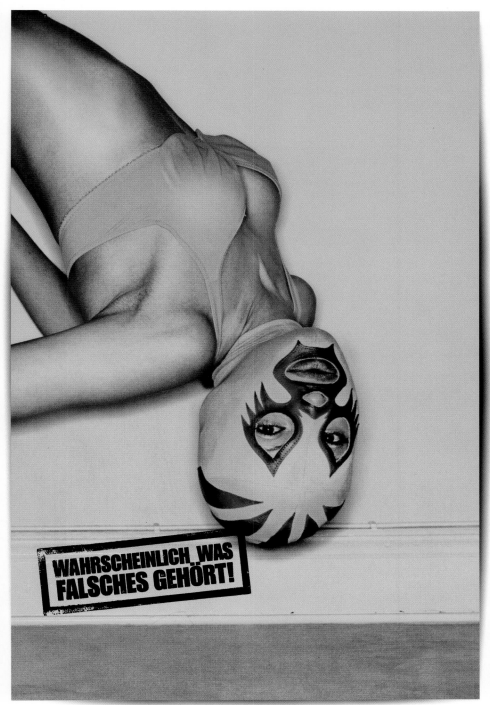

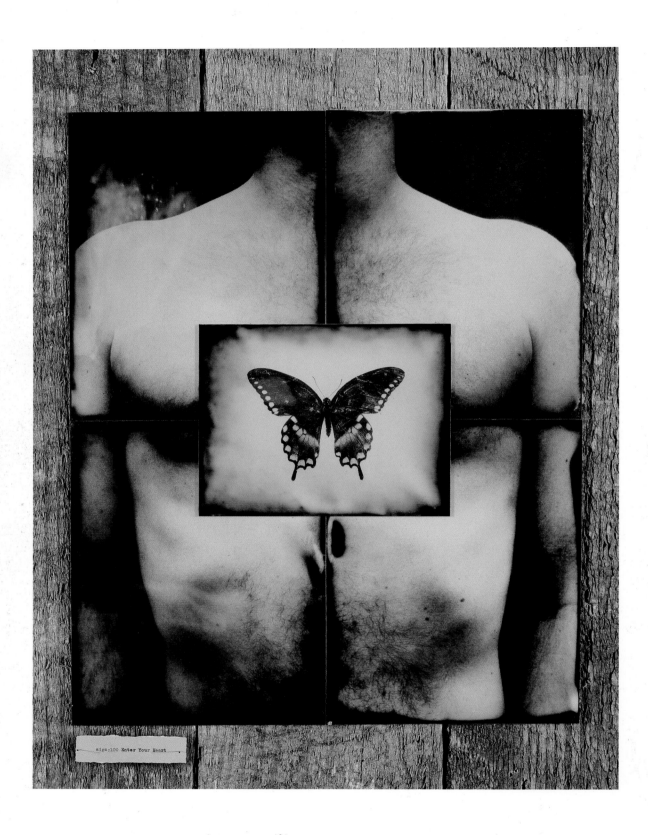

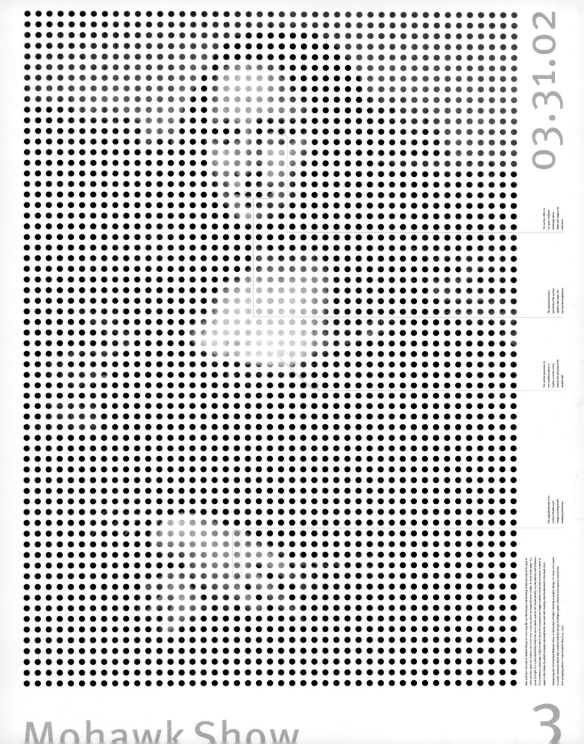

03.31.02

The surface offers to
our gaze a brilliant
landscape where
ideas and images can
take form.

The expressive texture
and tactile surface
speak to the hand, the
eye and the imagination.

The surface possesses its
own aesthetic power to
intensify or reverse each
image, investing it with
meaning and structure.

The palpable beauty of the
surface combines with each
image, investing it with
meaning and structure.

Now and then, we look at familiar things in a new way. We see that beauty and meaning reside not only in the play of
color and line and texture and shadow, but in the very substance by which an image derives visible. The medium of the paper is a
point of origin. It is a distributed that invites the eye to dwell upon its rich visual density, its smoothness and brilliance.
It is a luminous landscape, a field upon which ideas are composed and images take shape swiftly. The surface of the
paper is the means to an end: a field which ideas are composed and each visual body, weaving together the vitality of
color, movement and form.

Introducing the Third Annual Mohawk Show, a celebration of bright meaning in graphic design, for those who aspire
to create communications that combine brilliant design, intelligent paper selection and superior production.
Now accepting entries. Final deadline March 31, 2002.

Mohawk Show

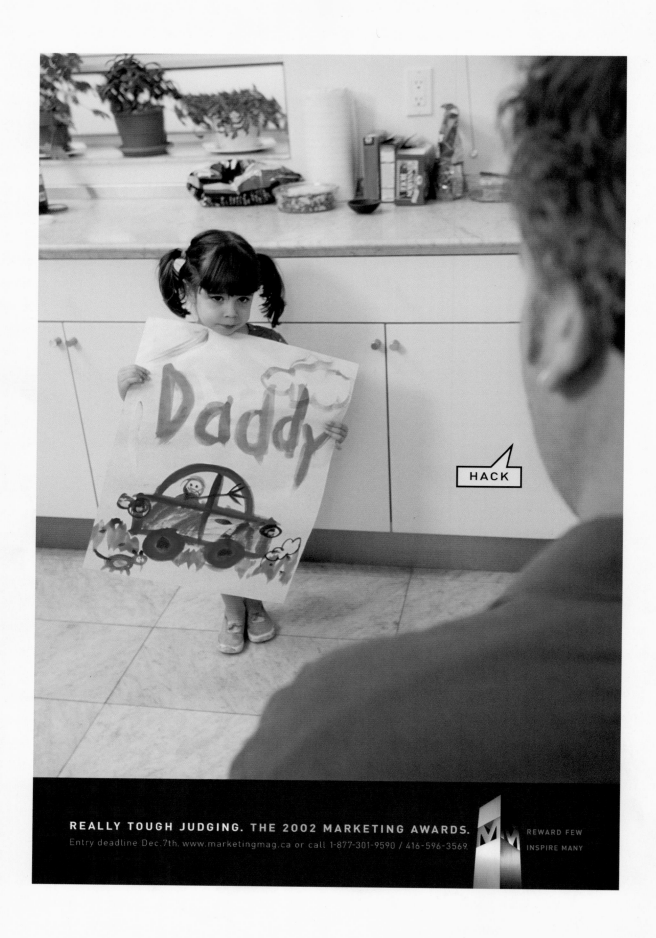

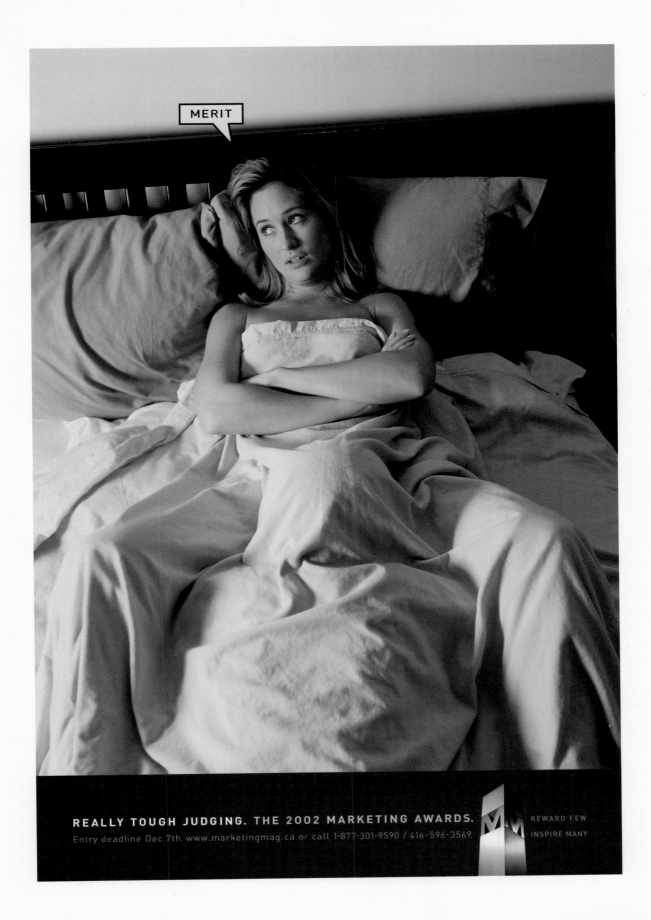

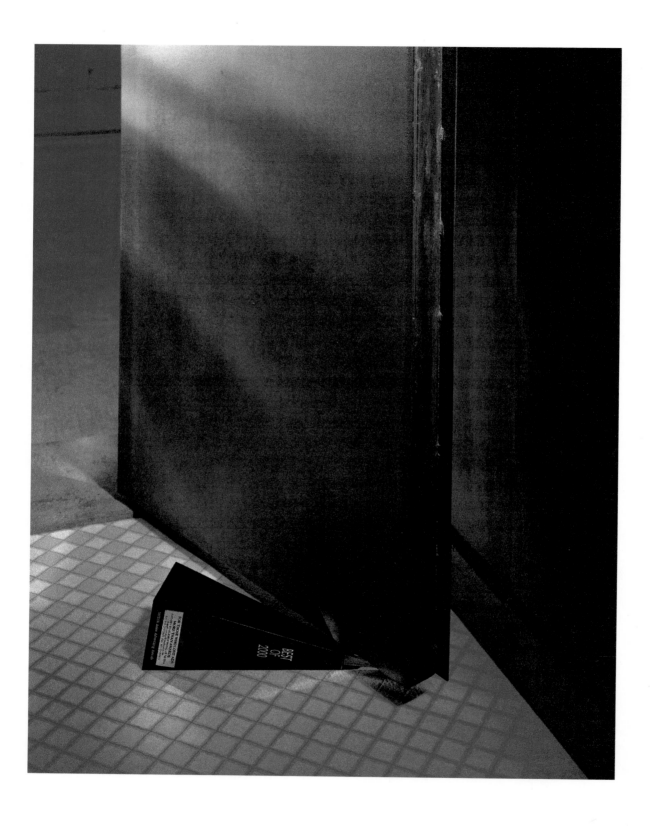

(this spread) Creative Director: Stanley Wong Art Director: Stanley Wong Designer: Tony Ma Photographers: Josiah Leung and Stanley Wong Copywriter: Raymond Client: Media & Marketing Ltd.

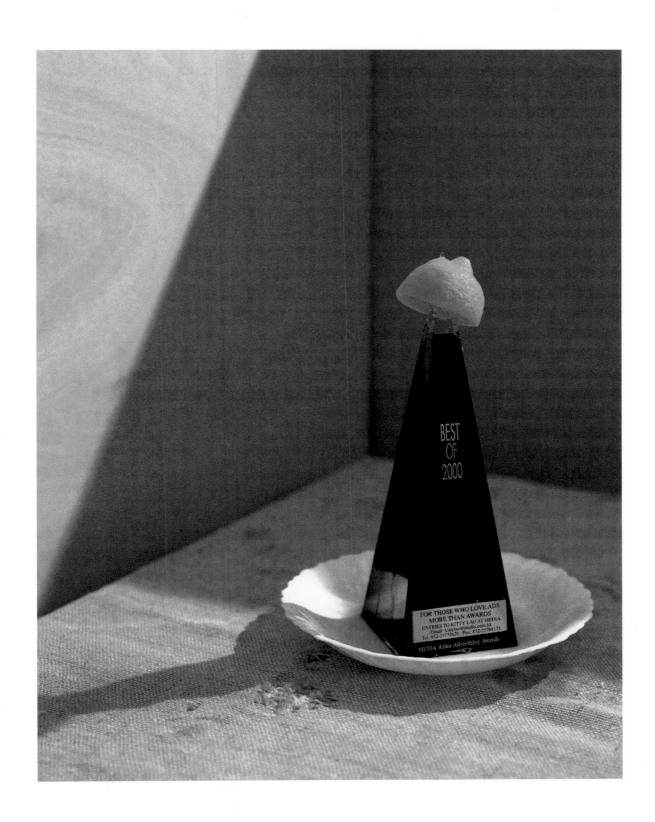

(this spread) Creative Director: Stanley Wong Art Director: Stanley Wong Designer: Tony Ma Photographers: Josiah Leung and Stanley Wong Copywriter: Raymond Client: Media & Marketing Ltd.

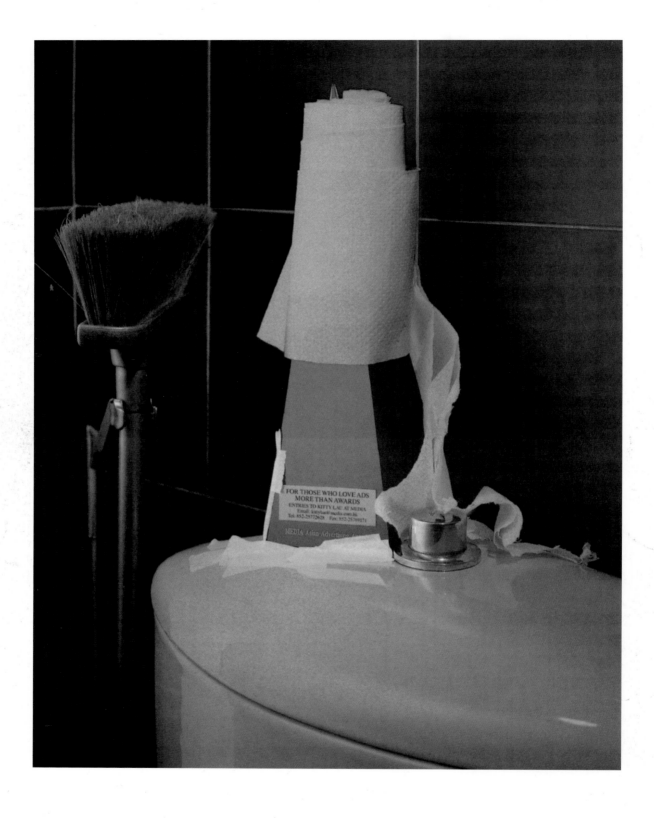

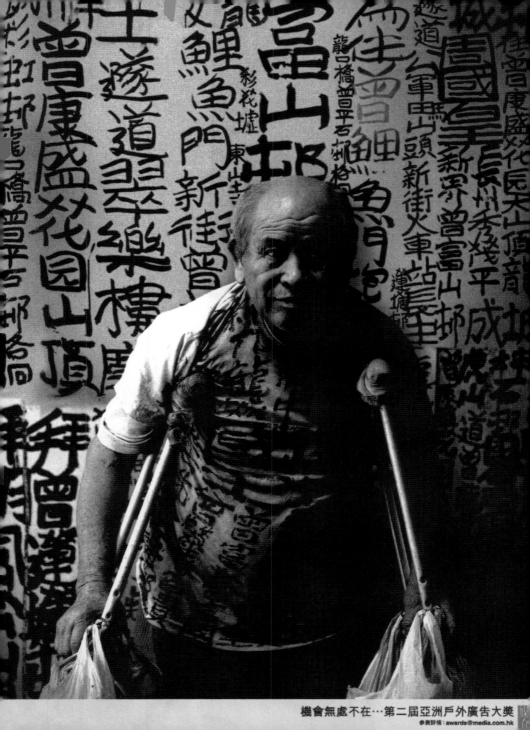

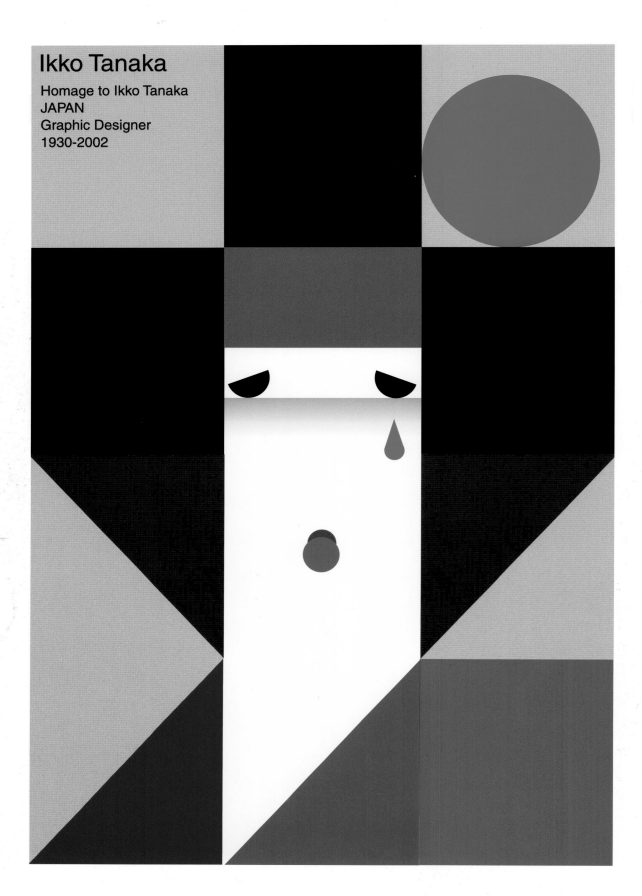

Ikko Tanaka

Homage to Ikko Tanaka
JAPAN
Graphic Designer
1930-2002

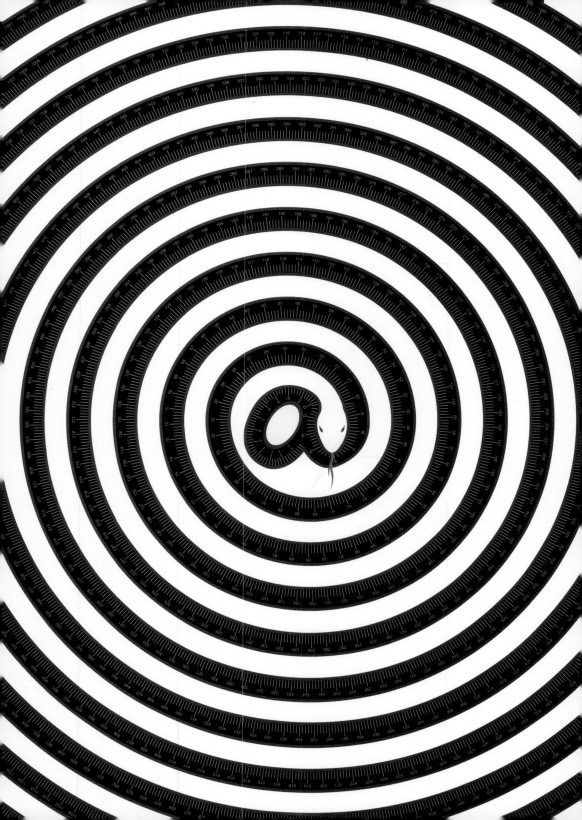

丁寧。

王子コンテナー

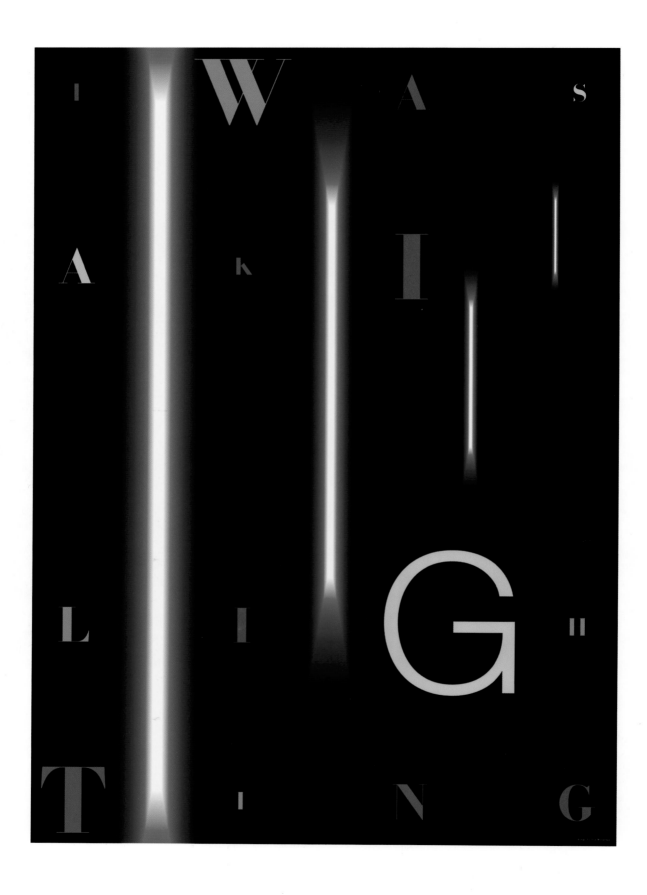

(this spread) Design Firm: Shin Matsunaga Design, Inc. Art Director: Shin Matsunaga Designer: Shin Matsunaga Client: Iwasaki Electric Co., Ltd.

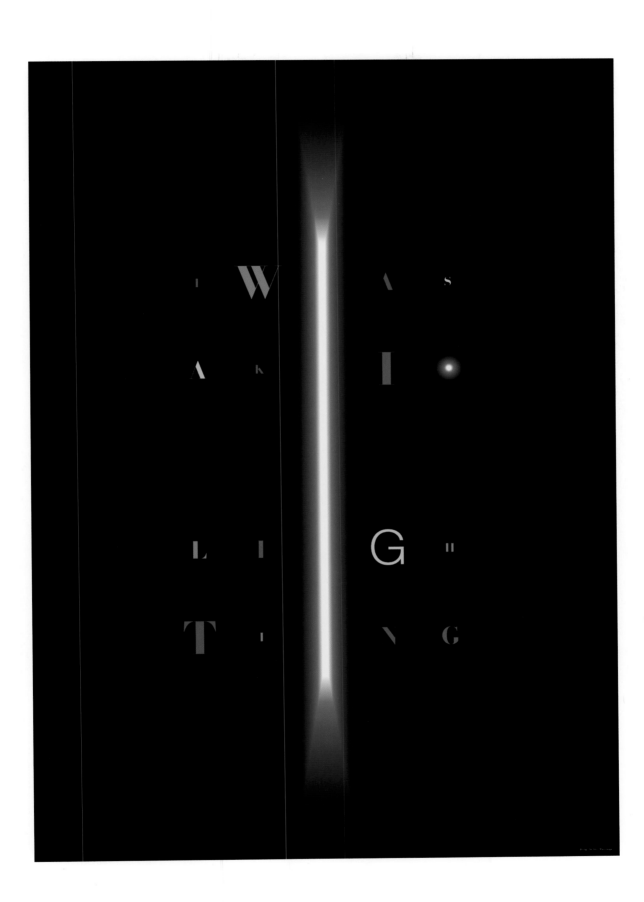

(this spread) Design Firm: Ogilvy & Mather Japan Creative Director: Keiichi Uemura Art Director: Keiichi Uemura Designer: Keiichi Uemura Photographer: Akira Sakamoto Copywriter: Haruyuki Takato Client: Machida Hiroko Academy

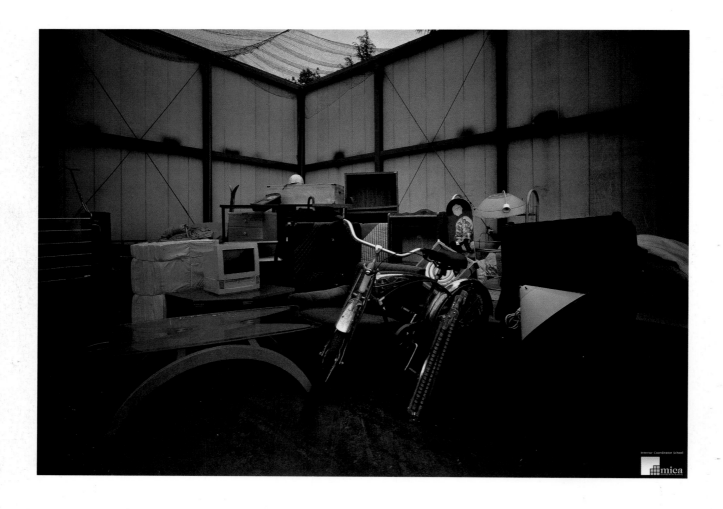

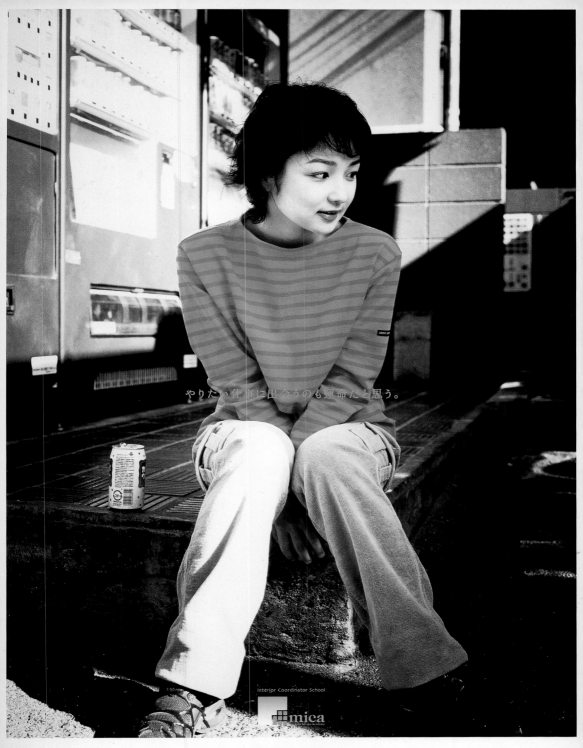

やりたい仕事に出会うのも運命だと思う。

interior Coordinator School

mica

4月生募集

町田ひろ子アカデミー トリトン校 お問合せ・お申込みは、☎0120-844211 e-mail:triton@machida-academy.co.jp ● http://www.machida-academy.co.jp/

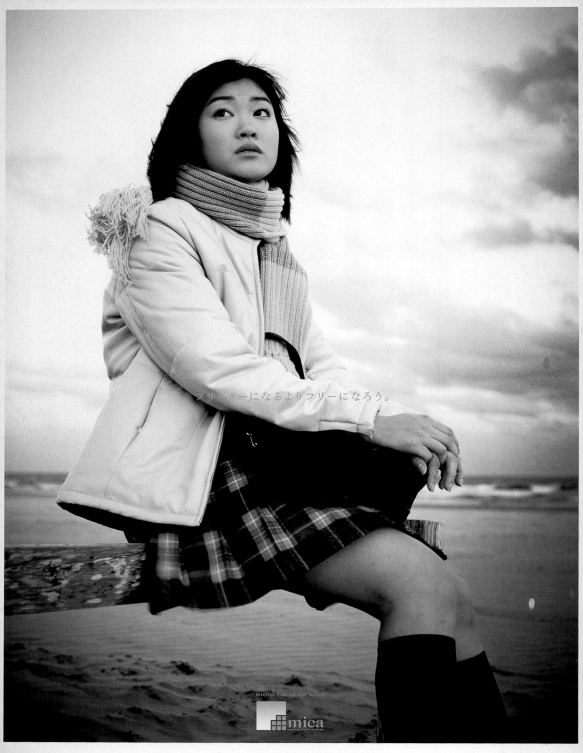

フリーターになるよりフリーになろう。

Interior Coordinator School

mica
machida hiroko academy

4月生募集

町田ひろ子アカデミー トリトン校　お問合せ・お申込みは、☎0120-844211 e-mail:triton@machida-academy.co.jp ●http://www.machida-academy.co.jp/

JOYFULNESS
COMES from
DESIGN

JCD
Design Manufacturer on
LIFESTYLE PRODUCTS
tel +852 2191 2113 web-site jcdgroup.com

(this spread) Design Firm: Shinnoske Inc. Art Director: Shinnoske Sugisaki Designer: Chiaki Acuno Client: Camuro Dance Studio

CAMURO DANCE STUDIO PRESENTS
DANCE TREATMENT 3
NEW SHOOTS

Sunday. 04.01.2001 @ Bay Side Jenny

CAMURO DANCE STUDIO PRESENTS "DANCE TREATMENT 3 "NEW SHOOTS"
OPEN 17:30 / START 18:00 / CHARGE adv. 2,500yen door 3,000yen
GUEST DANCERS: Cool B-Do, DEF, HOT-WAX, JIG, New Black-izm, PARADOX,
SOUND OF MAN with VENOM SPECIAL SESSION, STEP FLOWERS, Value Combo, and more!!
VJ: BABU²/FRY MC: KIYOMI (FM802 GROOVE NIGHT)
Information: telephone 06-6947-0055 e-mail ken@camuro.co.jp

Sunday. 04.01.2001 @ Bay Side Jenny

CAMURO DANCE STUDIO PRESENTS "DANCE TREATMENT 3 "NEW SHOOTS"
OPEN 17:30 / START 18:00 / CHARGE adv. 2,500yen door 3,000yen
GUEST DANCERS: Cool B-Do, DEF, HOT-WAX, JIG, New Black-izm, PARADOX,
SOUND OF MAN with VENOM SPECIAL SESSION, STEP FLOWERS, Value Combo, and more!!
VJ: BABU²/FRY MC: KIYOMI (FM802 GROOVE NIGHT)
Information: telephone 06-6947-0055 e-mail ken@camuro.co.jp

Sunday. 04.01.2001 @ Bay Side Jenny

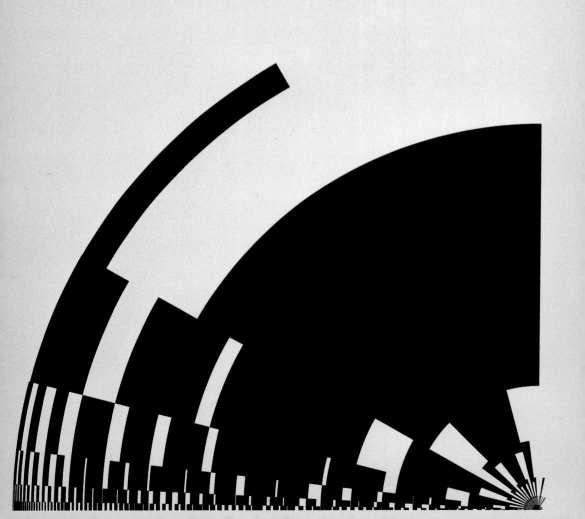

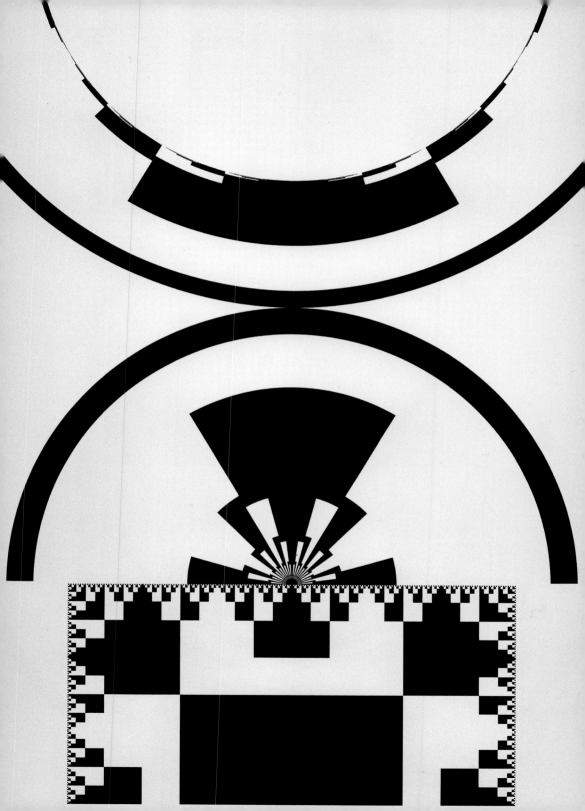

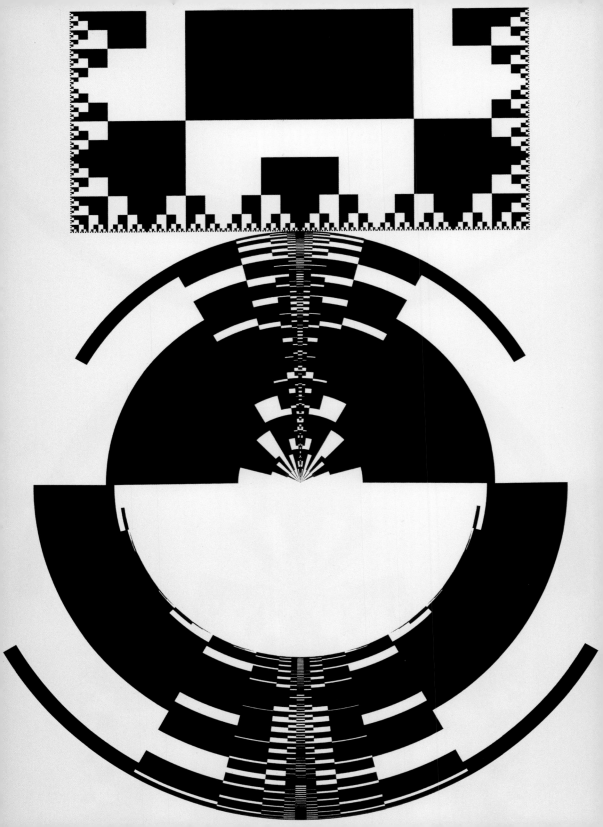

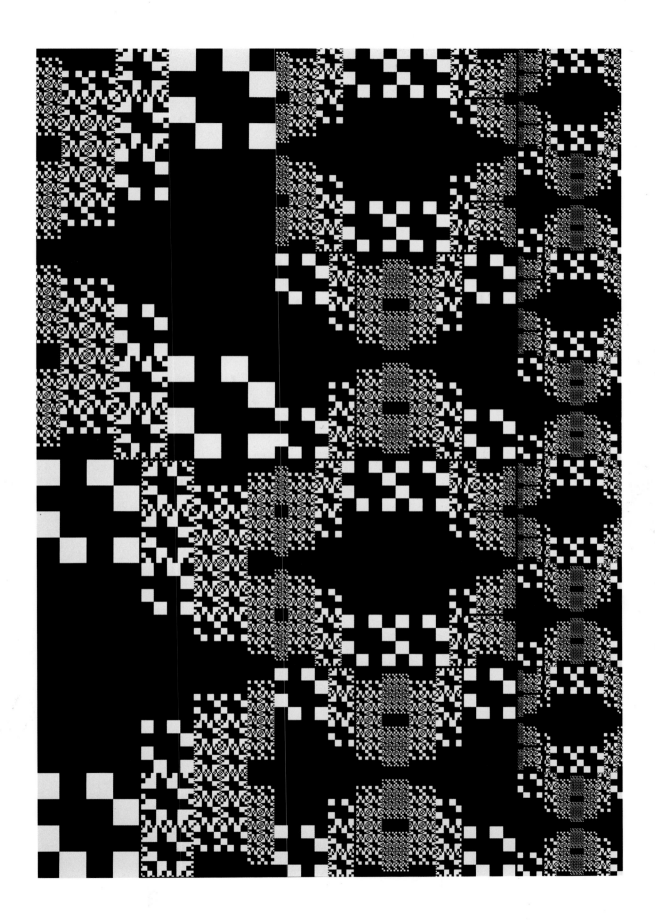

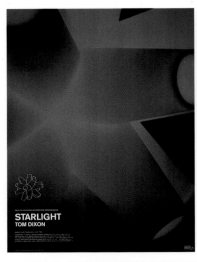

STARLIGHT
TOM DIXON

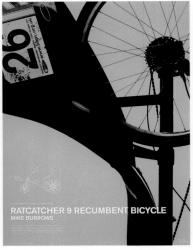

RATCATCHER 9 RECUMBENT BICYCLE
MIKE BURROWS

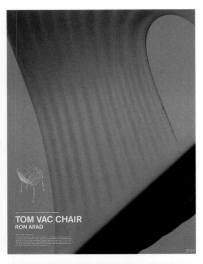

TOM VAC CHAIR
RON ARAD

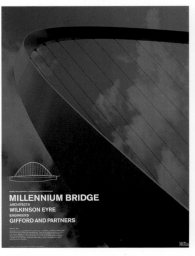

MILLENNIUM BRIDGE
ARCHITECTS
WILKINSON EYRE
ENGINEERS
GIFFORD AND PARTNERS

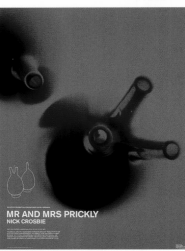

MR AND MRS PRICKLY
NICK CROSBIE

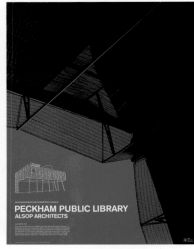

PECKHAM PUBLIC LIBRARY
ALSOP ARCHITECTS

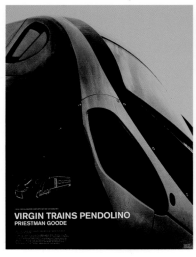

VIRGIN TRAINS PENDOLINO
PRIESTMAN GOODE

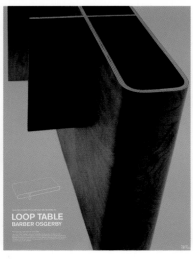

LOOP TABLE
BARBER OSGERBY

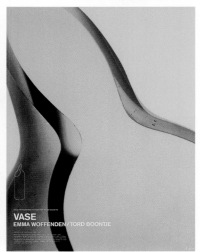

VASE
EMMA WOFFENDEN/TORD BOONTJE

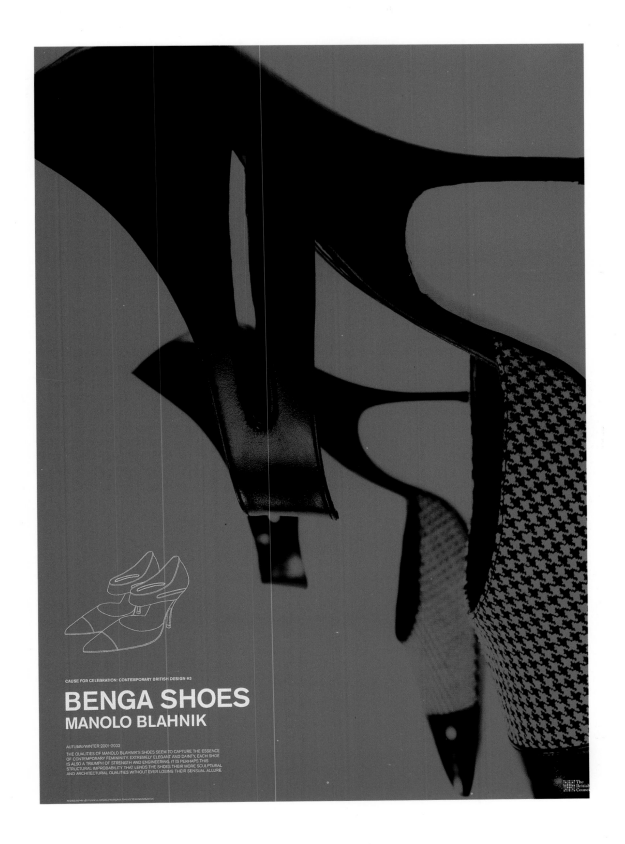

CAUSE FOR CELEBRATION: CONTEMPORARY BRITISH DESIGN #3

BENGA SHOES
MANOLO BLAHNIK

AUTUMN/WINTER 2001-2002

THE QUALITIES OF MANOLO BLAHNIK'S SHOES SEEM TO CAPTURE THE ESSENCE
OF CONTEMPORARY FEMININITY, EXTREMELY ELEGANT AND DAINTY, EACH SHOE
IS ALSO A TRIUMPH OF STRENGTH AND ENGINEERING. IT IS PERHAPS THIS
STRUCTURAL IMPROBABILITY THAT LENDS THE SHOES THEIR MORE SCULPTURAL
AND ARCHITECTURAL QUALITIES WITHOUT EVER LOSING THEIR SENSUAL ALLURE.

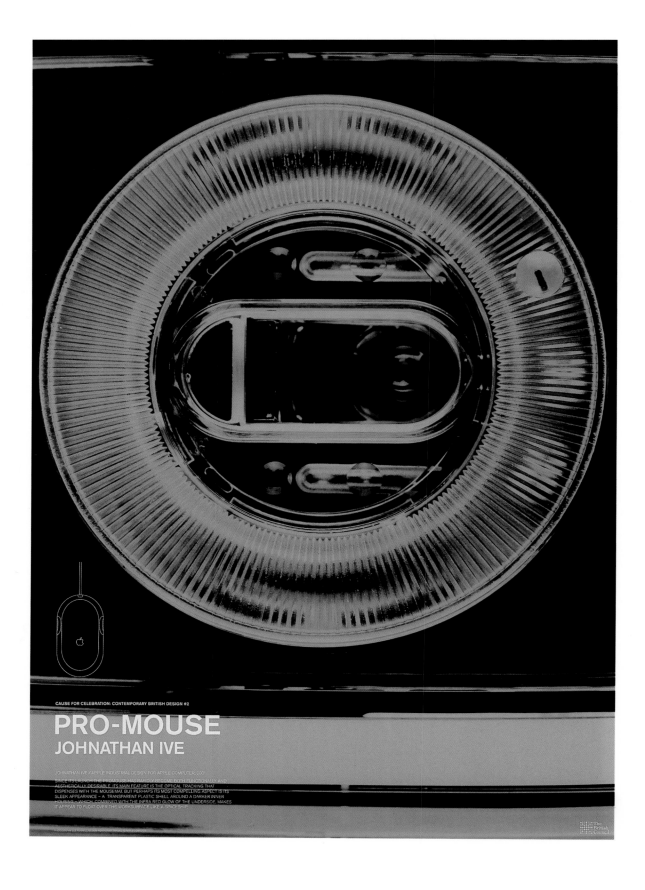

CAUSE FOR CELEBRATION: CONTEMPORARY BRITISH DESIGN #2

PRO-MOUSE
JOHNATHAN IVE

JOHNATHAN IVE / APPLE INDUSTRIAL DESIGN FOR APPLE COMPUTER, 2001

SINCE ITS LAUNCH THE PRO-MOUSE HAS RAPIDLY BECOME BOTH FUNCTIONALLY AND
AESTHETICALLY DESIRABLE. ITS MAIN FEATURE IS THE OPTICAL TRACKING THAT
DISPENSES WITH THE MOUSEMAT BUT PERHAPS ITS MOST COMPELLING ASPECT IS ITS
SLEEK APPEARANCE – A TRANSPARENT PLASTIC SHELL AROUND A DARKER INNER
HOUSING – WHICH COMBINED WITH THE INFRA RED GLOW OF THE UNDERSIDE, MAKES
IT APPEAR TO FLOAT OVER THE WORKSURFACE LIKE A SPACESHIP.

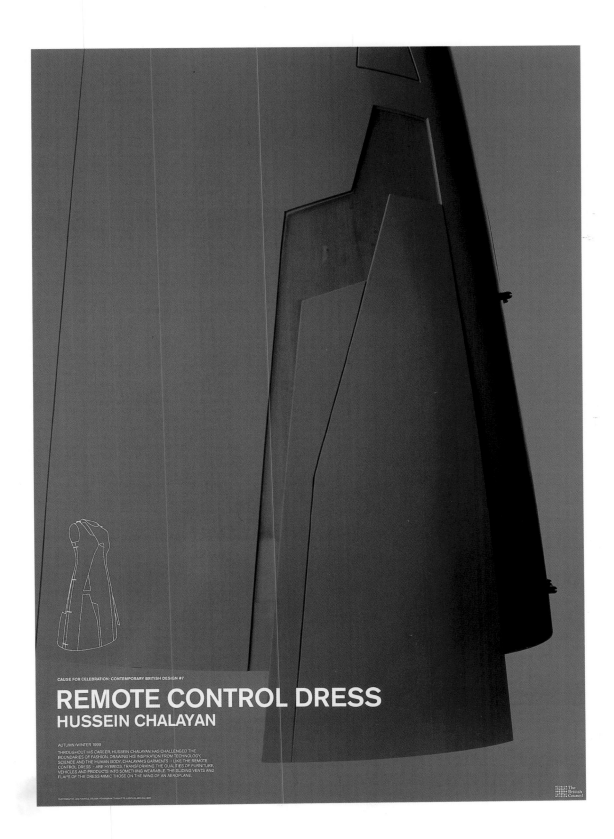

CAUSE FOR CELEBRATION: CONTEMPORARY BRITISH DESIGN #7

REMOTE CONTROL DRESS
HUSSEIN CHALAYAN

AUTUMN/WINTER 1999

THROUGHOUT HIS CAREER, HUSSEIN CHALAYAN HAS CHALLENGED THE
BOUNDARIES OF FASHION, DRAWING HIS INSPIRATION FROM TECHNOLOGY,
SCIENCE AND THE HUMAN BODY. CHALAYAN'S GARMENTS – LIKE THE REMOTE
CONTROL DRESS – ARE HYBRIDS, TRANSFORMING THE QUALITIES OF FURNITURE,
VEHICLES AND PRODUCTS INTO SOMETHING WEARABLE. THE SLIDING VENTS AND
FLAPS OF THE DRESS MIMIC THOSE ON THE WING OF AN AEROPLANE.

PHOTOGRAPHY: LES FUNKHILL. DESIGN: PENTAGRAM. THANKS TO JUDITH CLARK GALLERY.

The British Council

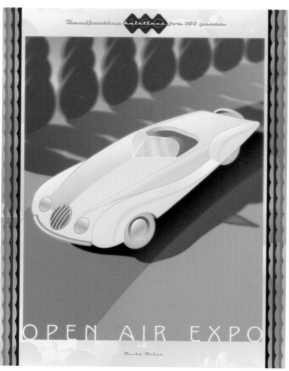

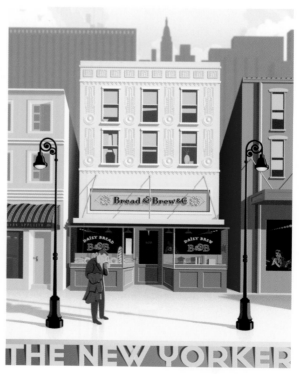

(this spread) Design Firm: DDB International, Ltd. Creative Director: David Brier Art Director: David Brier Designer: David Brier Illustrator: David Brier Copywriter: David Brier Client: DDB International, Ltd.

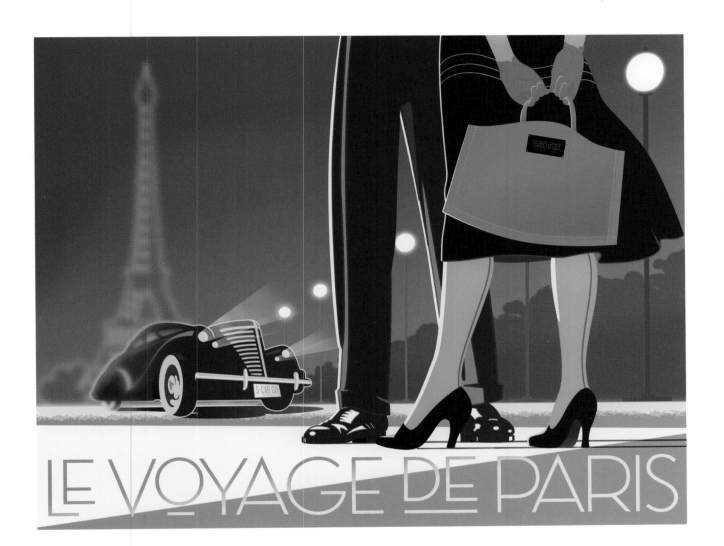

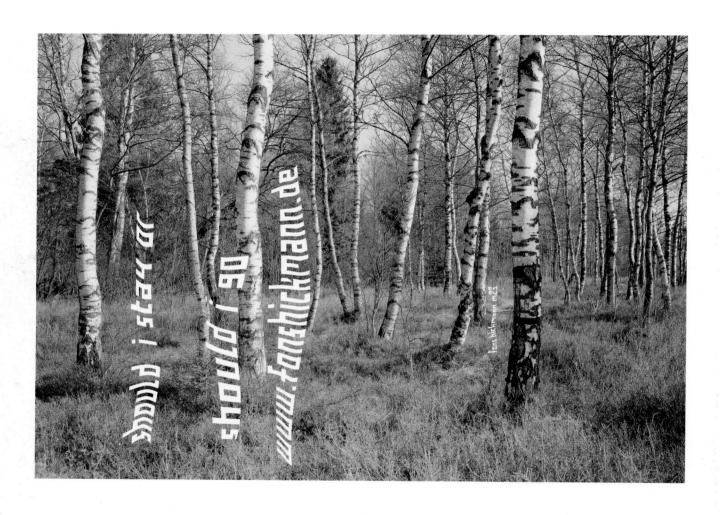

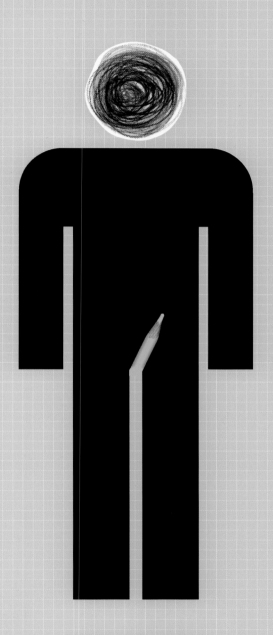

AN'S DESIGN ROOM
Matsusiro 3-24, Tsukubasi, 305-0035
TEL/FAX 0298-54-8300

2001+
11+11
OPEN

GRAPHIC DESIGN / ILLUSTRATION / ADVERTISEMENT / LOGOTYPE, SYMBOL & MARK / PACKAING

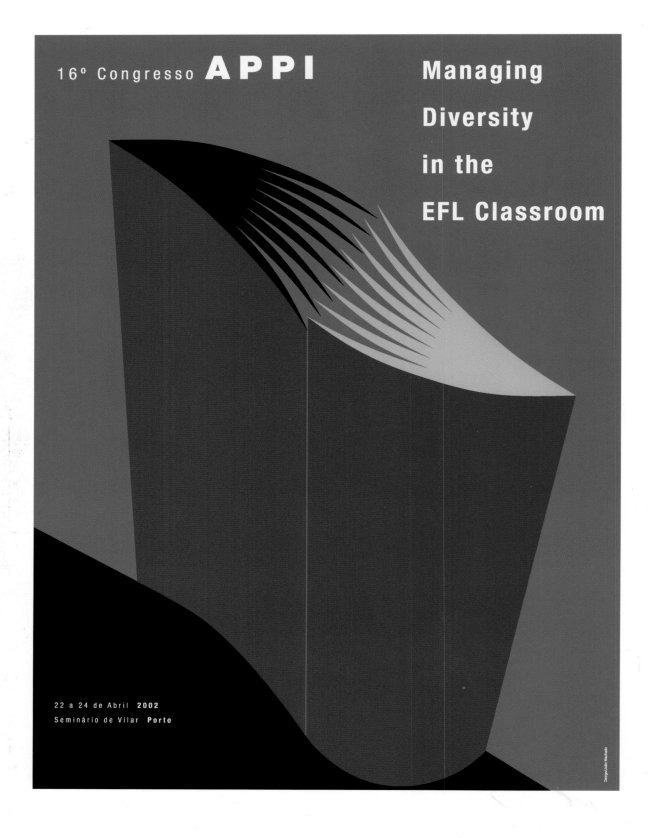

16° Congresso **APPI**

Managing
Diversity
in the
EFL Classroom

22 a 24 de Abril **2002**
Seminário de Vilar **Porto**

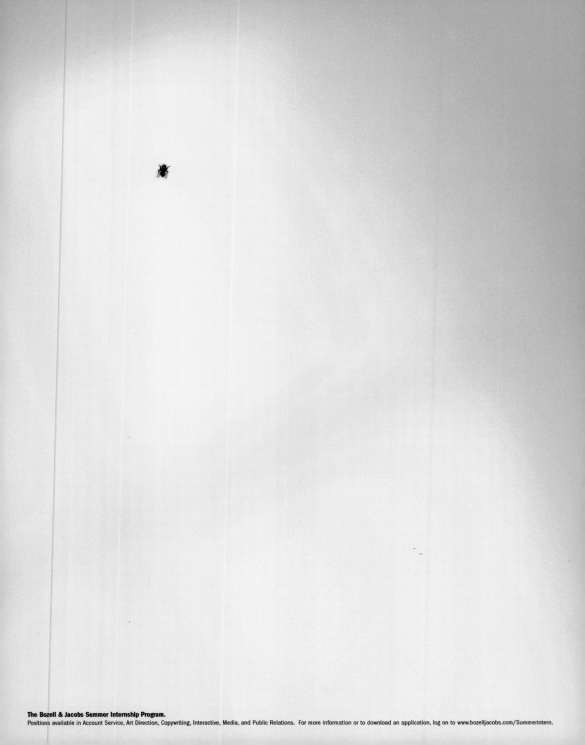

The Bozell & Jacobs Summer Internship Program.
Positions available in Account Service, Art Direction, Copywriting, Interactive, Media, and Public Relations. For more information or to download an application, log on to www.bozelljacobs.com/Summerintern.

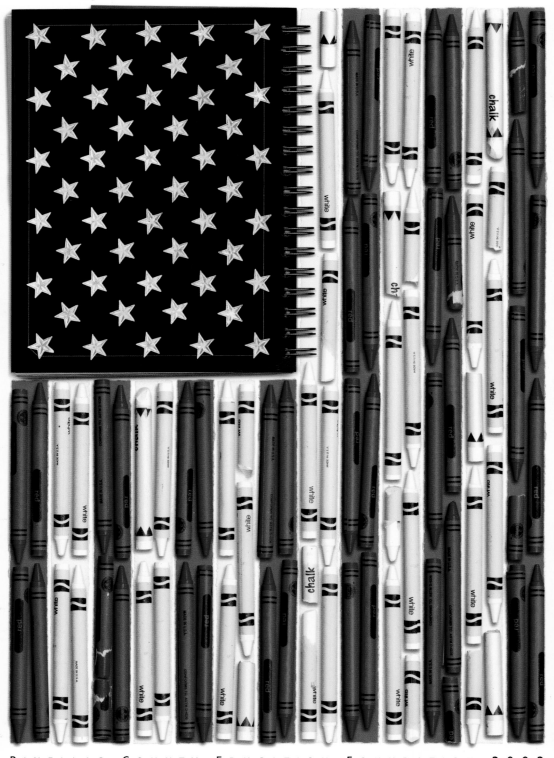

PINELLAS COUNTY EDUCATION FOUNDATION **2002**

I pledge allegiance to the Flag of the United States of America, and to the Republic for which it stands, one Nation under God, indivisible, with liberty and justice for all.

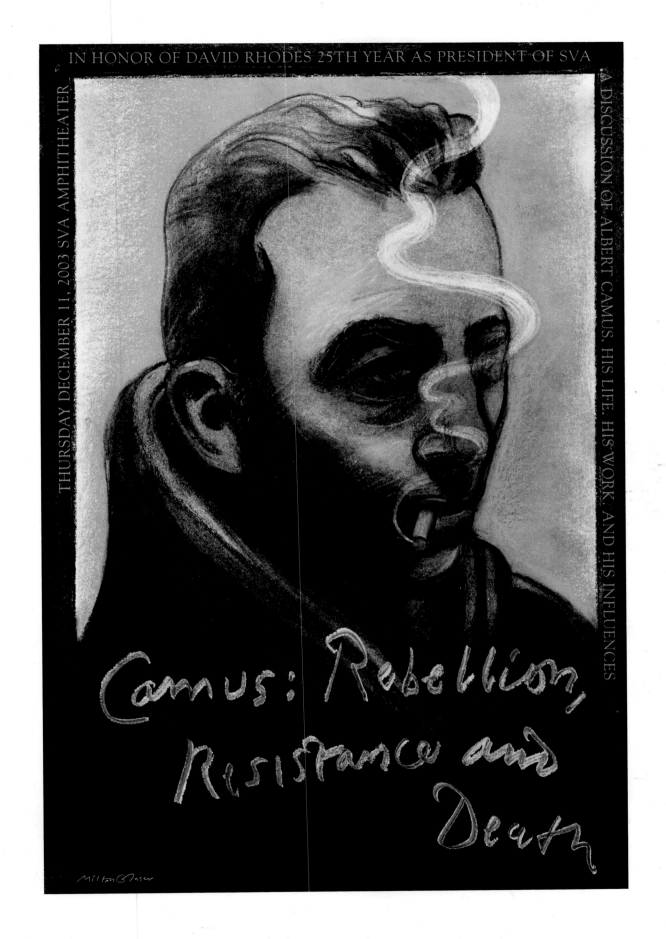

IN HONOR OF DAVID RHODES 25TH YEAR AS PRESIDENT OF SVA

THURSDAY DECEMBER 11, 2003 SVA AMPHITHEATER

A DISCUSSION OF ALBERT CAMUS. HIS LIFE. HIS WORK. AND HIS INFLUENCES

Camus: Rebellion, Resistance and Death

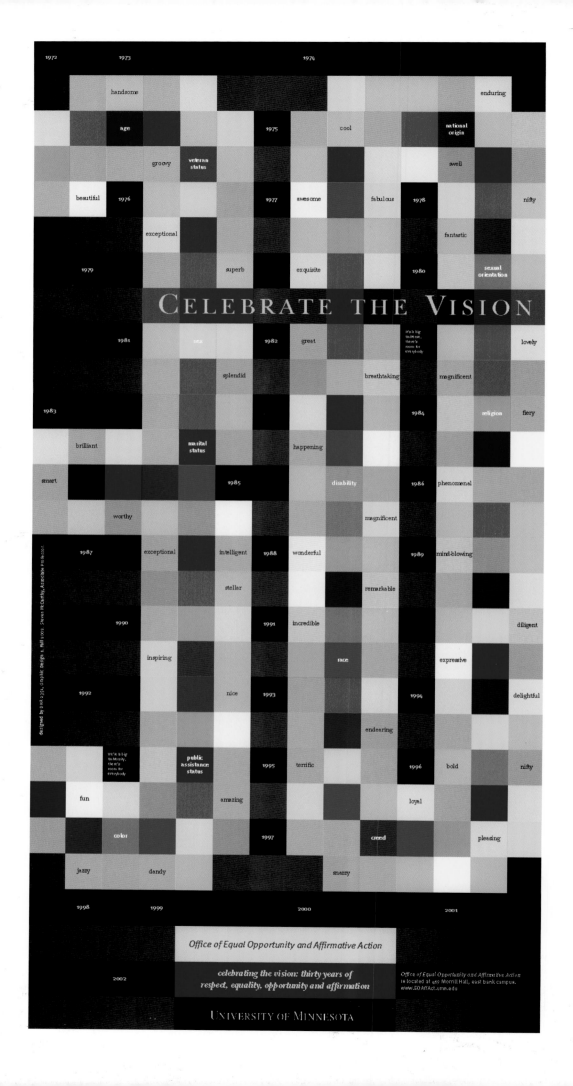

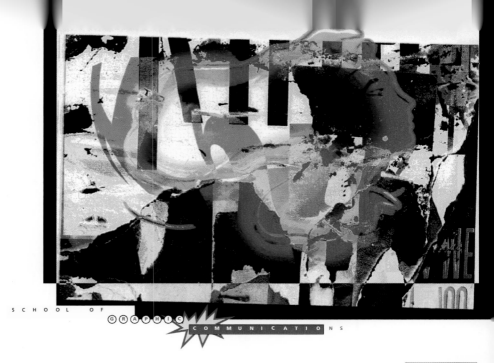

Visual Arts

Fundamentals

Graphic

Design

Digital

Media

SCHOOL OF GRAPHIC COMMUNICATIONS

George Br

200 King Street East

Toronto ON

Canada M5A 3W8

www.gbrowns.on.ca/design

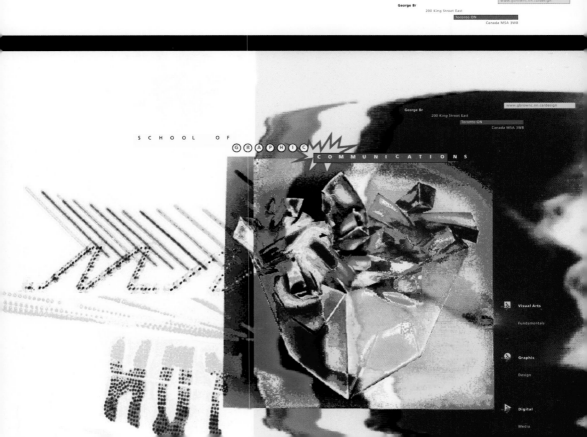

www.gbrownc.on.ca/design

George Br

200 King Street East

Toronto ON

Canada M5A 3W8

SCHOOL OF GRAPHIC COMMUNICATIONS

Visual Arts

Fundamentals

Graphic

Design

Digital

Media

の連続

インターメディウム研究所・IMI大学院スクールは、
アッの連続

2003年度（第8期）研究生募集

インターメディウム研究所・IMI大学院スクールは、1996年の開講
以来、情報・文化およびメディア産業界で創造力を発揮する人を
多数輩出し、また新しい創造のための豊かなコンテンツを育んでき
ました。

芸術系・文系・理系などさまざまなバックグラウンドを持つ研究生
が全国から集い、映像、デザイン、サウンド、ネットワーク、建築、
編集、文化・哲学、アートマネージメントなど多様な領域を横断的
に学び、さらにはCS番組やWebコンテンツ制作など、社会と関わ
る実践的プロジェクトに参加し研修がつめる、画期的なプロフェッ
ショナル・スクールとして全国的に大きな注目を集めています。

IMI大学院スクール　説明会日程
9月15日（日）　10月6日（日）　10月13日（日）　10月26日（土）
11月4日（月・祝）　11月23日（土）　12月7日（土）　12月14日（土）
各日13:00〜14:30開催
内容：映像によるカリキュラム紹介、講師によるミニレクチャー施設見学、
　　　個別進路相談など
会場：インターメディウム研究所（千里万博公園内）
※上記の日程以外にも、個別見学を随時受け付けております

M1コース、M0コース　前期特別AO入試開催
第4期研究生を募集にともない、前期特別AO入試を行います。
前期特別AO入試日程：2002年9月29日（日）
出願期間：9月9日（月）〜9月19日（木）

特別AO入試合格者の特典：
・アドミニストレーション講座、特別講座など本年度開講のレクチャーを一部受講できる
・映像メディア図書館を利用でき、IMIのレクチャービデオなどの映像資料を閲覧できる
・合格者のための特別レクチャーを開催

IMI大学院スクールの各コース

文系学部　　　　　　　　　　　　　→　　　アーティスト
法学・社会学・経営学・文学・美学　→

芸術系大学　　　　　　　　　　　　→　　　編集者、ディレクター
芸術・絵画・デザイン・音楽　　　　→

理工系学部　　　　　　　　　　　　→　　　クリエイターズ・ユニット、
建築・生物学・数学・情報工学　　　→　　　ベンチャー企業

短期大学　　　　　　　　　　　　　→　　　デザイン事務所、映像プロダクション
デザイン・文学・生活科　　　　　　→

アート系専門学校　　　　　　　　　→　　　Web制作などのSOHOクリエイター
メディア・写真・ファッション　　　→

社会人　　　　　　　　　　　　　　→　　　海外、他の大学院
デザイナー、映像関係、印刷会社、
システムエンジニア　　　　　　　　→　　　デジタルアート系学校講師

ダブルスクール　　　　　　　　　　→　　　IMIグループのスタッフ
大学生、大学院生　　　　　　　　　→

M1コース
ハイレベルのプロの表現者をめざし、世界の第一
線で活躍するアーティストやディレクター、研究
者とのワークショップを通して実践的な思考と技
術を学ぶ、主・副コースに関連するコース。
（定員人数100名）

2002年度M1・M0コース講座一覧
ヴィジョン・セオリー／アドミニストレーション（エレメンタリータ・ワークス／スペシャルレクチャー）／
セオリー・ディレクション（メディア編集＆ディレクション／映像プロデュース／地域プロデュース）／
アートマネージメント（パフォーマンス／アーツ）／グラフィック／ネットワークデザイン／
デジタル・ピクチャーコミュニケーション・ピクチャー／サウンドデザイン／インターフェイスラボ／プログラミング／
アートドキュメンタリー／現代美術専攻特別

M2コース
M1を修了した研究生が、それぞれの専門分野の
要る各department内において、ティーチングアシス
タントや技術アシスタントとして講師の助手を目的
なが52年目を経験。制作活動を行うコース。
（定員人数20名）

M0コース
多様なメディアを横断し長足が求められるデジ
タル時代のクリエイターとなる人のための、幅広
い技術と知識を基盤から習得する入門的なベー
シックコース。講座は平日の昼間に開講。
（定員人数20名）

夜間コース
週目の夜間（19:00〜21:45）、技術と思考の両面
を研鑽す基礎からリキュラムのエッセンスを長心的
に学ぶ、ダブルスクールや会社に勤めながらでも
受講可能なコース。（定員人数40名）

2002年度M0・夜間コース講座一覧 Graphic Design/DTP, Movie/CG, Photography, Web/Network、一般教養

2･3

インターメディウム研究所・IMI大学院スクール
問い合わせ専用フリーダイヤル0120-366 603
〒565-0826 大阪府吹田市千里万博公園内・後1号館内
phone 06-6816-4563　fax 06-6816-4565
e-mail: office@iminet.ac.jp　http://www.iminet.ac.jp

芸術筋を鍛える アスレチックジム

インターメディウム研究所・IMI大学院スクールは、
芸術筋を鍛えるアスレチックジム。

2003年度〈第8期〉研究生募集

インターメディウム研究所・IMI大学院スクールは、1996年の開講以来、情報・文化およびメディア産業界で創造力を発揮する人材を多数輩出し、また新しい創造のための豊かなコンテンツを育んできました。芸術系・文系・理系などさまざまなバックグラウンドを持つ研究生が全国から集い、映像、デザイン、サウンド、ネットワーク、建築、編集、文化・哲学、アートマネジメントなど多様な領域を横断的に学び、さらにはCS番組やWebコンテンツ制作など、社会と関わる実践的プロジェクトに参加し研修がつづく、画期的なプロフェッショナル・スクールとして全国的に大きな注目を集めています。

IMI大学院スクール 説明会日程
9月15日（日）10月6日（日）10月13日（日）10月26日（土）
11月4日（月・祝）11月23日（土）12月7日（土）12月14日（土）
各日13:00〜14:30開催
会場：インターメディウム研究所（千里万博公園内）
個別施設相談など
※上記の日程以外にも随時個別にお受けしております

M1コース、M0コース 前期特別AO入試開催
第1期研究生募集にともない、前期特別AO入試を行います。
前期特別AO入試日程：2002年9月29日（日）
出願期間：9月9日（月）〜9月19日（木）

特別AO入試合格者の特典。
・アドミニストレーション講座、特別講座など2年度課程のレクチャーを一部免除できる
・合格者のための特別レクチャービデオなどの映像資料を閲覧できる
・合格者のための特別レクチャーを開催

IMI大学院スクールの各コース

文系学群
法学・社会学・経営学・文学・美学 →

理工系学群
建築・映像・デザイン・音楽 →

理工系学群
理工・生物学・数学・情報工学 →

域報大学
デザイン・文学・生涯科 →

アート系専門校
メディア・写真・ファッション →

社会人
デザイナー、編集者・印刷会社、
システムエンジニア →

ダブルスクール
大学生、大学院生 →

→ アーティスト
→ 編集者・ディレクター
→ クリエイターズ・ユニット、ベンチャー企業
→ デザイン事務所、映像プロダクション
→ Web制作などのSOHOクリエイター
→ 海外・他の大学院
→ デジタル・アート系学校講師
→ IMIグループのスタッフ

M2　**M1**　**M0**　**夜間**

M1コース
M1を修了したのち、世界の第一線で活躍するアーティスト・ディレクター、研究者とのワークショップを通じて実践的な思考と感性を学ぶ、土・日中心に開講するコース。（募集人員100名）

2002年度M1・M0コース講座一覧
ヴィジョン・セオリー／アドミニストレーション＝レメンタリーワーク・クラス／スペシャルクチャー／セオリー・ディレクション／メディア編集＆ディレクション／映像プロデュース＝映像プロデュース／アートマネージメント（パフォーミングアーツ）／グラフィック＝ネットワークデザイン／デジタル・ピクチャー／モーション・ピクチャー／サウンドデザイン／インターフェイスラボ／プログラミング／アートドキュメンタリー＝現代美術／表現論

M2コース
M1を修了した研究生が、それぞれの専門分野で縮力を増強するために、ティーチングアシスタント／技術アシスタントとして話題の世界を動かすなどの62年目も研究・制作活動を行うコース。

M0コース
多様なメディア表現が求められるデジタル時代のクリエイターとなる人のための、初級・中級と段階的かつ習得できる少人数制のベーシックコース。週末や平日の夜に開講。（募集人員400名）

2002年度M0・夜間コース講座一覧 Graphic Design／DTP、Movie／CG、Photography、Web／Network、一般教養

夜間コース
週2日の夜間（19:00〜21:45）、短期と思考の問題などを5日間を移転的に、ディー・メディアの視点なども含む。また、デジタルスクールや夜間のためでも受講できるなど、ダブルスクールや社会人が通学しやすいコース。（募集短期コース。（募集人員40名）

インターメディウム研究所・IMI大学院スクール
問い合わせ専用フリーダイヤル 0120-366 603
phone 06-6816-4563　fax 06-6816-4565
e-mail office@iminet.ac.jp／http://www.iminet.ac.jp/

2・3

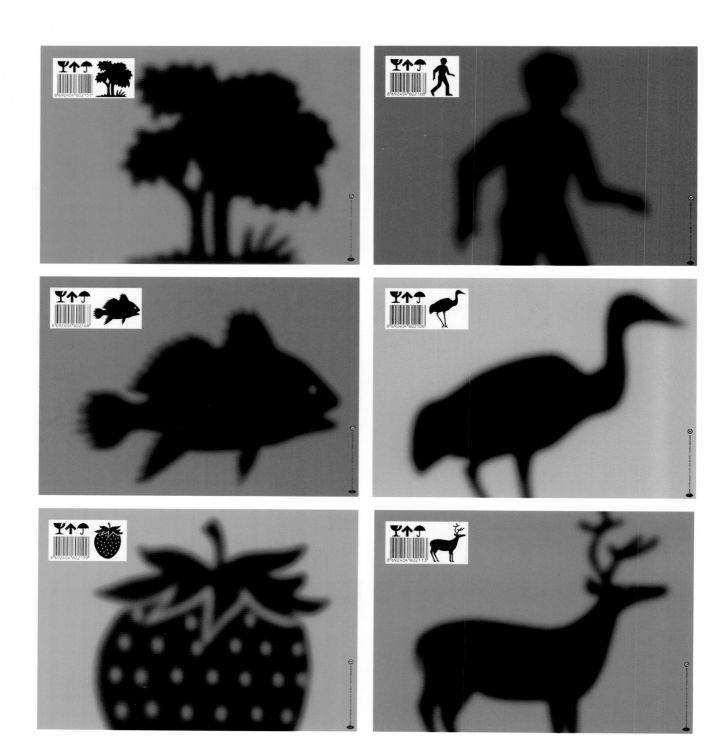

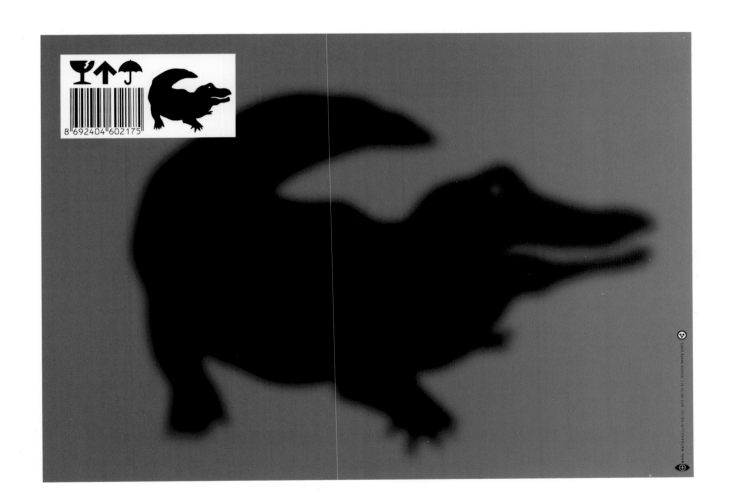

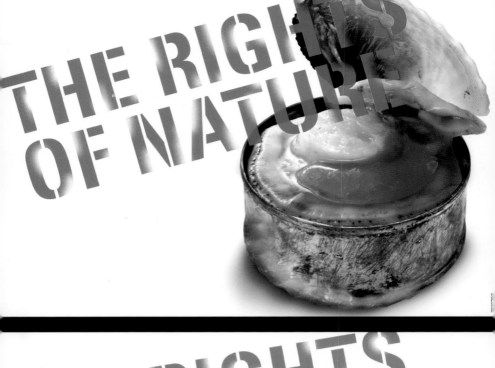

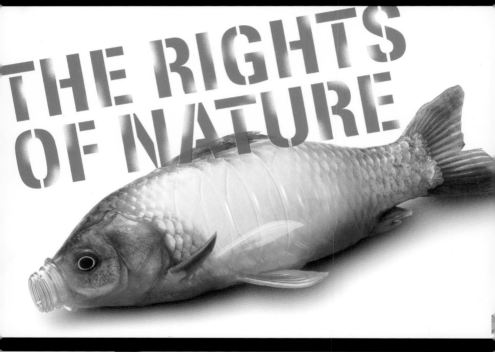

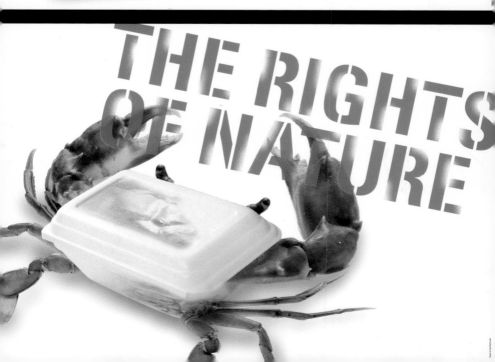

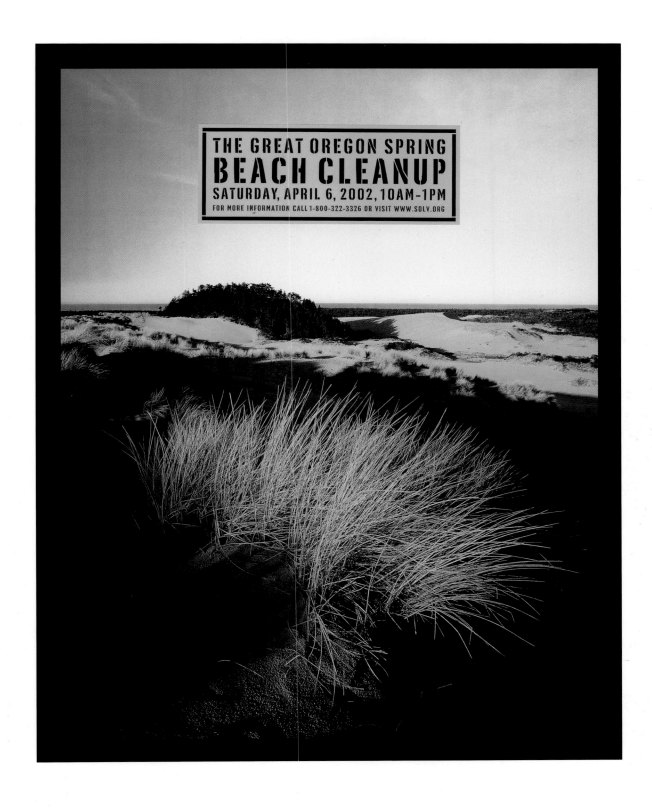

THE GREAT OREGON SPRING
BEACH CLEANUP
SATURDAY, APRIL 6, 2002, 10AM–1PM
FOR MORE INFORMATION CALL 1-800-322-3326 OR VISIT WWW.SOLV.ORG

Design Firm: Sandstrom Design Creative Director: Steve Sandstrom Art Director: Steve Sandstrom Designer: Steve Sandstrom Photographer: Rick Shafer Production Designer: Gerg Parra Client: SOLV

Environment 72,73

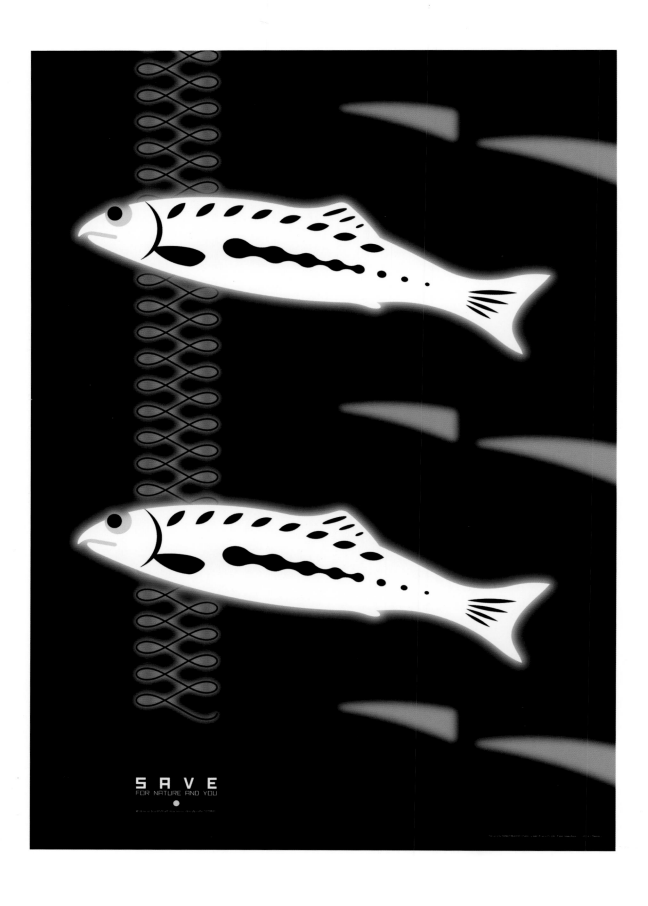

SAVE
FOR NATURE AND YOU

(this spread) Design Firm: Shima Design Office Inc. Creative Director: Takahiro Shima Designer: Takahiro Shima Illustrator: Takahiro Shima

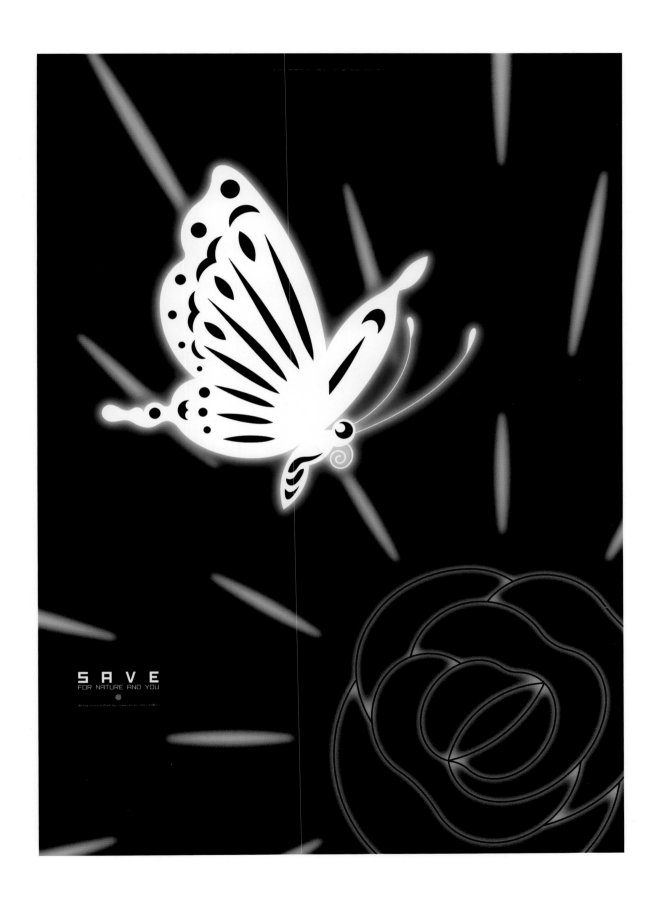

SAVE
FOR NATURE AND YOU

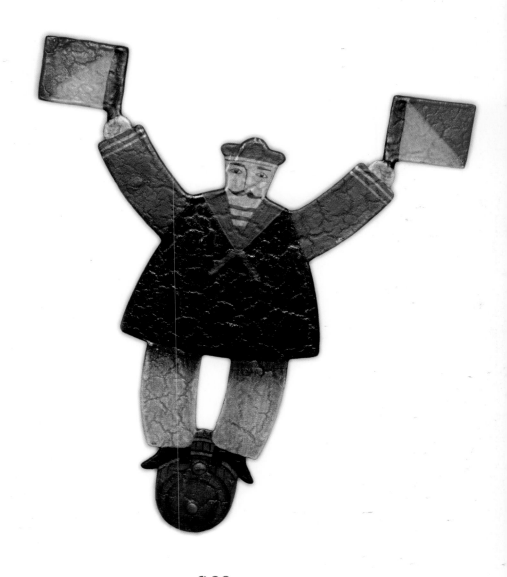

Kieler Woche 22
6
–
30
6.
20
02

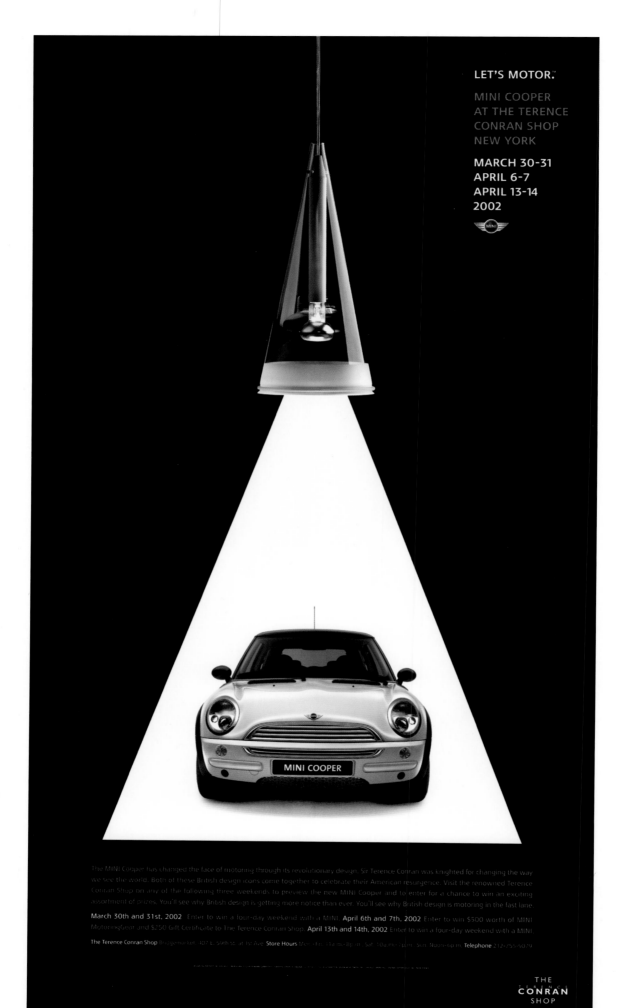

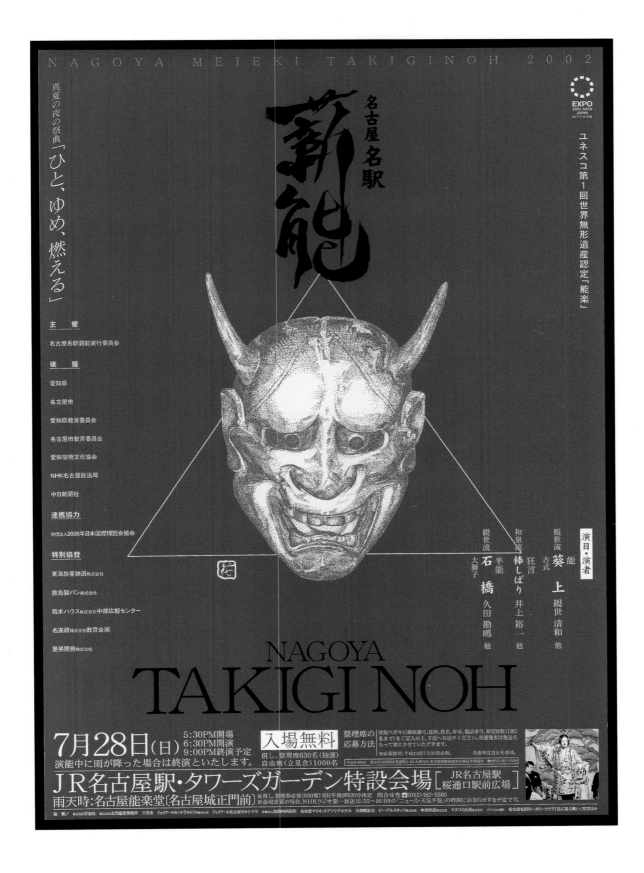

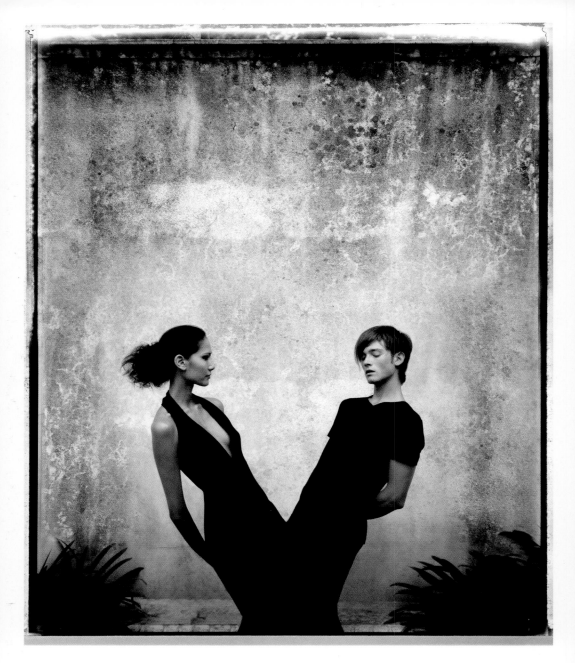

Design Firm: Gollings & Pidgeon Art Director: David Pidgeon Designer: Kate Rogers Photographer: Kate Rogers Client: AGIdeas Student Conference

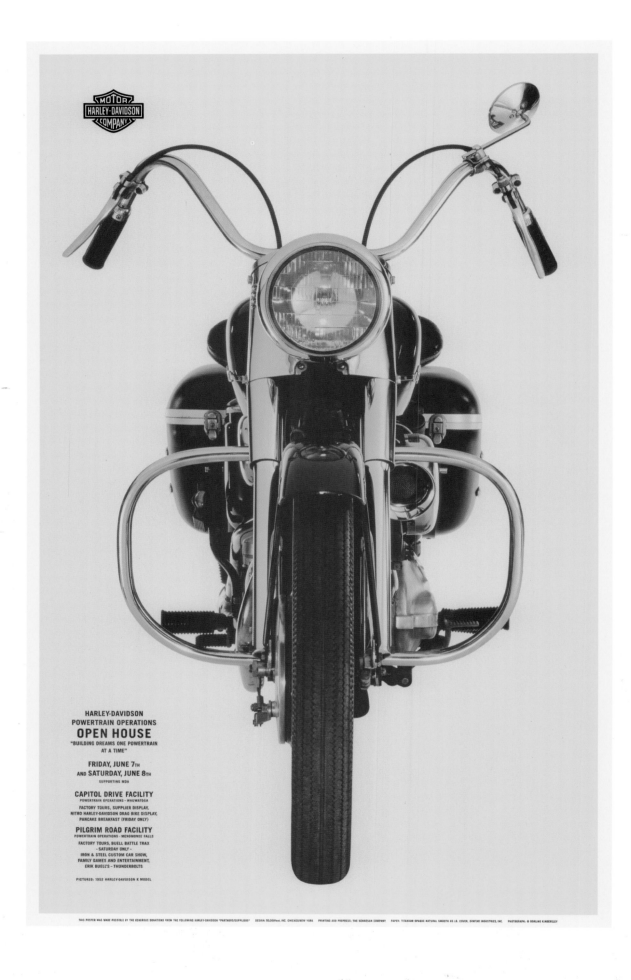

ANATOMY

OF A

CUSTOM

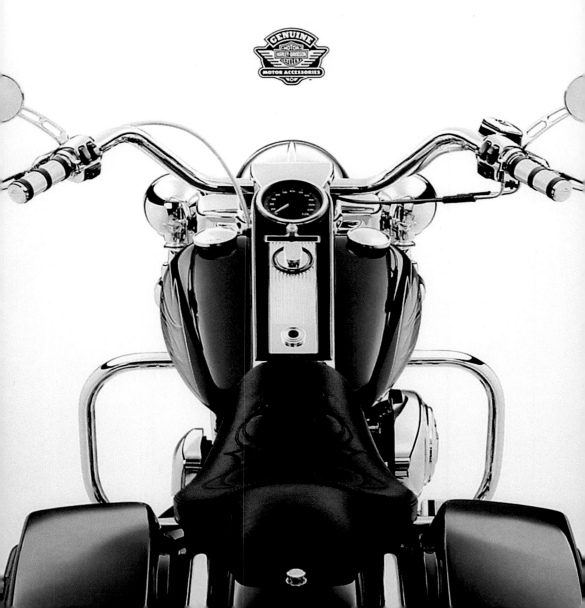

Sponsored by the College of Design, Architecture, Art, and Planning and the University of Cincinnati Faculty Development Council

2002

hael kobayashi
director of digital arts production

Hael Kobayashi is the Director of Digital Artists Production and heads up the management of Industrial Light+Magic's roster of animators, creature developers, rotu, sabrs, compositors, digital matte, rebel unit, multchmovers, technical directors, and digital production supervisors. In addition, Hael oversees management and development of the Digital Training department. Hael's extensive feature and broadcast post-production experience in editorial and audio positions has included work for Lucas Digital's Skywalker Sound on feature films such as "Terminator 2: Judgement Day," "Bugsy," and "The Godfather Part III."

monday, may 20
4:30pm
university of cincinnati
college of daap
5401 aronoff center for design+art

Industrial Light+Magic

Kobayashi

bayashi

UNIVERSITY OF
Cincinnati

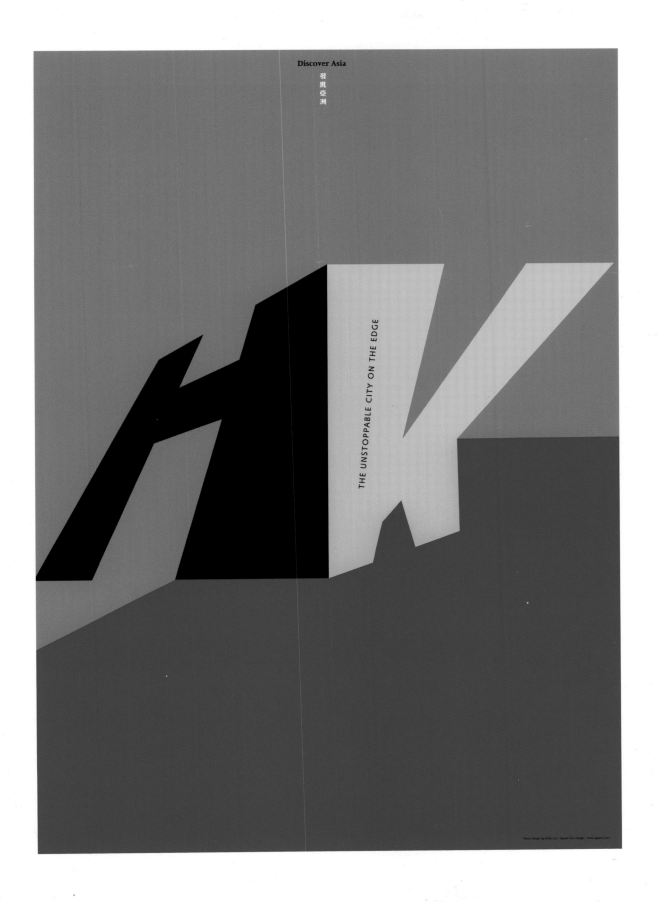

Discover Asia

發現
亞洲

THE UNSTOPPABLE CITY ON THE EDGE

Design Firm: Square Two Design Art Director: Eddie Lee Designer: Eddie Lee Client: Icograda

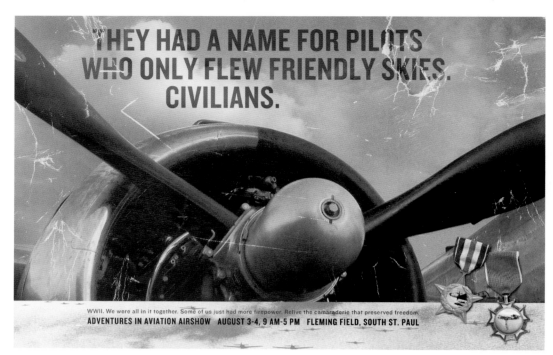

THEY HAD A NAME FOR PILOTS
WHO ONLY FLEW FRIENDLY SKIES.
CIVILIANS.

WWII. We were all in it together. Some of us just had more firepower. Relive the camaraderie that preserved freedom.
ADVENTURES IN AVIATION AIRSHOW AUGUST 3-4, 9 AM-5 PM FLEMING FIELD, SOUTH ST. PAUL

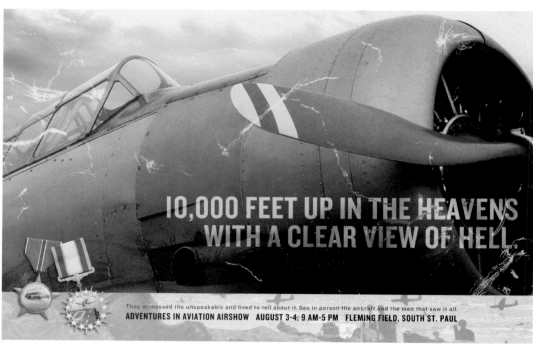

10,000 FEET UP IN THE HEAVENS
WITH A CLEAR VIEW OF HELL.

They witnessed the unspeakable and lived to tell about it. See in person the aircraft and the men that saw it all.
ADVENTURES IN AVIATION AIRSHOW AUGUST 3-4, 9 AM-5 PM FLEMING FIELD, SOUTH ST. PAUL

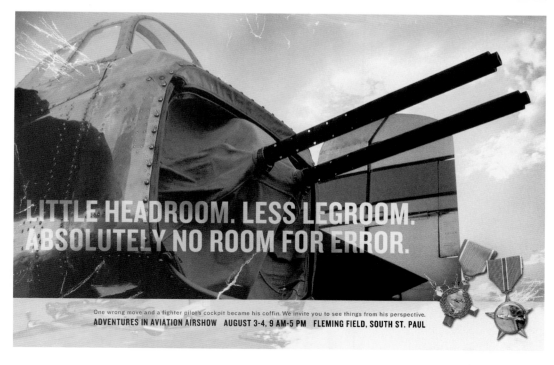

LITTLE HEADROOM. LESS LEGROOM.
ABSOLUTELY NO ROOM FOR ERROR.

One wrong move and a fighter pilot's cockpit became his coffin. We invite you to see things from his perspective.
ADVENTURES IN AVIATION AIRSHOW AUGUST 3-4, 9 AM-5 PM FLEMING FIELD, SOUTH ST. PAUL

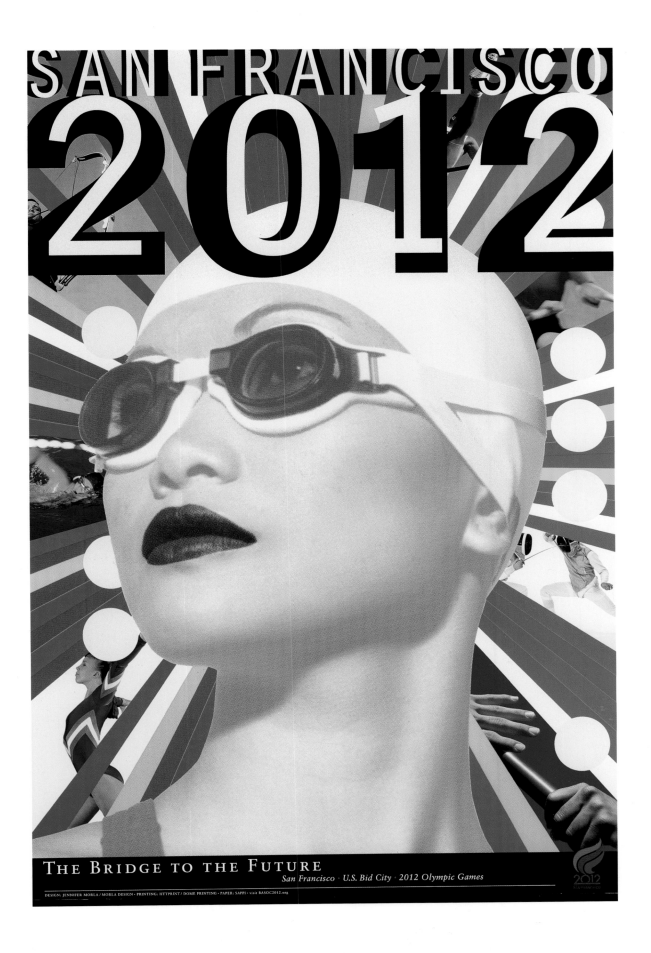

Design Firm: Morla Design Creative Director: Jennifer Morla Art Director: Jennifer Morla Designers: Jennifer Morla and Hizam Haron Photographers: Jock McDonald and Photodisc Client: San Francisco Bay Area Sports Organizing Committee

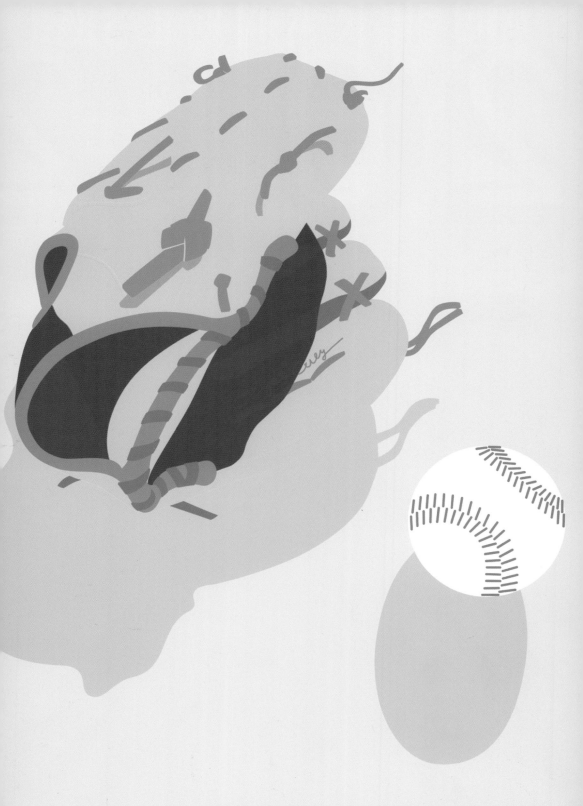

HERMAN MILLER SUMMER PICNIC 2002

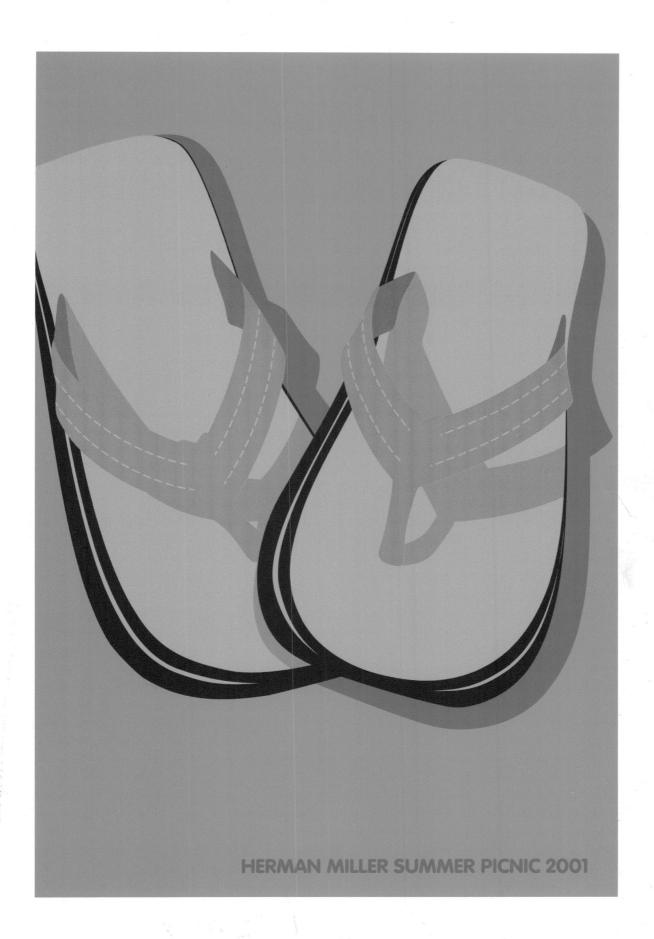

HERMAN MILLER SUMMER PICNIC 2001

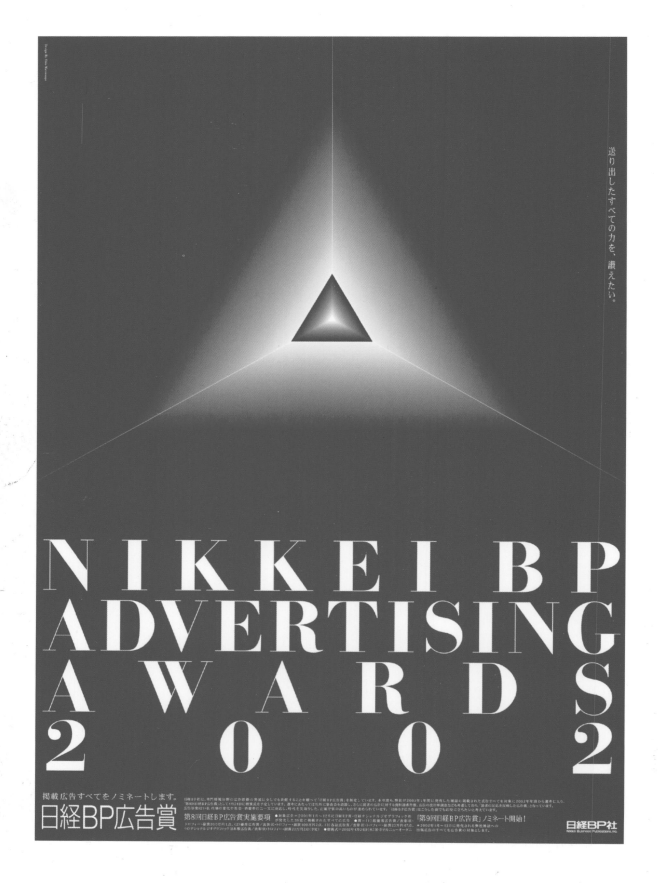

Burn up, Japan? Burn out, Japan?

JAPAN

utions

Re:solutions

2002

stimulate::provoke::inspire::discuss::explore:solutions

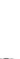

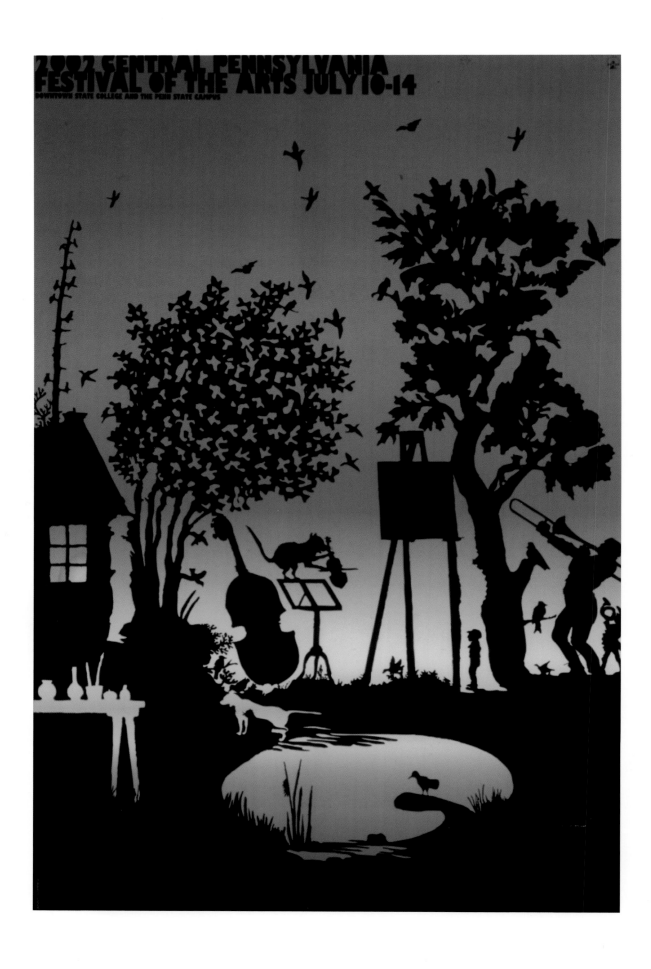

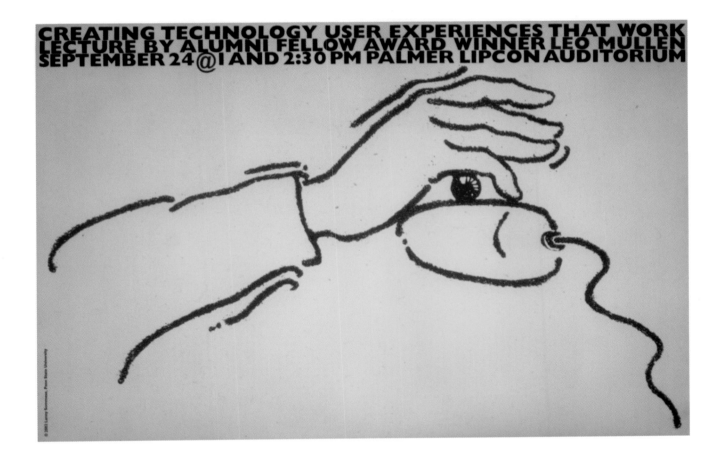

CREATING TECHNOLOGY USER EXPERIENCES THAT WORK
LECTURE BY ALUMNI FELLOW AWARD WINNER LEO MULLEN
SEPTEMBER 24 @1 AND 2:30 PM PALMER LIPCON AUDITORIUM

Design Firm: Sommese Design Creative Director: Lanny Sommese Art Director: Lanny Sommese Designer: Lanny Sommese Illustrator: Lanny Sommese Client: Penn State School of Visual Arts

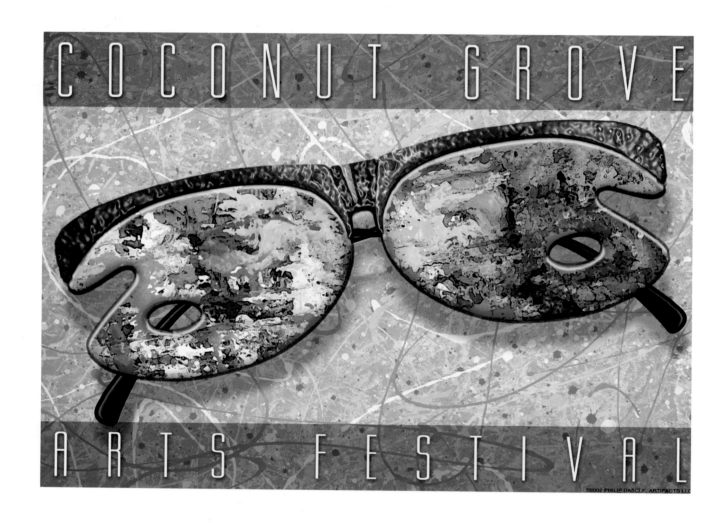

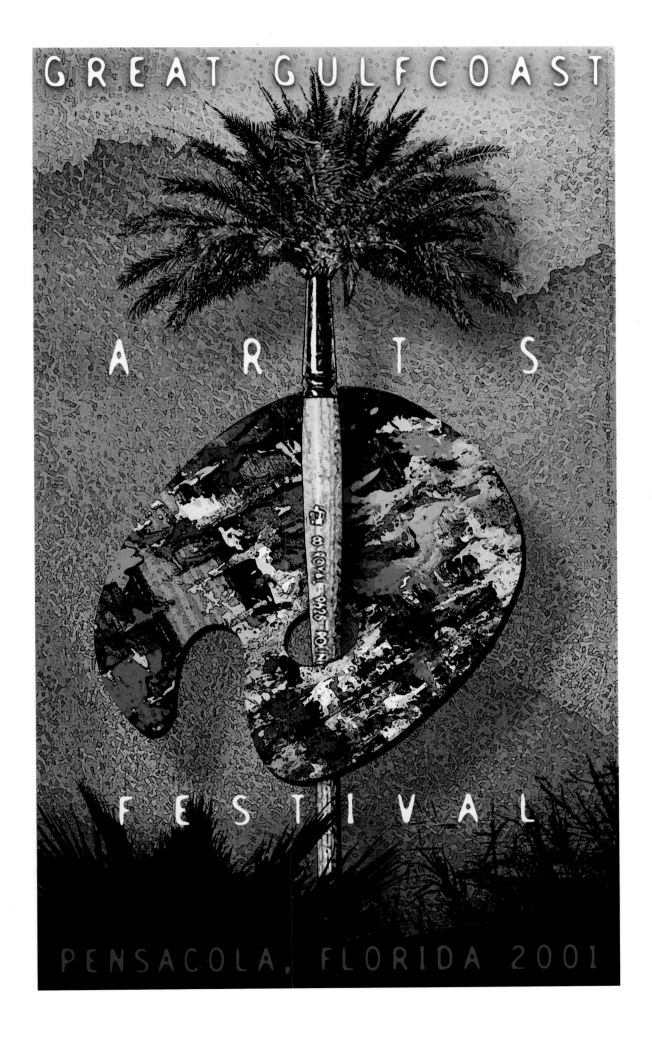

GREAT GULFCOAST

ARTS

FESTIVAL

PENSACOLA, FLORIDA 2001

LRS: Somerset College

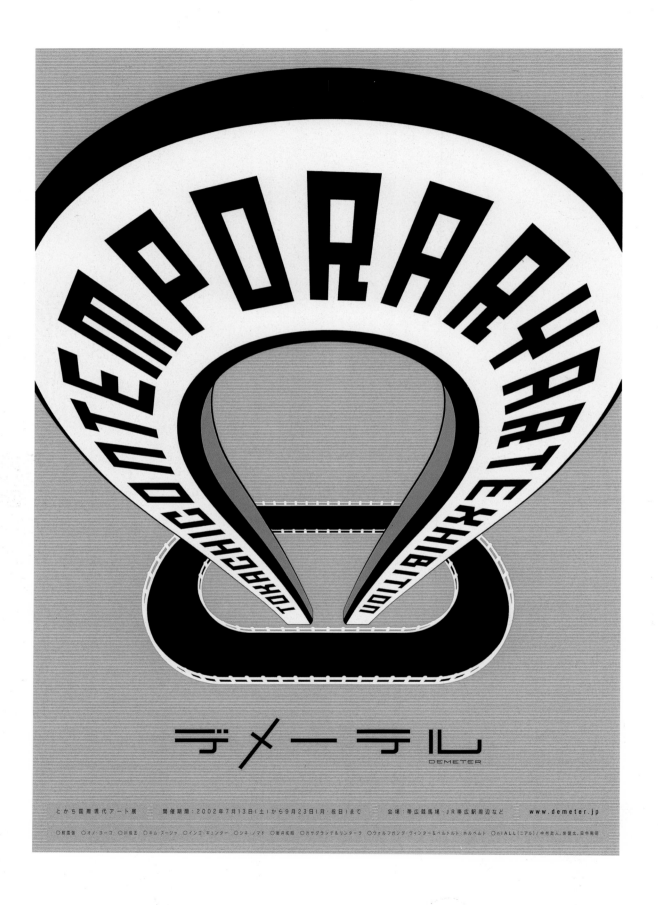

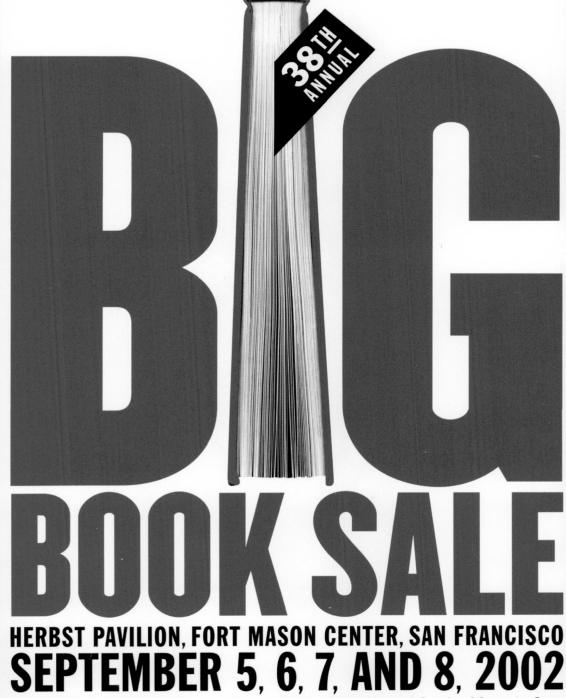

38TH / ANNUAL

BIG BOOK SALE

HERBST PAVILION, FORT MASON CENTER, SAN FRANCISCO
SEPTEMBER 5, 6, 7, AND 8, 2002

Free Admission: Thursday 1 pm to 6 pm · Friday, Saturday and Sunday 10 am to 6 pm

Members' Preview Sale: Thursday, September 5 10 am to 1 pm · All books $1 or less on Sunday

Muni Line #28. For more information: 415.437.4857 or www.friendsandfoundation.org

All proceeds benefit the San Francisco Public Library. Thanks to: Delancey Street Movers, Pentagram Design, Hirasuna Editorial, Anderson Lithograph

FRIENDS & FOUNDATION OF THE SAN FRANCISCO PUBLIC LIBRARY

1. Reihe: **Seltene Platten**
Samstags 14 Uhr
19. 2. 2000 Bruce Haak, The Electric Luzifer, 1968 Moog Sounds
26. 2. 2000 Silver Apples Spectrum, Spaceman 3

Labor für Soziale und Ästhetische Entwicklung
Berger Kirche, Bergerstrasse Ecke Wallstrasse, Düsseldorf
In Zusammenarbeit mit Hitsville

Design Firm: Fons Hickmann M23 Creative Director: Fons M. Hickmann Art Director: Fons M. Hickmann Copywriter: Fons M. Hickmann Designer: Fons M. Hickmann Client: Laboratorium for social and asthetics development Events 100.101

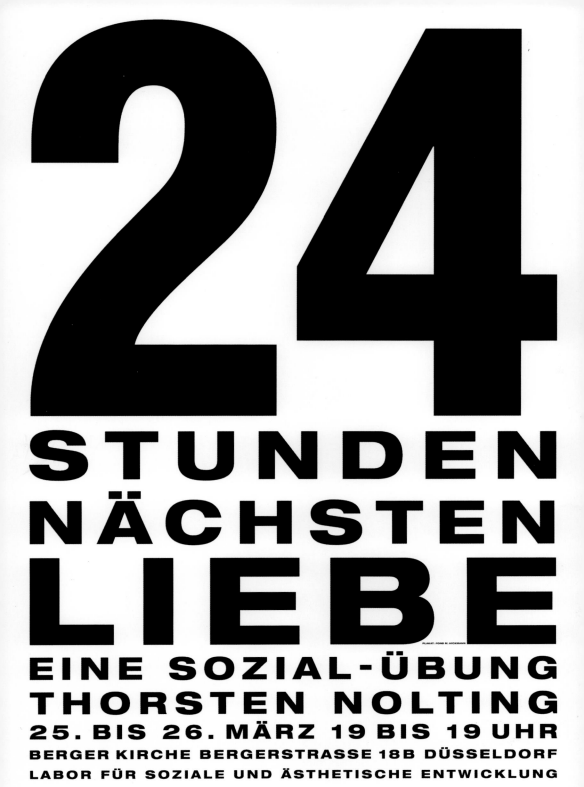

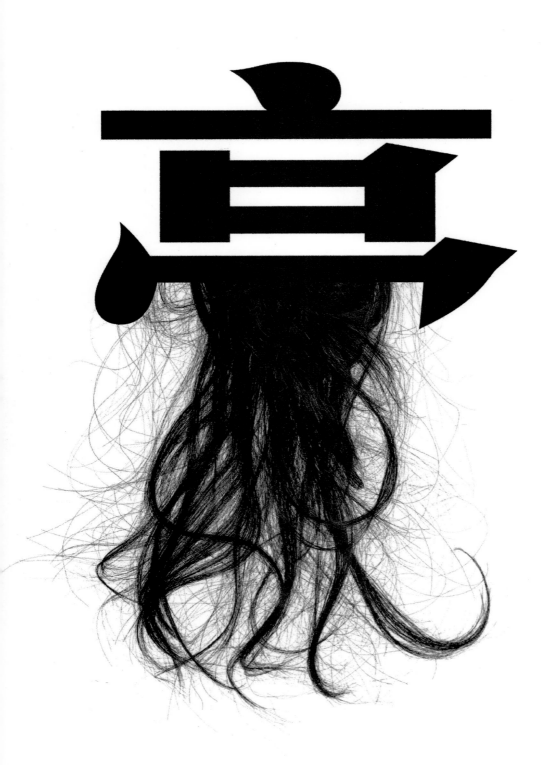

喜歡毫不相干的人不喜歡毫無頭緒的事喜歡毫不熟悉的地方不喜歡毫無節制的生活喜歡毫不猶疑地喜歡

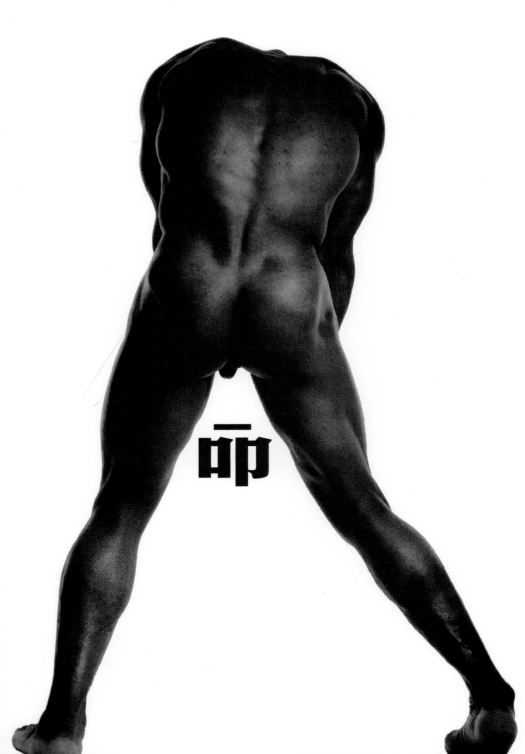

命

命運是對手不應低頭但自命不凡可能敵不過命中注定亡命之徒不會聽天由命有人命不該絕亦有人死不信命

八二

深居者少見左鄰右<ruby>舍<rt>舍</rt></ruby>磊落者少有神不守<ruby>舍<rt>舍</rt></ruby>倔強者少會退避三<ruby>舍<rt>舍</rt></ruby>江湖者少住寒<ruby>舍<rt>舍</rt></ruby>多居旅<ruby>舍<rt>舍</rt></ruby>

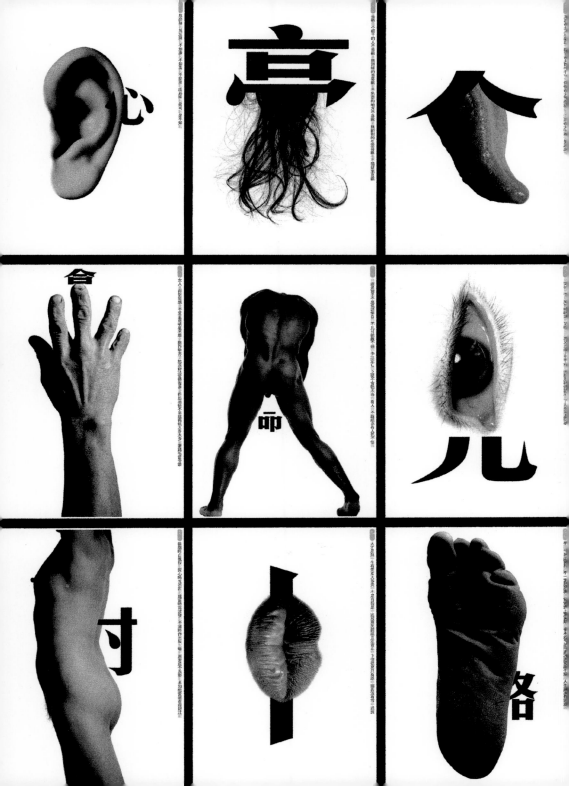

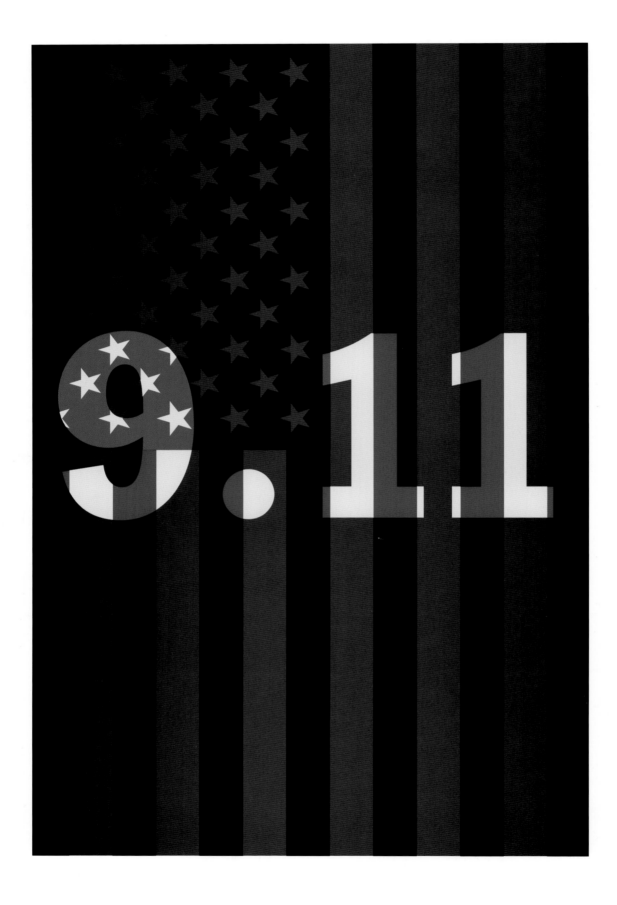

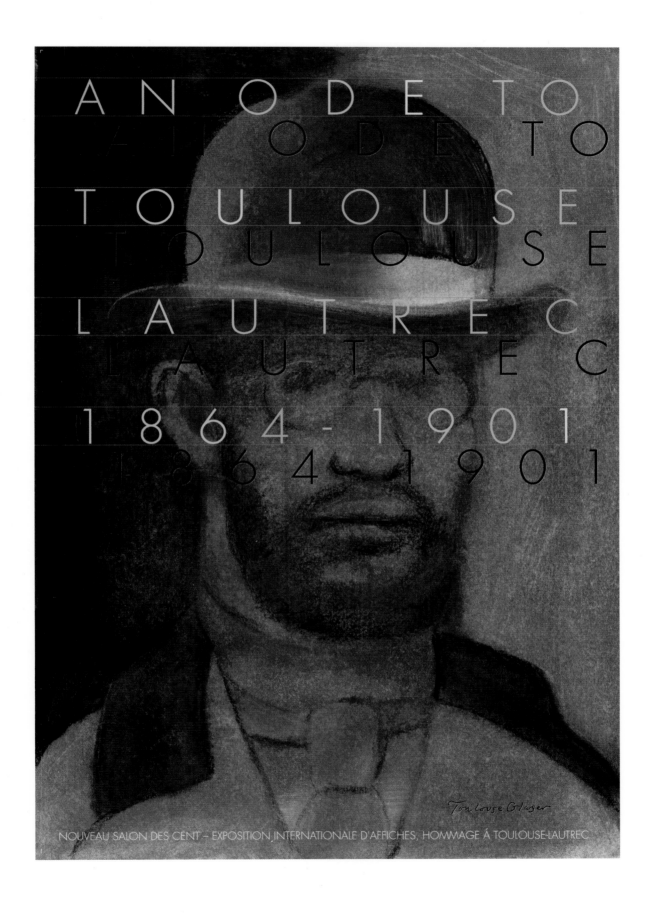

AN ODE TO
TOULOUSE
LAUTREC
1864 - 1901

NOUVEAU SALON DES CENT – EXPOSITION INTERNATIONALE D'AFFICHES, HOMMAGE À TOULOUSE-LAUTREC

No Place

Tania Bruguera
Luis Gómez
Quisqueya Henriquez
Ernesto Leal
Manuel Piña

10. April – 09. Juni 2002

ifa-Galerie Bonn
Museumsmeile
Willy-Brandt-Allee 9
53113 Bonn

Dienstag – Freitag 12 – 18 Uhr
Samstag, Sonntag 12 – 17 Uhr
Eintritt frei

Museumsmeilenfest 2002
30. Mai – 2. Juni, 11 – 18 Uhr
www.ifa.de

i f a

NATIONALITÄT IDENTITÄT

Kuba

HOMMAGE À
**TOULOUSE-
LAUTREC**
1869 - 1901

EXPOSITION
INTERNATIONALE
D'AFFICHE
—◆—
NOUVEAU
SALON DES CENT

TOULOUSE
SCHWAB

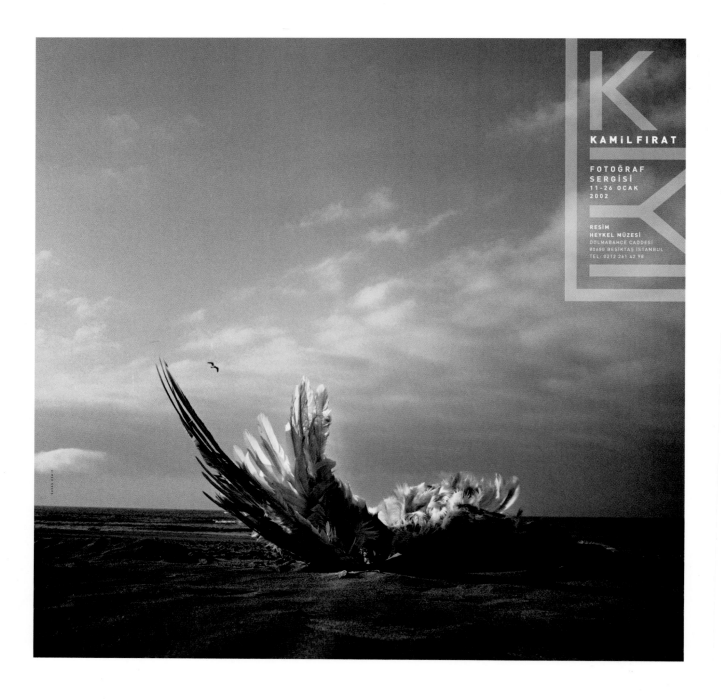

KAMiL FIRAT

FOTOĞRAF
SERGİSİ
11-26 OCAK
2002

RESİM
HEYKEL MÜZESİ
DOLMABAHÇE CADDESİ
80680 BEŞİKTAŞ İSTANBUL
TEL : 0212 261 42 98

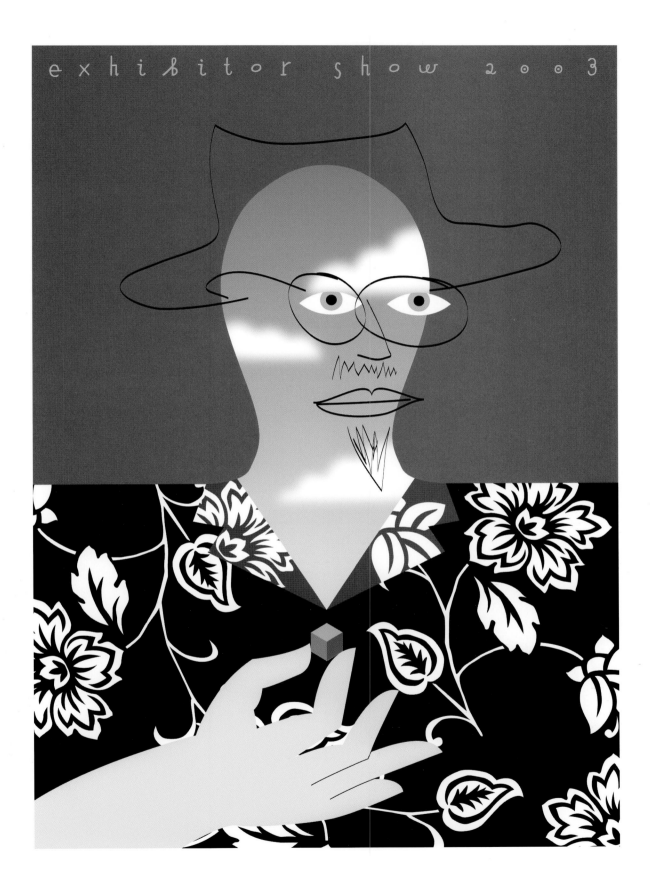

exhibitor show 2003

Design Firm: Vanderbyl Design Creative Director: Michael Vanderbyl Art Director: Michael Vanderbyl Designer: Michael Vanderbyl Illustrator: Michael Vanderbyl Client: Exhibitor Magazine

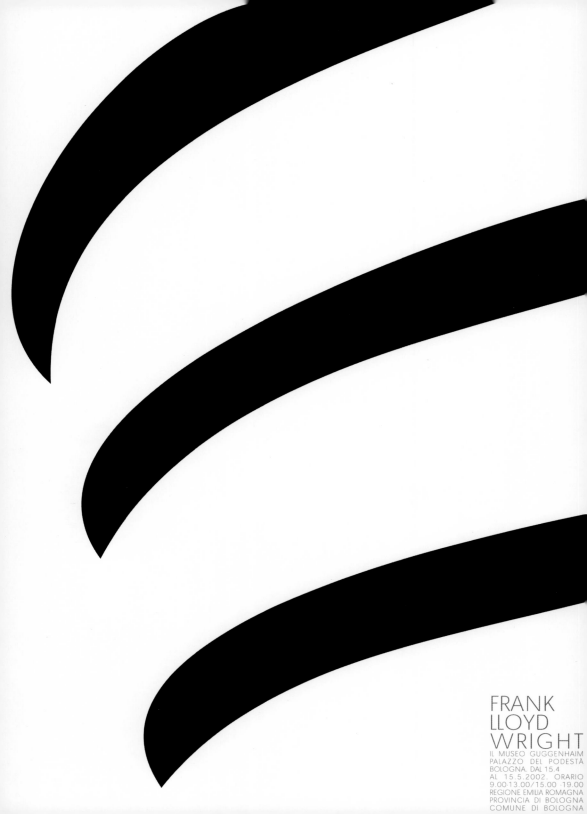

FRANK
LLOYD
WRIGHT
IL MUSEO GUGGENHAIM
PALAZZO DEL PODESTÀ
BOLOGNA. DAL 15.4
AL 15.5.2002. ORARIO
9.00-13.00/15.00 -19.00
REGIONE EMILIA ROMAGNA
PROVINCIA DI BOLOGNA
COMUNE DI BOLOGNA

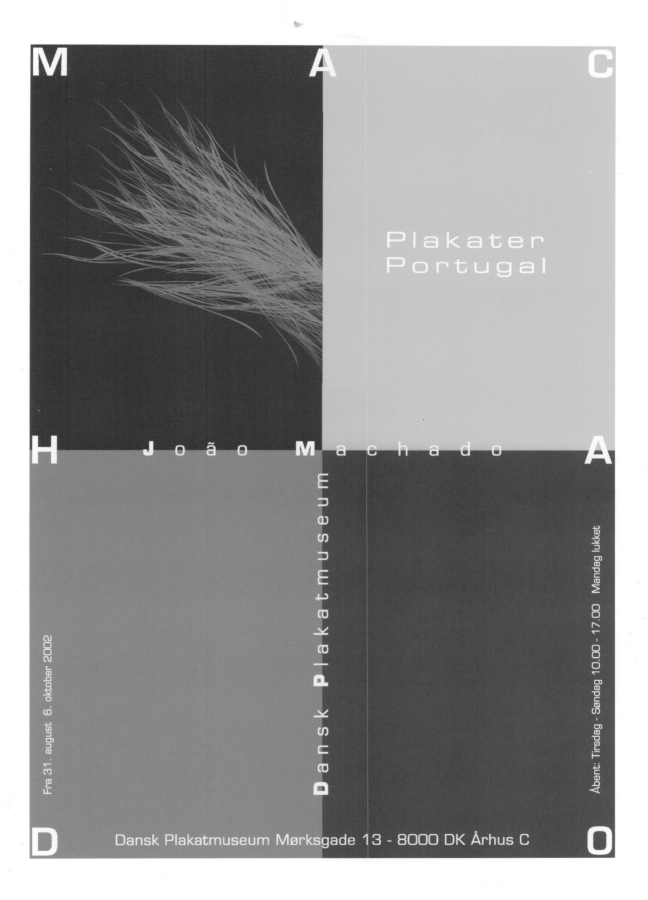

2002

The 48th N.Y.TDC Exhibition

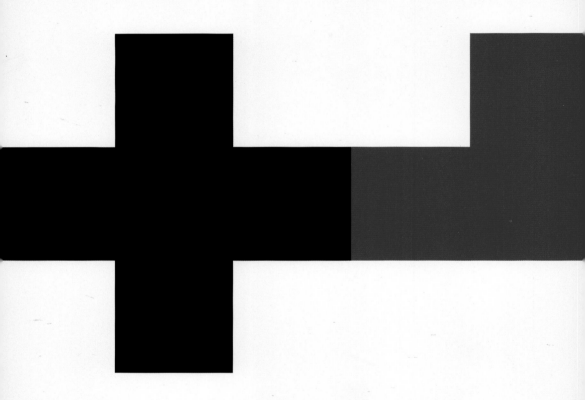

Applied Typography 12

第48回NY.TDC展
2002日本タイポグラフィ年鑑受賞作品展

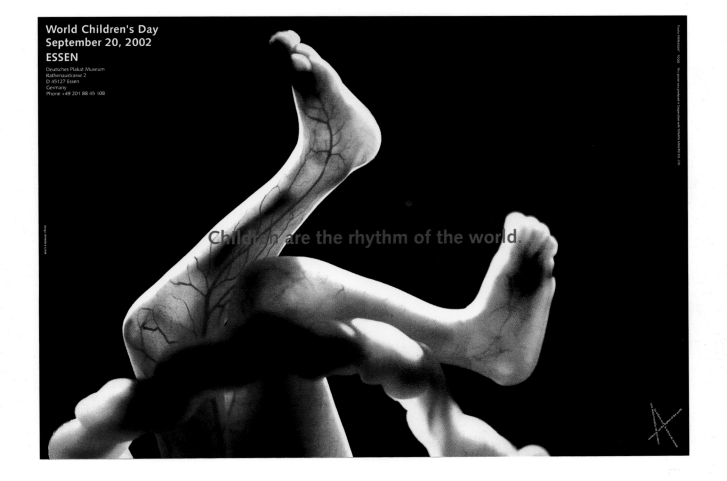

World Children's Day
September 20, 2002
ESSEN

Deutsches Plakat Museum
Rathenaustrasse 2
D 45127 Essen
Germany
Phone +49 201 88 45 108

Children are the rhythm of the world.

Design Firm: Giichi Design Art Director: Giichi\Designers: Miyako and Giichi Client: Deutsches Plakat Museum Essen

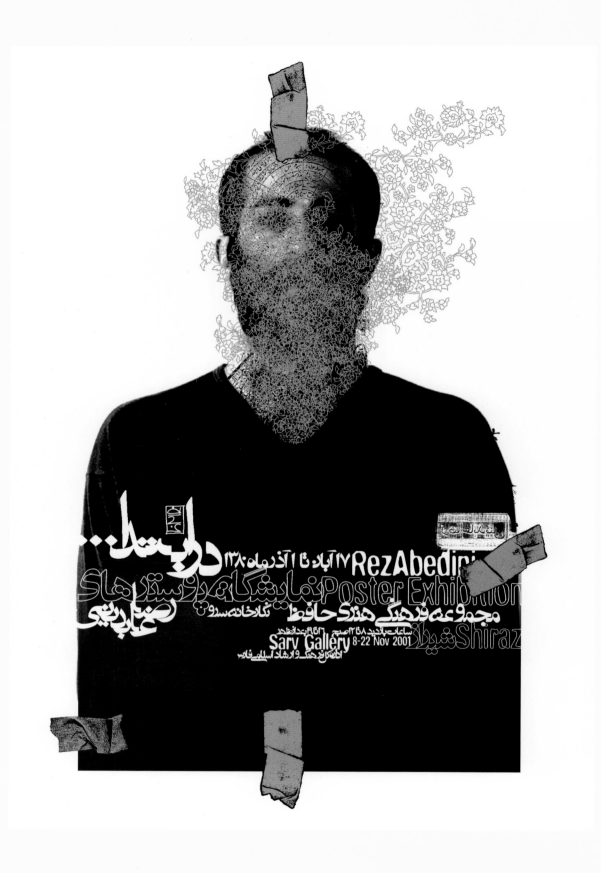

ESKİFORMLAR

İBRAHİM ÇİFTÇİOĞLU RESİM SERGİSİ 26 EKİM-26 KASIM 2001

KARGART KADİFE SOKAK NO:16 KADIKÖY İSTANBUL T: 0216 449 17 26 F: 0216 346 55 46 W: www.kargabar.com E: karga@kargabar.com

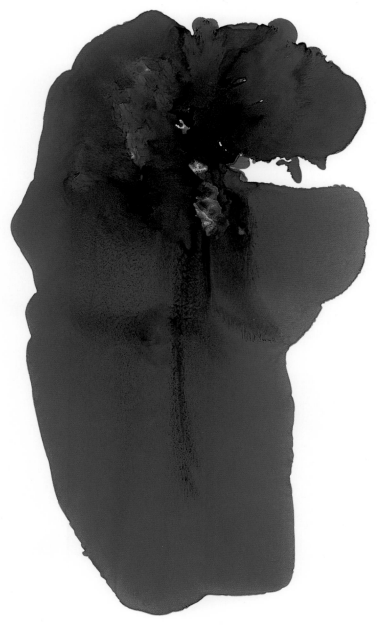

kargart

Design Firm: Savas Cekic Tasarim Ltd. Creative Director: Savas Cekic Art Director: Savas Cekic Designer: Savas Cekic Illustrator: Ibrahim Ciftcioglu Client: Kargart

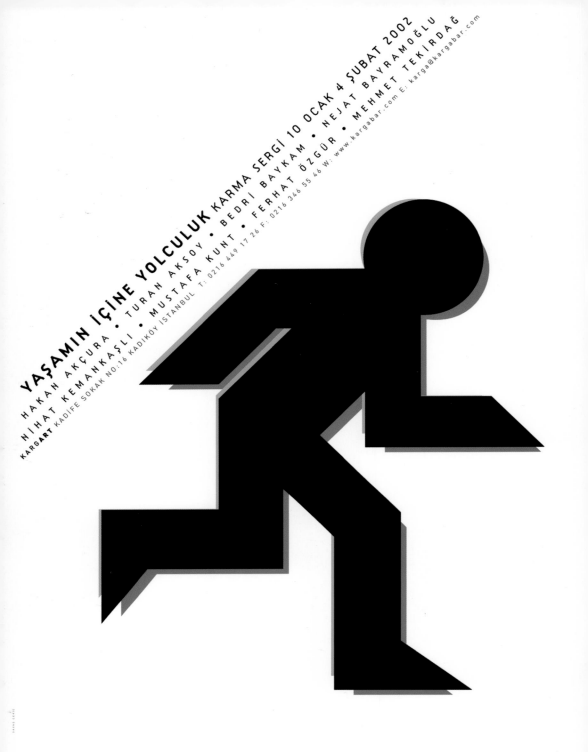

YAŞAMIN İÇİNE YOLCULUK KARMA SERGİ 10 OCAK 4 ŞUBAT 2002

HAKAN AKÇURA • TURAN AKSOY • BEDRİ BAYKAM • NEJAT BAYRAMOĞLU
NİHAT KEMANKAŞLI • MUSTAFA KUNT • FERHAT ÖZGÜR • MEHMET TEKİRDAĞ

KARGART KADİFE SOKAK NO:16 KADIKÖY İSTANBUL T: 0216 449 17 26 F: 0216 346 55 46 W: www.kargabar.com E: karga@kargabar.com

karg**art**

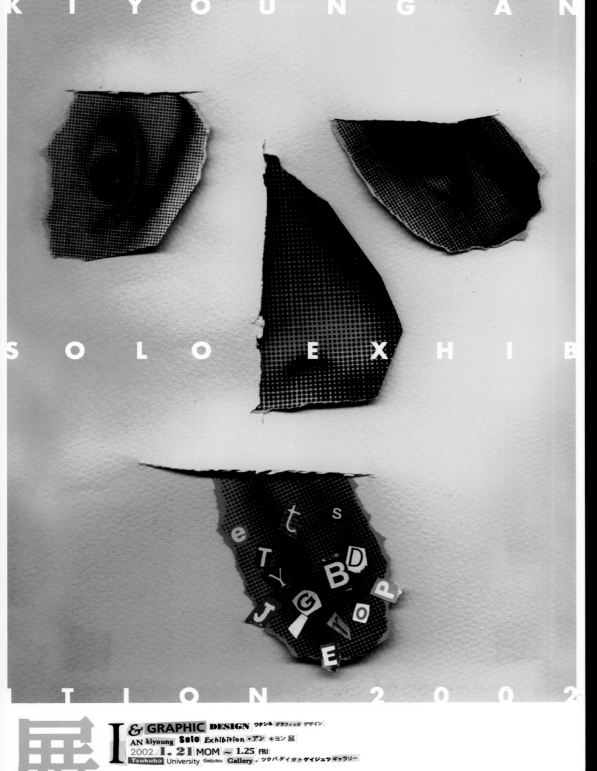

KIYOUNG AN

SOLO EXHIB

ITION 2002

SOLO EXHIBITION 2002

I & GRAPHIC DESIGN ワタシ & グラフィック デザイン
AN kiyoung Solo Exhibition ・アン キヨン 展
2002. 1. 21 MOM ～ 1.25 FRI
Tsukuba University Geijutsu Gallery ・ ツクバダイガク ゲイジュツ ギャラリー

展

I & TYPOGRAPHY

elementism
creative studies

番画廊

elementism
creative studies

番画廊

elementism
creative studies
Shinnoske@BanGallery
01.21–26, 2002

エレメンチズム
杉崎真之助 デザイン・スタディ展
2002.1.21月–26土　大阪・番画廊
11AM–7PM　26土は6PMまで

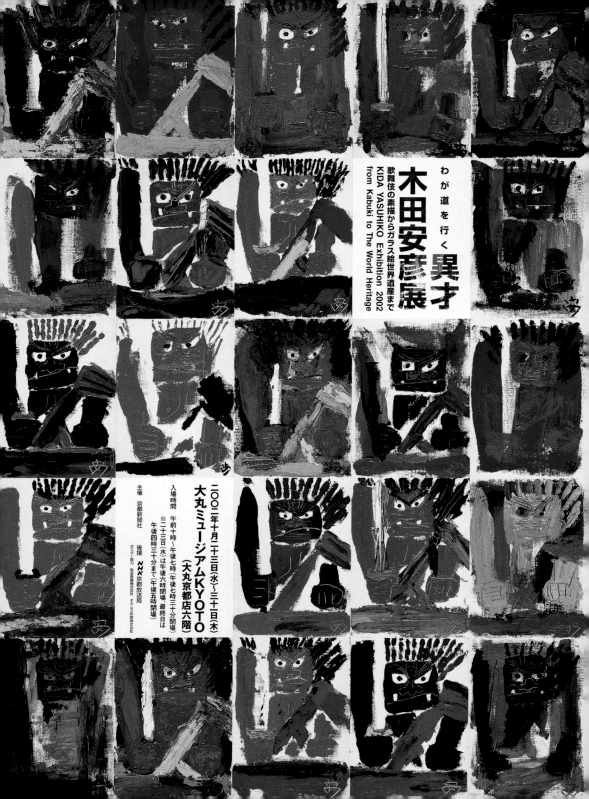

わが道を行く 異才

木田安彦展

歌舞伎の素描からガラス絵世界遺産まで
KIDA YASUHIKO Exhibition 2002
from Kabuki to The World Heritage

二〇〇二年十月二十三日(水)〜三十日(木)

大丸ミュージアムKYOTO
(大丸京都店六階)

入場時間
午前十時〜午後七時(午後七時三十分閉場)最終日は
※二十三日(水)は午後六時閉場
午後四時三十分まで(午後五時閉場)

主催 京都新聞社

後援 NHK京都放送局
ポスター協力 岩田屋産業株式会社 オカム印刷株式会社

Haus für Kunst Uri, Altdorf
15. September bis 27. Oktober 2002
Öffnungszeiten:
Donnerstag & Freitag 15 bis 19 Uhr
Samstag & Sonntag 12 bis 17 Uhr
Marianne Kuster
Edwin Grüter
Alois Lichtsteiner
Jürg Benninger
Heidi Arnold
Pia Gisler
Eva Hälliger
Daniel Wicky
Luca Scenardi
Gerda Steiner/Jörg Lenzlinger
Irene Naef
Erwin Hofstetter
Charlotte Greber

Rathaus, Willisau
8. September bis 29. September 2002
Öffnungszeiten:
Donnerstag & Freitag 19 bis 21 Uhr
Samstag & Sonntag 11 bis 17 Uhr
Lea Achermann
Franz Wanner
Andreas Wegmann
Ems Troxler
Stefan Banz
Peter Regli
Adriana Stalder

Einwohnergemeinde Altdorf
Kanton Uri
Daetwiler Stiftung Altdorf
Die Mobiliar Altdorf

Neue Urner Zeitung

Gemeinden Willisau-Stadt & -Land
Kanton Luzern
Eugen Meyer Stiftung Willisau
Die Mobiliar Willisau

Willisauer Bote

Design Firm: Niklaus Troxler Design Creative Director: Niklaus Troxler Art Director: Niklaus Troxler Designer: Niklaus Troxler Photographer: Erich Brechbuhl Illustrator: Niklaus Troxler Client: Kultur Altdorf/Willisau

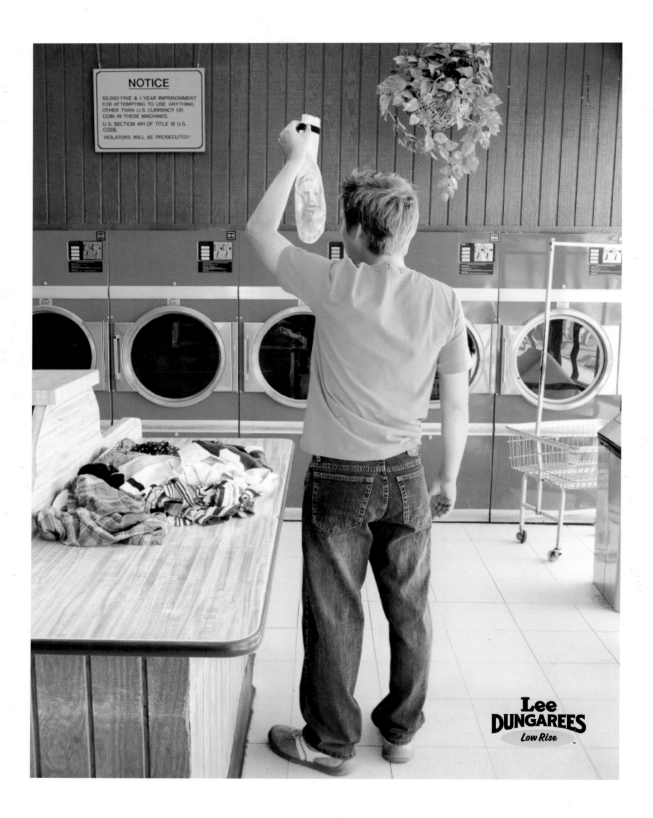

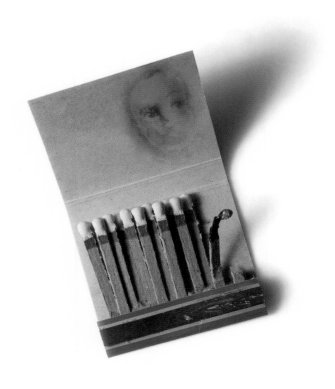

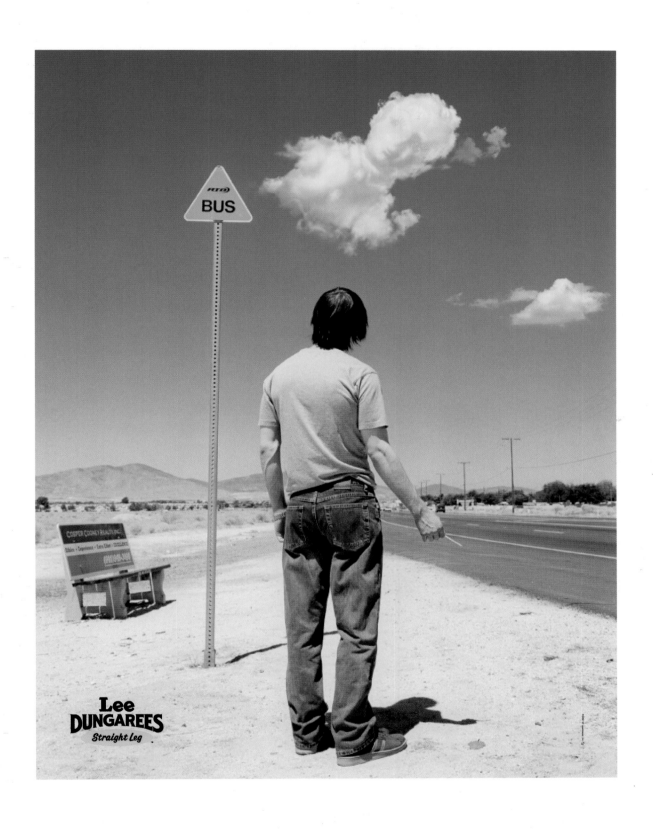

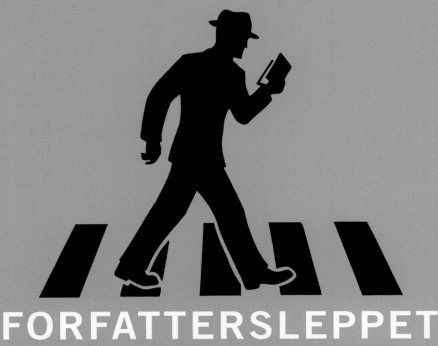

FORFATTERSLEPPET

Bergen 24. oktober - 5. November 2002

For tiende gang kan Norsk Forfattersentrum ønske velkommen til Forfattersleppet, høstens litteraturfestival i Bergen. Her får du bl.a. møte 50 forfattere med tilknytning til Vestlandet, og høre dem lese fra bøkene sine. Bergen Poesifest 2002 presenterer poeter fra USA, Danmark, Sverige, Finland og Norge (se egen plakat og folder). Vi gjentar også suksessen med Sentimentale Sunnhordlendinger. Sett av tid, studer programmet og ta for deg av tilbudene! NORSK FORFATTERSENTRUM VESTLANDET

FORFATTERSLEPPET ARRANGERES AV NORSK FORFATTERSENTRUM VESTLANDET MED STØTTE FRA BERGEN KOMMUNE, KULTURAVDELINGEN, AKTIVE STUDENTERS FORENING OG BERGEN OFFENTLIGE BIBLIOTEK

5th los angeles latino international
film

egyptian theatre, hollywood

latinofilm.org

july 20-29

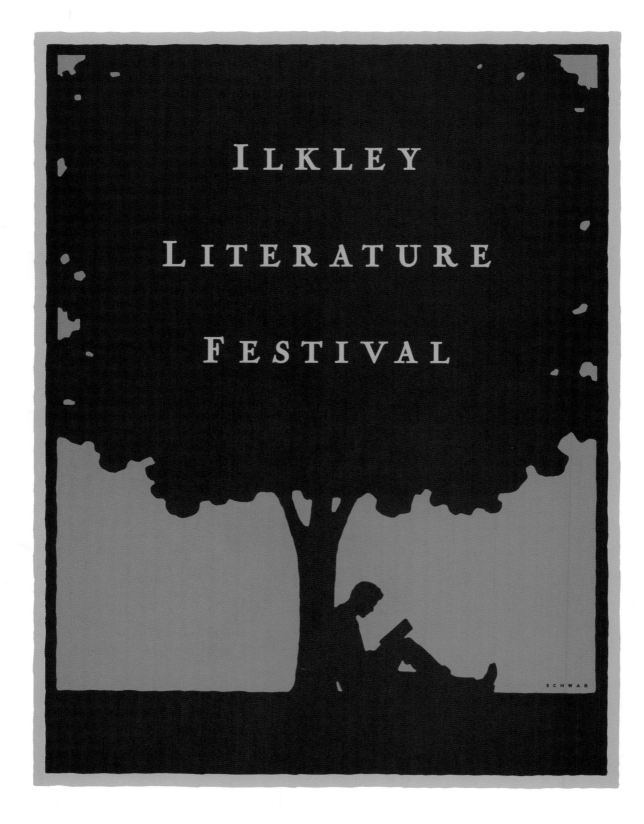

ILKLEY

LITERATURE

FESTIVAL

SCHWAB

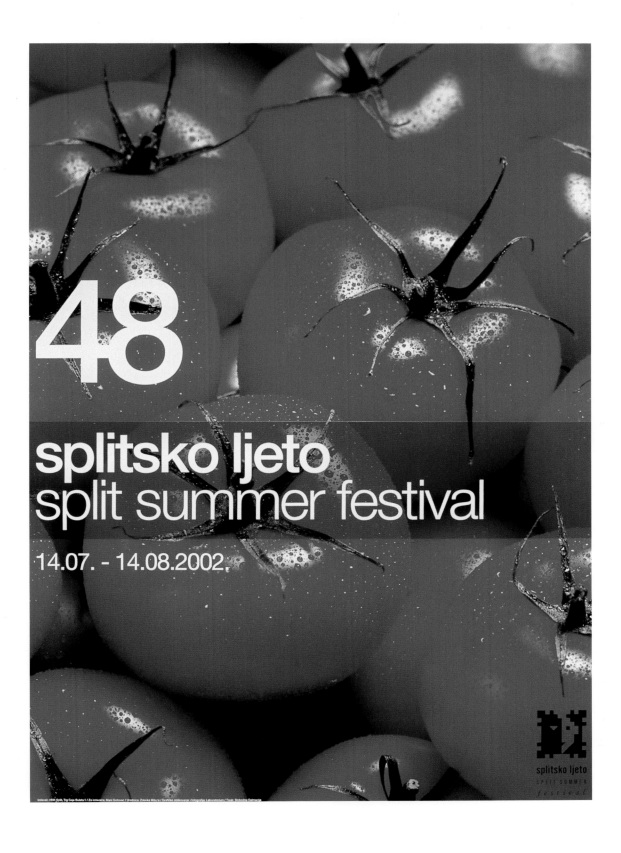

Design Firm: Laboratorium Creative Director: Ivana Vucic Art Directors: Orsat Frankovic and Ivana Vucic Designers: Orsat Frankovic and Ivana Vucic Photographer: Ivana Vucic Client: Croatian National Theatre, Split

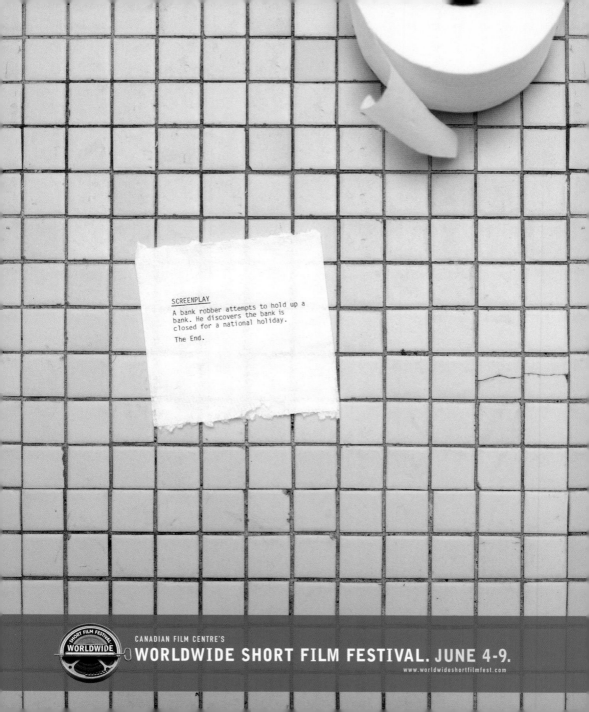

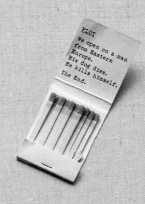

PLOT

We open on a man
from Eastern
Europe.
His dog dies.
He kills himself.
The End.

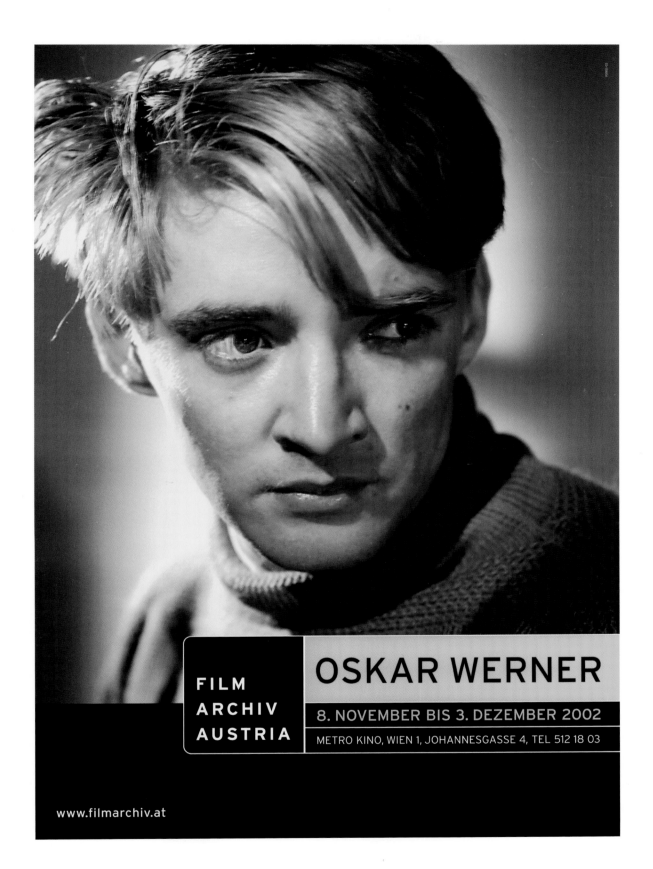

FILM
ARCHIV
AUSTRIA

OSKAR WERNER

8. NOVEMBER BIS 3. DEZEMBER 2002

METRO KINO, WIEN 1, JOHANNESGASSE 4, TEL 512 18 03

www.filmarchiv.at

Design Firm: Perndl & Co. Design Creative Director: Gerhard Bauer Art Director: Gerhard Bauer Designer: Gerhard Bauer Copywriter: Filmarchiv Austria Client: Filmarchiv Austria

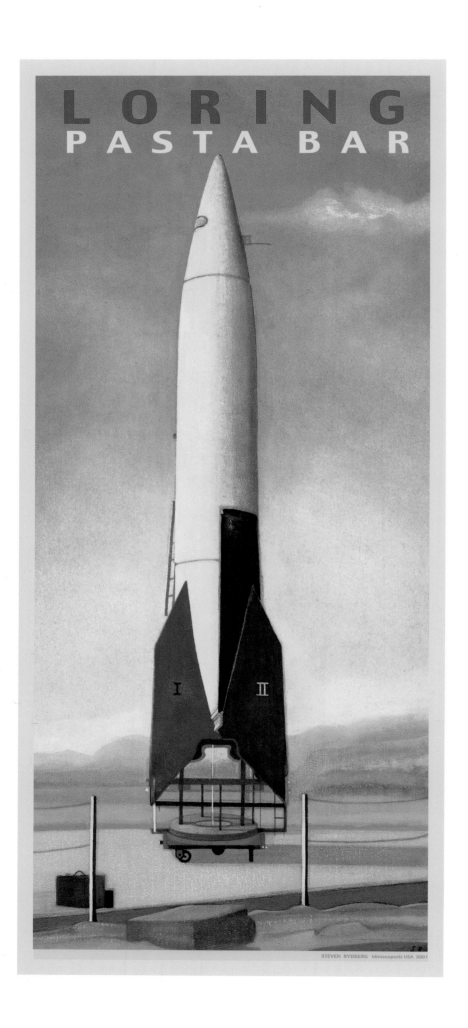

ZANDU
HONEY
PURE

Design Firm: Saatchi & Saatchi India Creative Directors: Ramesh Ramanathan and Shabnam Sirur Art Director: Ashok Lad Photographer: Vinay Patil Copywriter: Debamgshu Kumar Kerr Client: Zandu Pharmaceutical Works

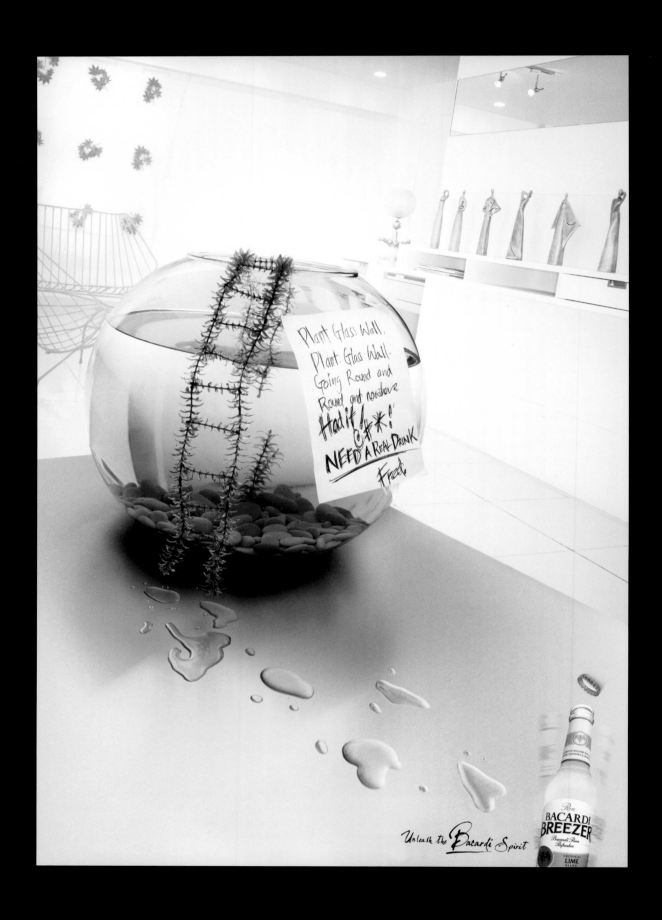

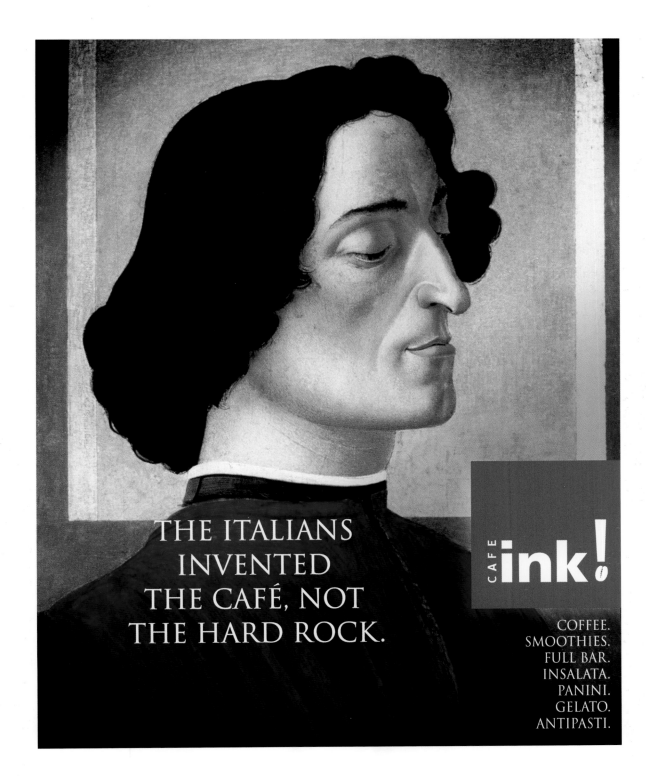

THE ITALIANS
INVENTED
THE CAFÉ, NOT
THE HARD ROCK.

CAFE ink!

COFFEE.
SMOOTHIES.
FULL BAR.
INSALATA.
PANINI.
GELATO.
ANTIPASTI.

Design Firm: Cultivator Advertising and Design Creative Directors: Tim Abare and Chris Beatty Art Director: Chris Beatty Copywriter: Tim Abare Client: Café Ink!

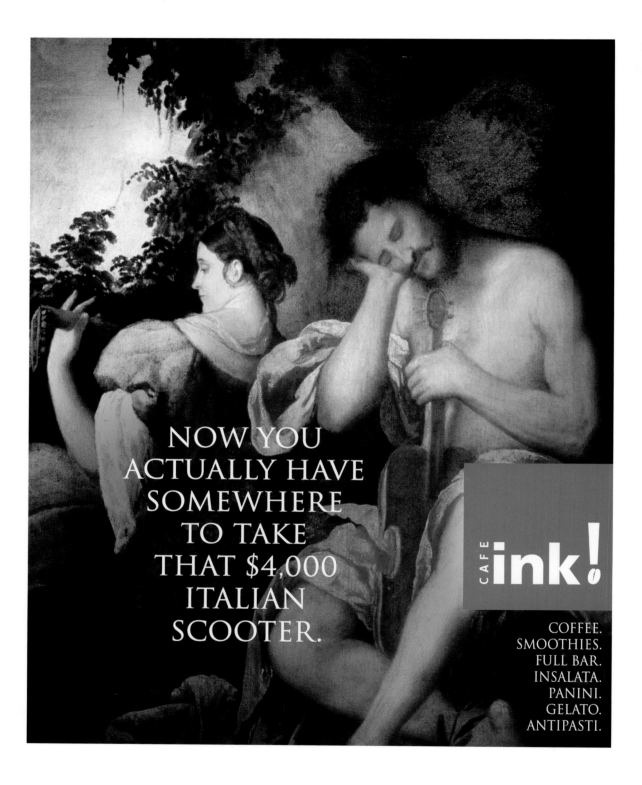

NOW YOU ACTUALLY HAVE SOMEWHERE TO TAKE THAT $4,000 ITALIAN SCOOTER.

CAFE ink!

COFFEE. SMOOTHIES. FULL BAR. INSALATA. PANINI. GELATO. ANTIPASTI.

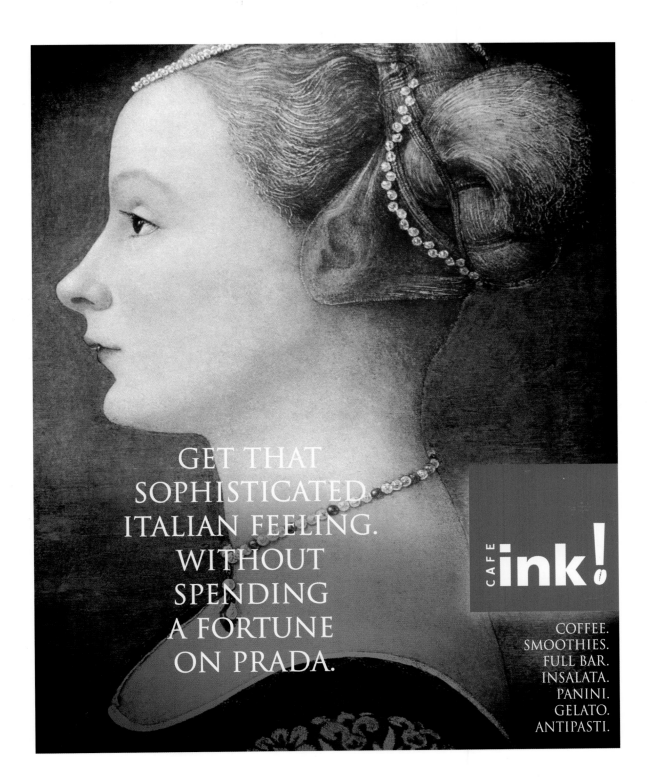

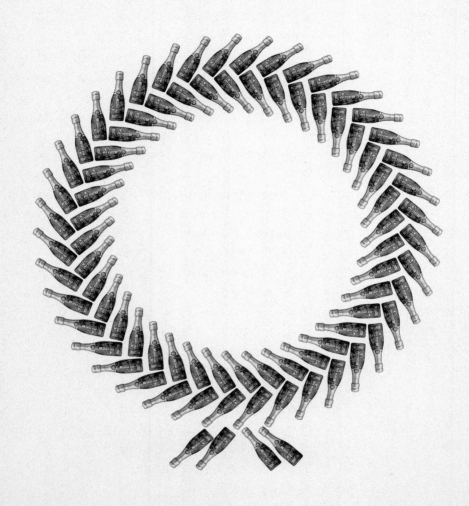

ボーナスが増えなかったぶん、贅沢しませんか？

MERRY X'MAS
冬季限定ボトル入荷
ベビーシャンパン［ビバリーノ］

マキシアム・ジャパン株式会社　Tel: 03-5401-6287/6271　www.piper-heidsieck.com　お酒は20歳になってから。

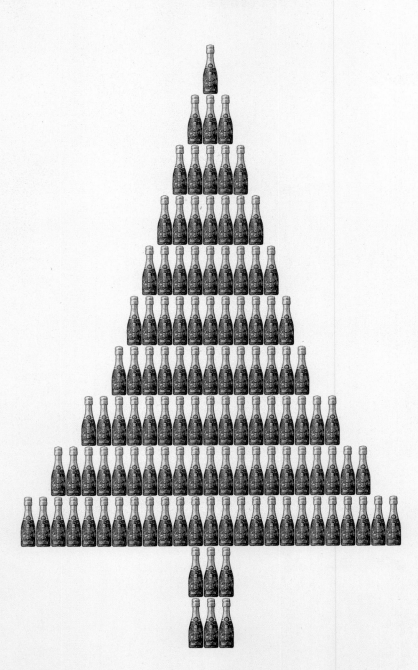

いまニッポンは、何に乾杯したらいいのだろう。

MERRY X'MAS

冬季限定ボトル入荷

ベビーシャンパン［ピパリーノ］

マキシアム・ジャパン株式会社 Tel: 03-5401-6287/6271 www.piper-heidsieck.com お酒は20歳になってから。

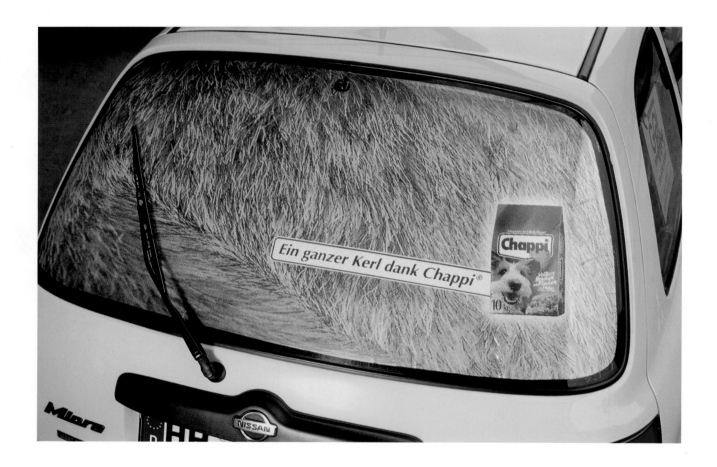

(this spread) Design Firm: Heye Creative Director: Andreas Forberger Art Director: Wolfgang Biebach Copywriters: Florian Ege and Gunnar Immisch Client: Masterfoods GmbH

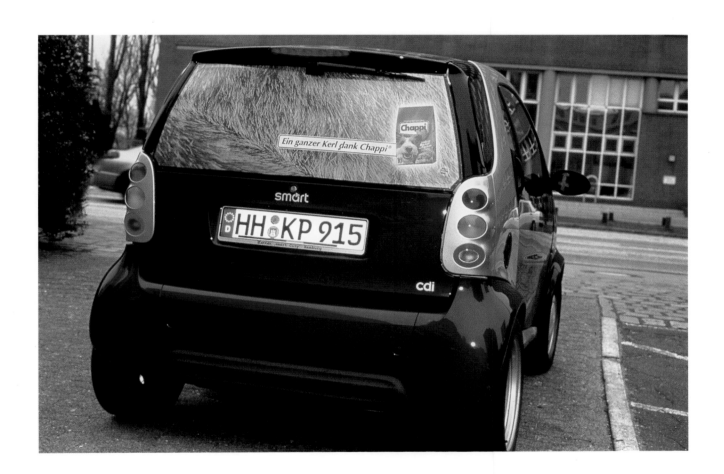

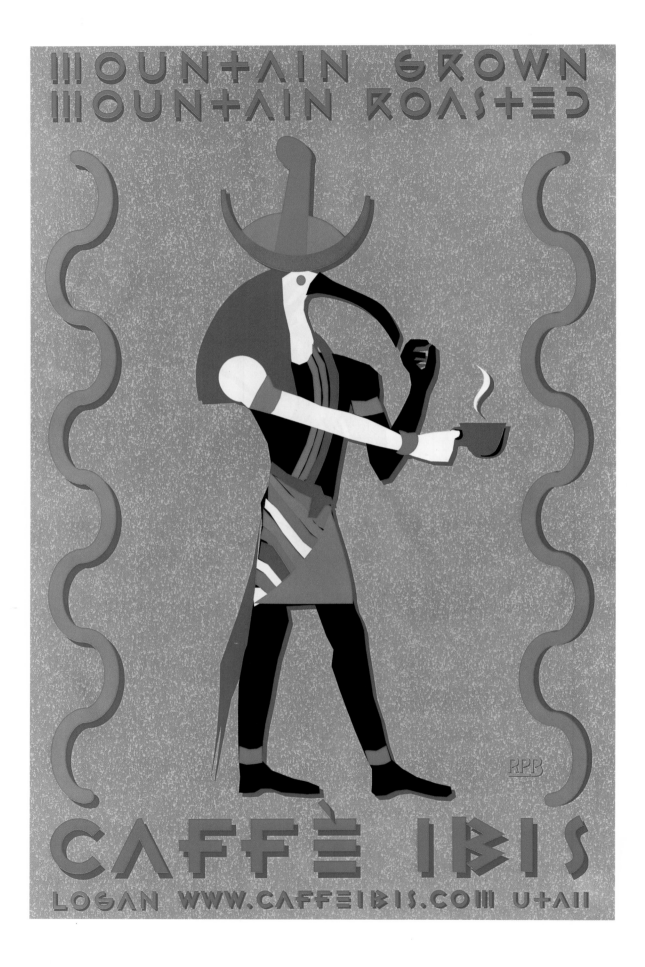

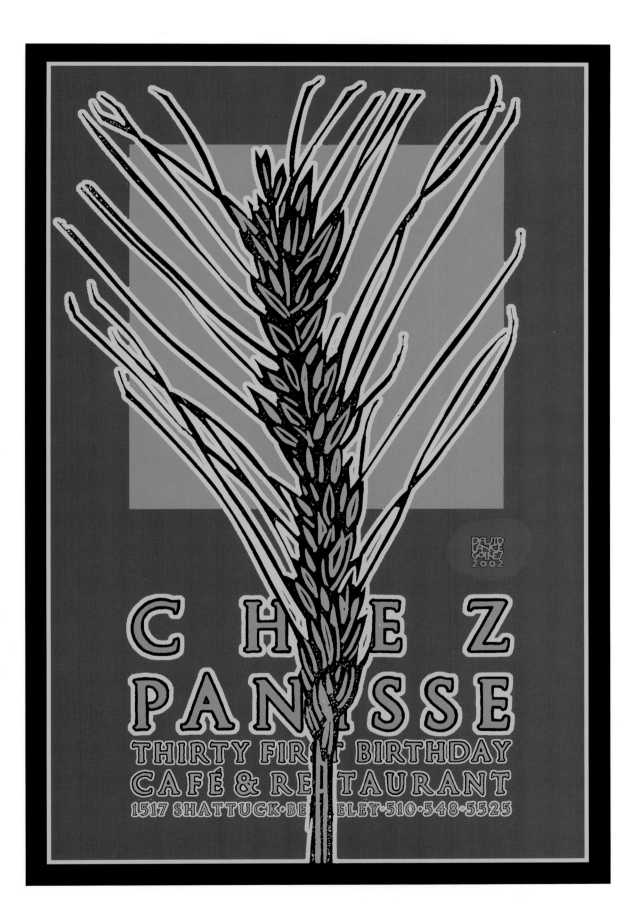

CHEZ
PANISSE
THIRTY FIRST BIRTHDAY
CAFÉ & RESTAURANT
1517 SHATTUCK·BERKELEY 510·548·5525

Food & Beverages 150,151

Design Firm: Saint Hieronymus Press Creative Director: David Lance Goines Art Director: David Lance Goines Designer: David Lance Goines Illustrator: David Lance Goines Client: Chez Panisse Restaurant

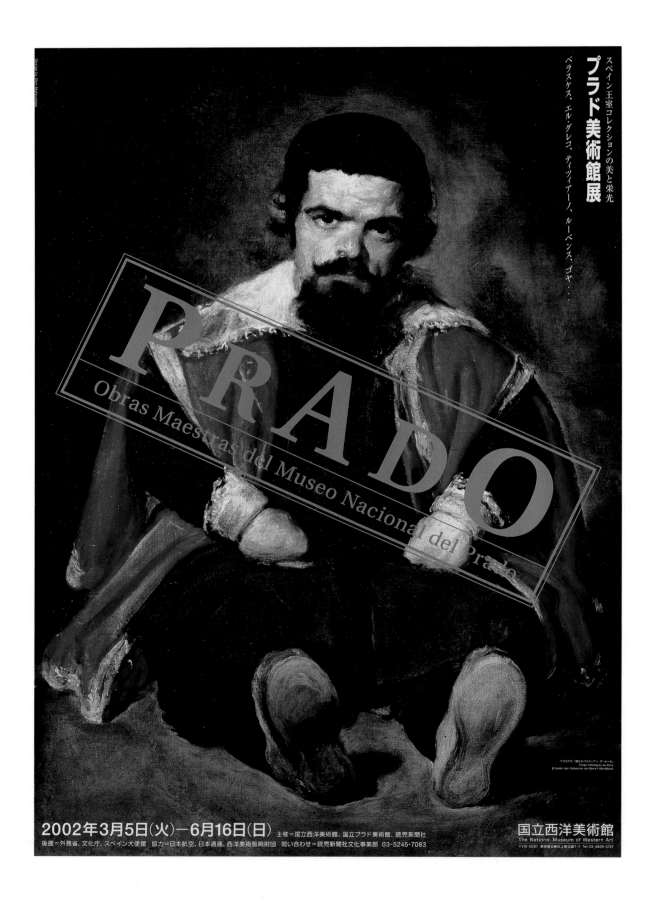

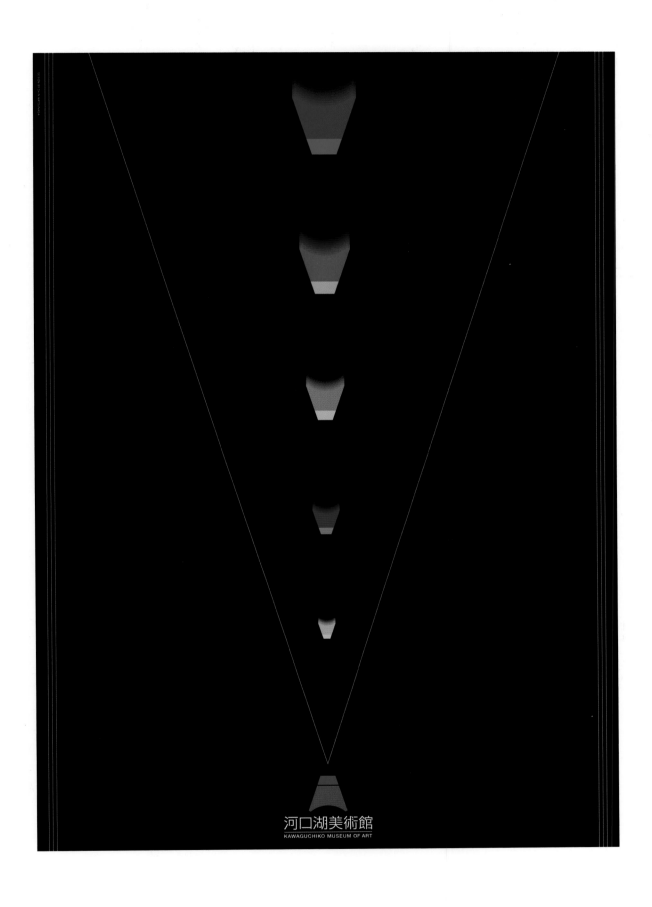

河口湖美術館
KAWAGUCHIKO MUSEUM OF ART

Design Firm: Shin Matsunaga Design Inc. Art Director: Shin Matsunaga Designer: Shin Matsunaga Client: Kawaguchiko Museum of Art

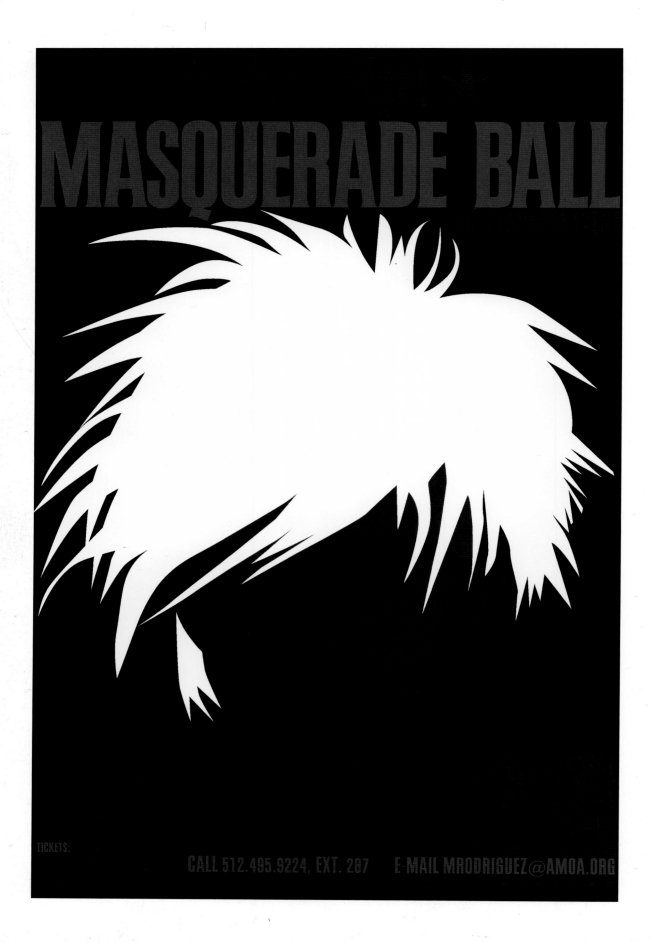

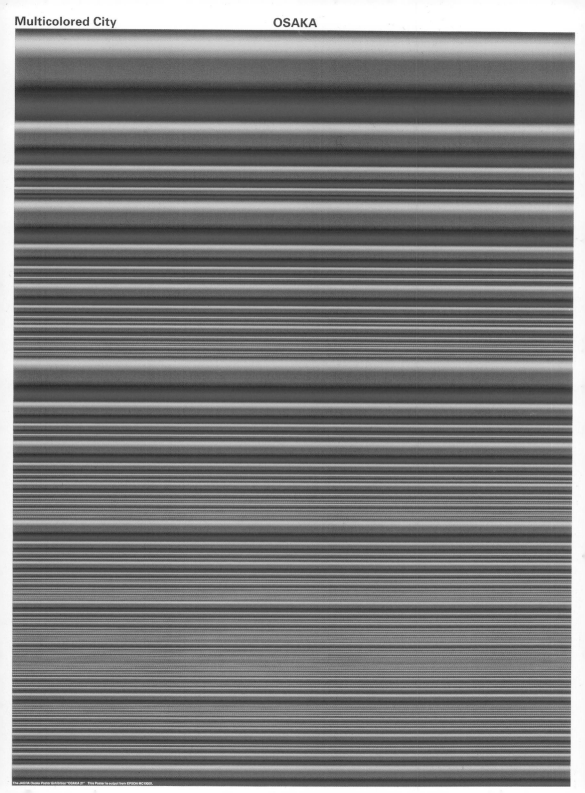

The JAGDA Osaka Poster Exhibition "OSAKA 21" This Poster is output from EPSON MC10000.

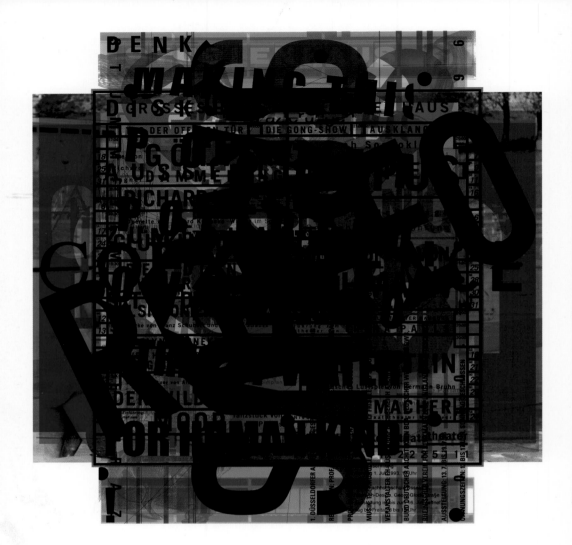

all my posters for the museum of modern art toyama ipt 2000

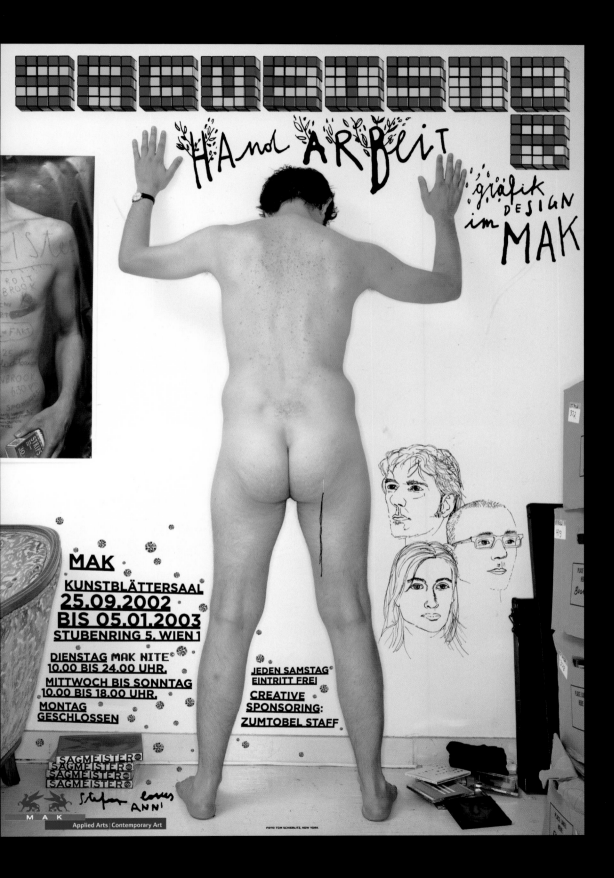

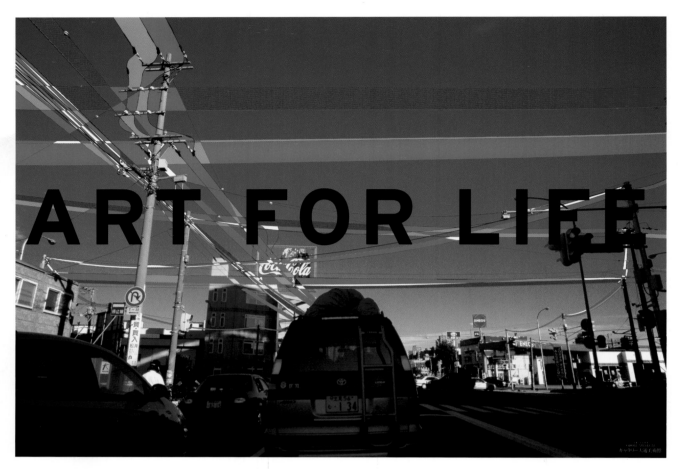

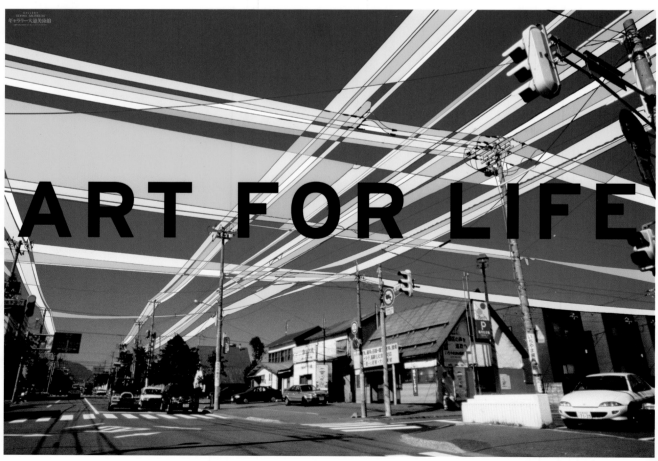

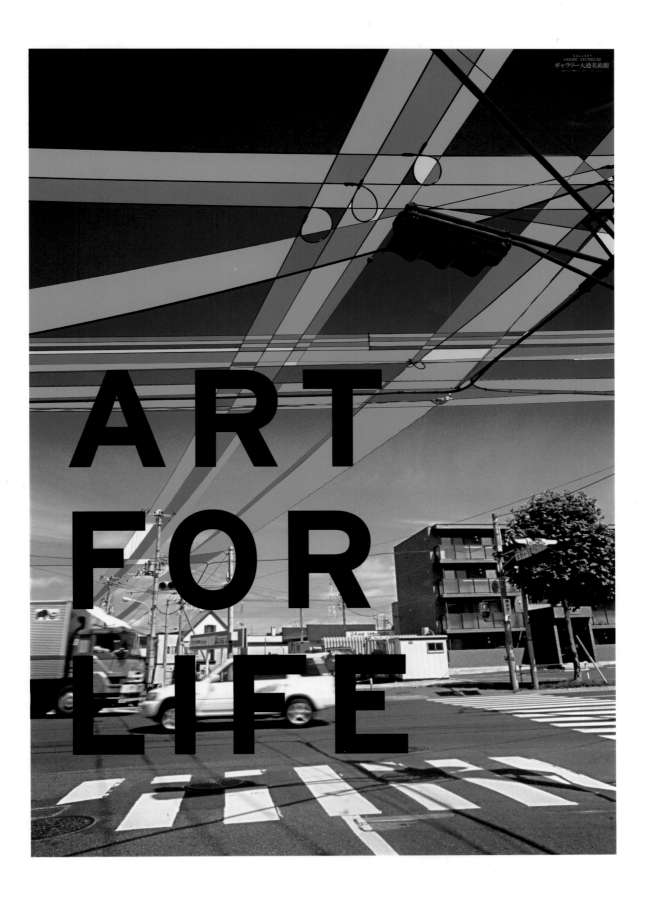

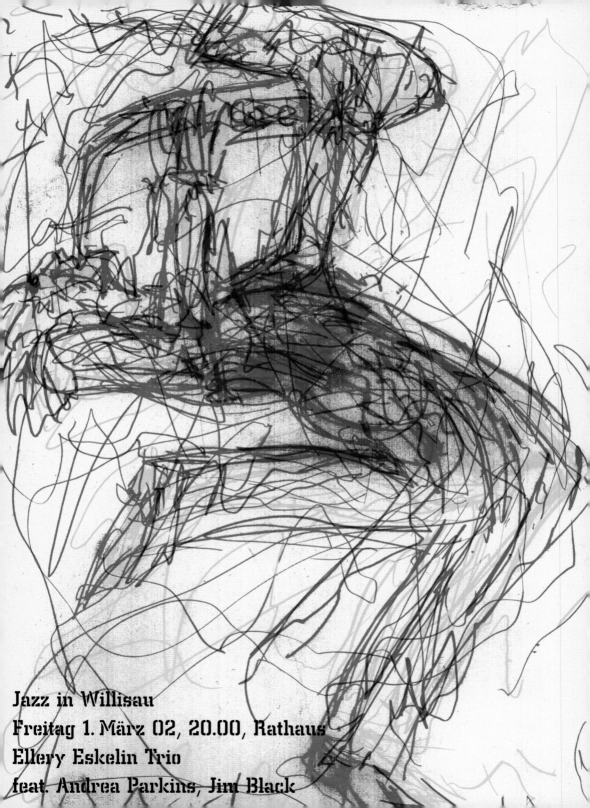

Jazz in Willisau
Freitag 1. März 02, 20.00, Rathaus
Ellery Eskelin Trio
feat. Andrea Parkins, Jim Black

JAZZ IN WILLISAU
SAMSTAG, 12. OKTOBER 02
20.00 UHR IM NEUEN
CLUB FOROOM / WELLIS AG
CHRISTY DORAN'S
NEW BAG
CHRISTY DORAN G
BRUNO AMSTAD VOICE
HANS PETER PFAMATTER P
FABIAN KURATLI DR, PERC
WOLFGANG ZWIAUER E-B
CD-TAUFE UND
CLUB OPENING

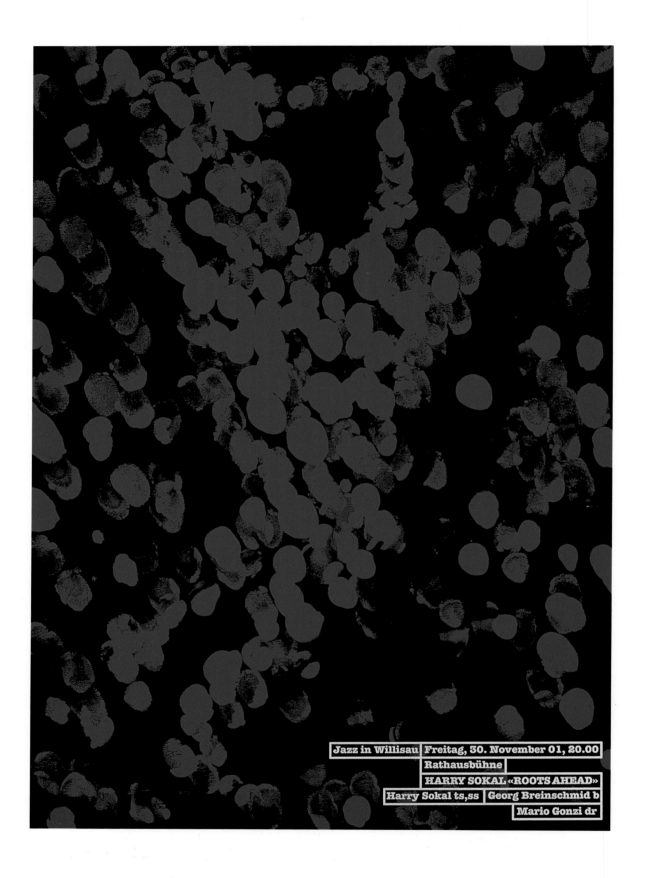

Jazz in Willisau | Freitag, 30. November 01, 20.00
Rathausbühne
HARRY SOKAL «ROOTS AHEAD»
Harry Sokal ts,ss | Georg Breinschmid b
Mario Gonzi dr

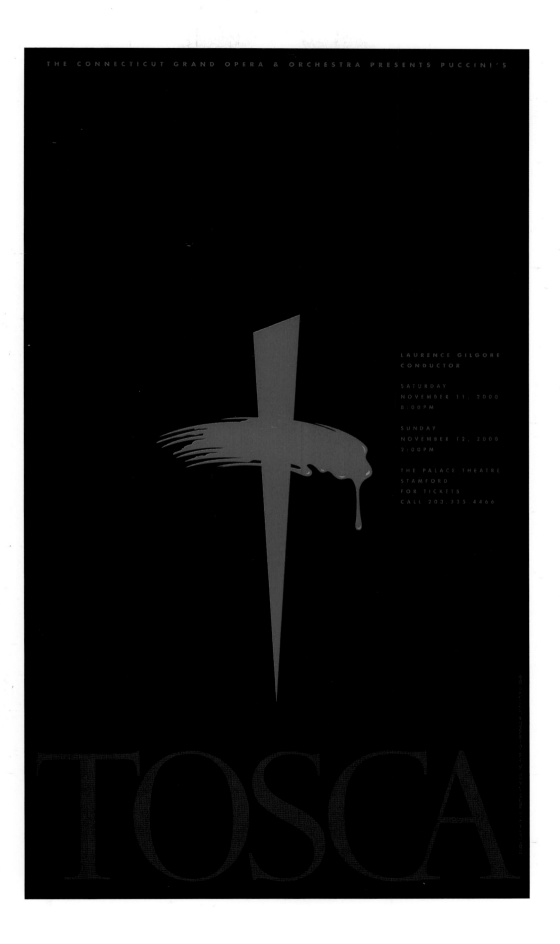

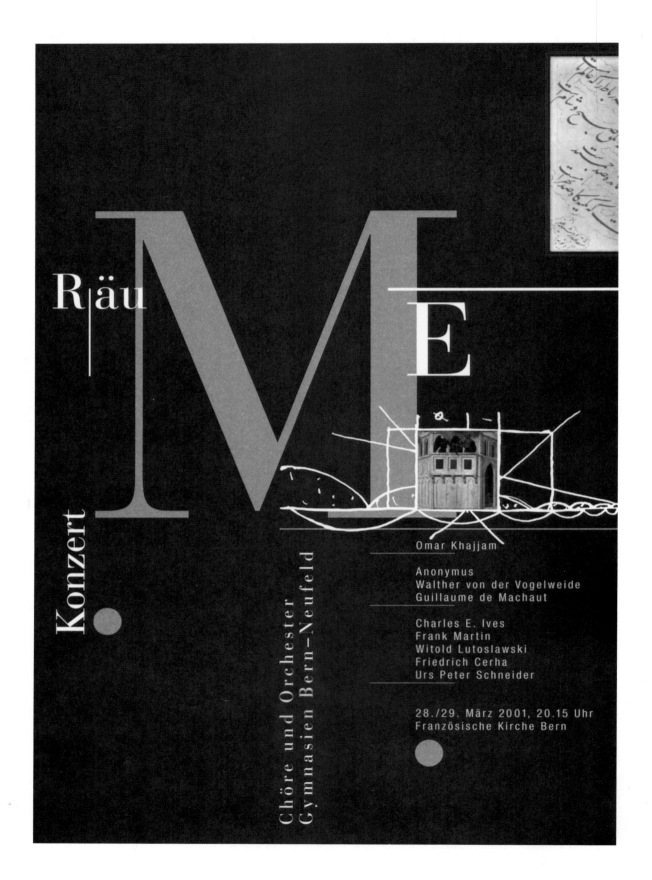

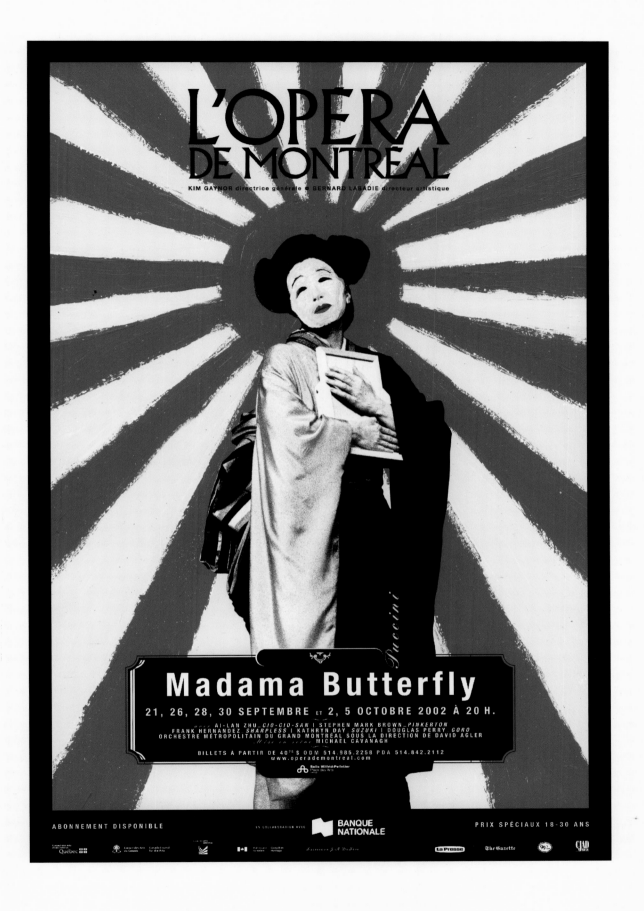

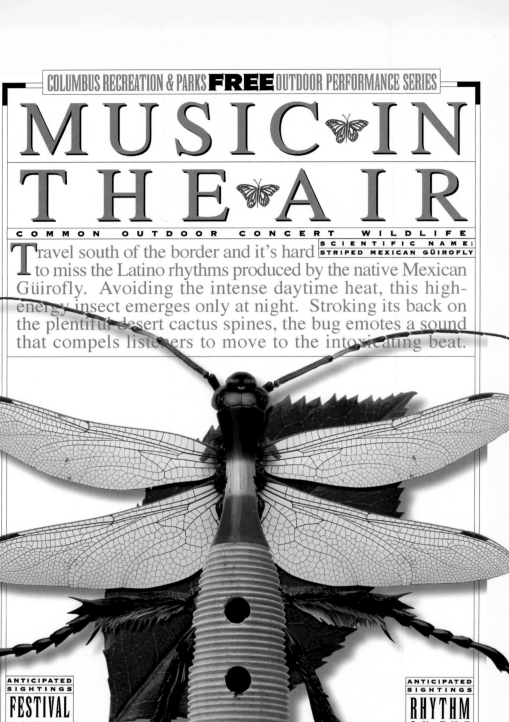

MUSIC·IN THE·AIR

COMMON OUTDOOR CONCERT WILDLIFE

SCIENTIFIC NAME:
STRIPED MEXICAN GÜIROFLY

Travel south of the border and it's hard to miss the Latino rhythms produced by the native Mexican Güirofly. Avoiding the intense daytime heat, this high-energy insect emerges only at night. Stroking its back on the plentiful desert cactus spines, the bug emotes a sound that compels listeners to move to the intoxicating beat.

ANTICIPATED SIGHTINGS

FESTIVAL LATINO JUNE 21 & 22

GRANGE INSURANCE FAMILY FUN FEST SEPTEMBER 7 & 8!!!!!

INFORMATION

614-645-3800 or
614-645-3317 (TDD)

RELATED SPECIES

AUSTRIAN ACCORDION BEETLE

ANTICIPATED SIGHTINGS

RHYTHM ON THE RIVER

SHORT NORTH SUNDAY JAZZ

TOPIARY GARDEN CONCERTS

MAGICAL MUSICAL MORNINGS

COMMON HABITAT

THE PACIFIC COASTAL REGIONS OF MEXICO

1ST YEAR 2002 POSTER SERIES OF 2

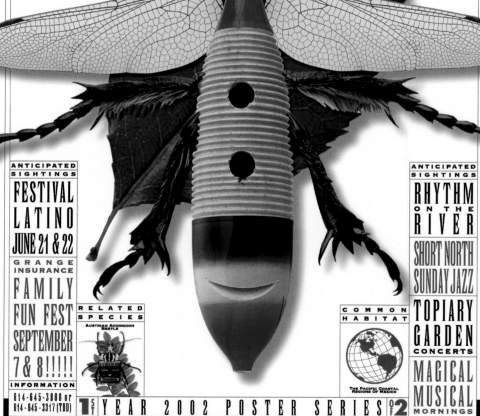

DESIGN: RICKABAUGH GRAPHICS PRINTING: HOPKINS PRINTING PHOTOS: STOCKBYTE & ARTVILLE PAPER: PRODUCTOLITH DULL COVER

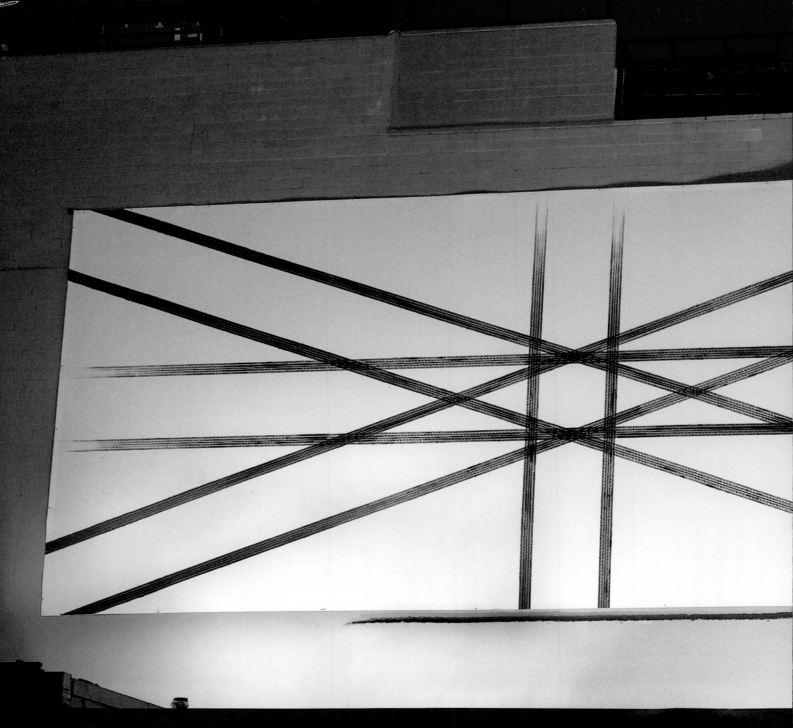

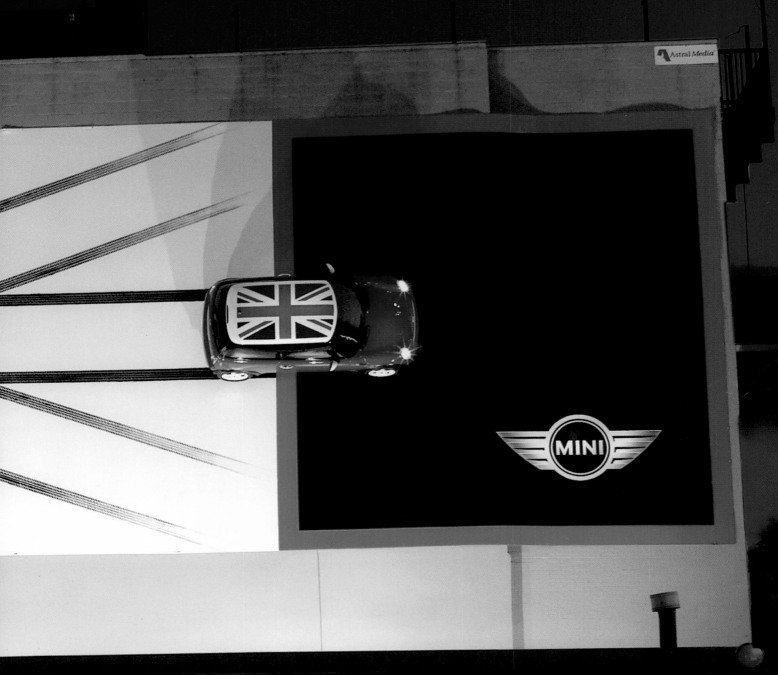

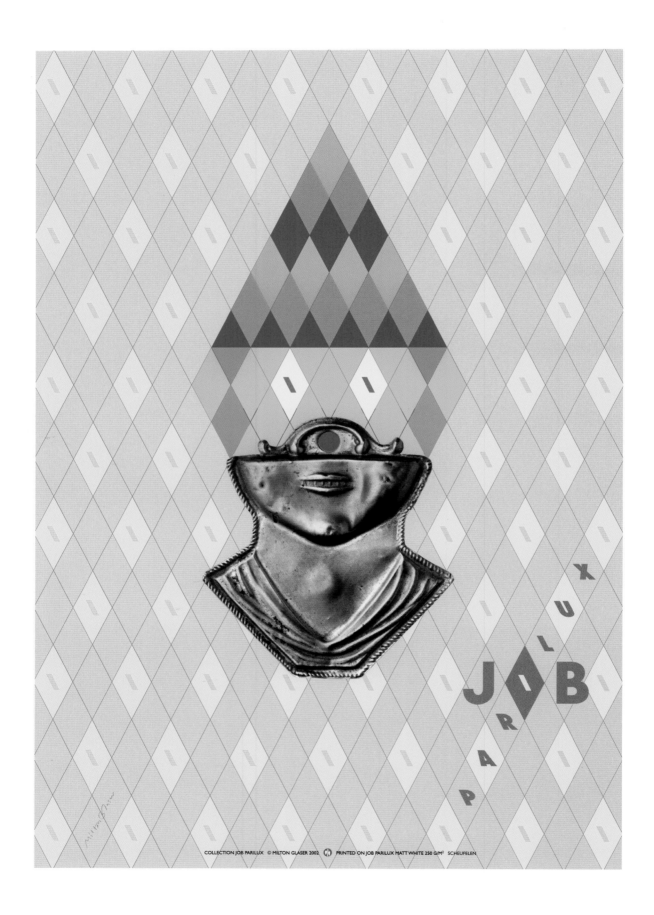

COLLECTION JOB PARILUX © MILTON GLASER 2002 PRINTED ON JOB PARILUX MATT WHITE 250 G/M² SCHEUFELEN

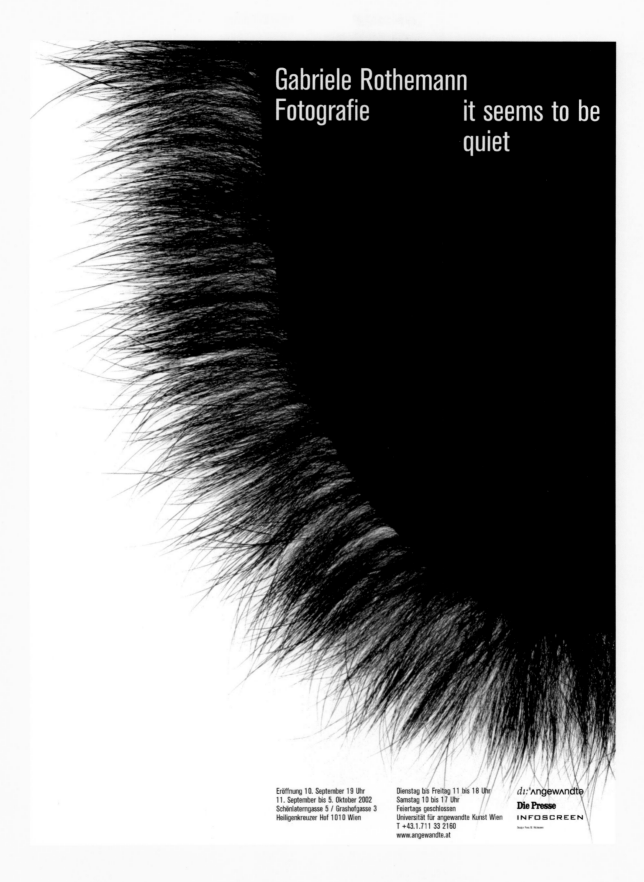

Gabriele Rothemann
Fotografie it seems to be
 quiet

di: ʌngewʌndte

Die Presse

INFOSCREEN

Design: Fons M. Hickmann

Eröffnung 10. September 19 Uhr
11. September bis 5. Oktober 2002
Schönlaterngasse 5 / Grashofgasse 3
Heiligenkreuzer Hof 1010 Wien

Dienstag bis Freitag 11 bis 18 Uhr
Samstag 10 bis 17 Uhr
Feiertags geschlossen
Universität für angewandte Kunst Wien
T +43.1.711 33 2160
www.angewandte.at

Design Firm: Fons Hickmann M23 Creative Director: Fons M. Hickmann Art Director: Fons M. Hickmann Designer: Fons M. Hickmann Copywriter: Fons M. Hickmann Client: Gabrielle Rothemann

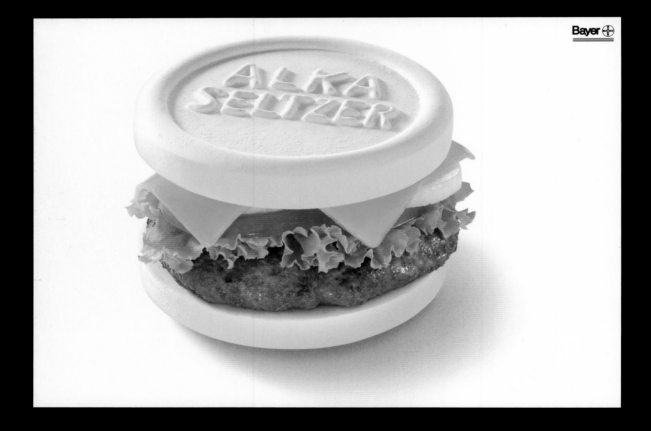

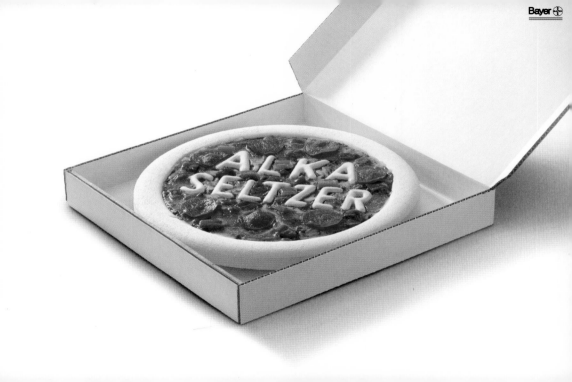

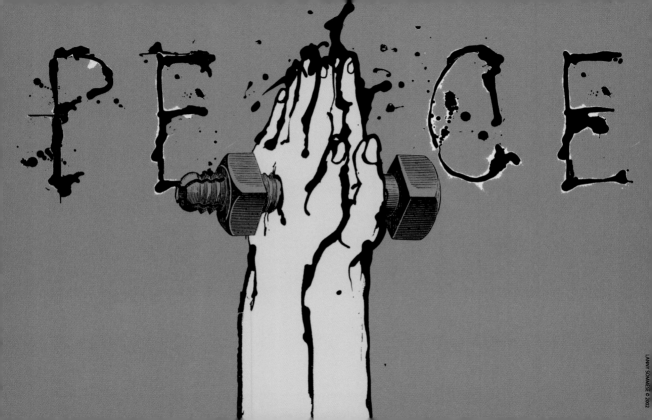

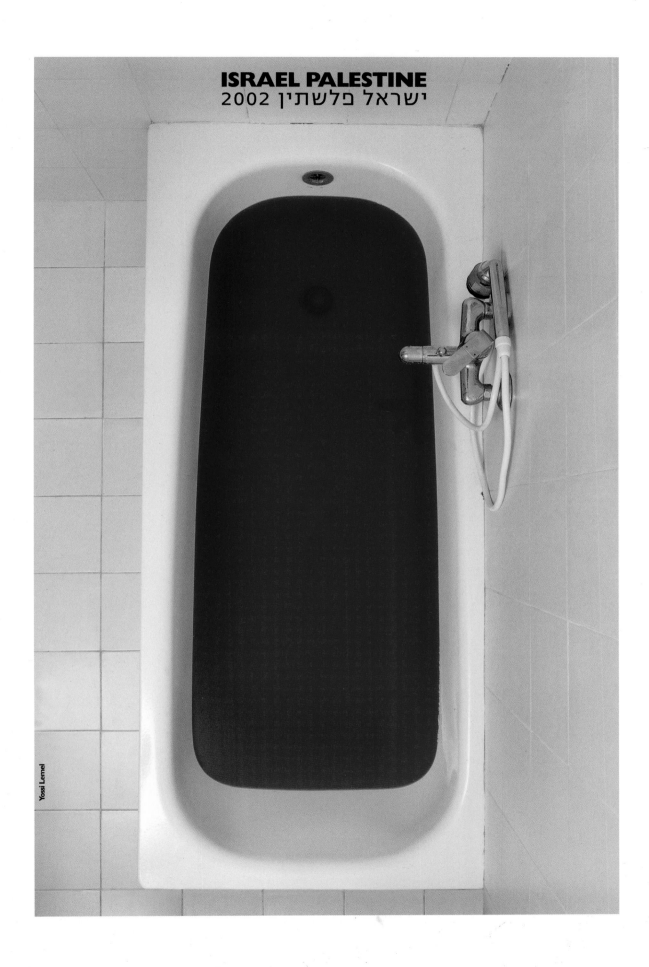

ISRAEL PALESTINE
ישראל פלשתין 2002

Yossi Lemel

Design Firm: Yossi Lemel Creative Director: Yossi Lemel Art Director: Yossi Lemel Designer: Yossi Lemel Photographer: Shuker Sidor Client: Yossi Lemel Political 174,175

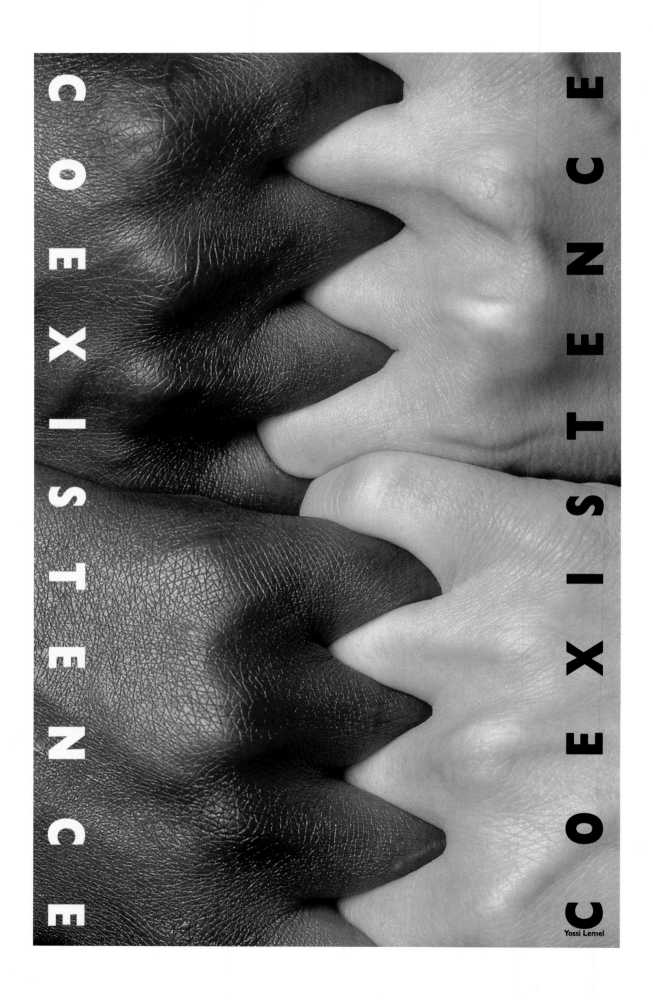

COEXISTENCE

COEXISTENCE

Yossi Lemel

(this spread) Design Firm: Yossi Lemel Creative Director: Yossi Lemel Art Director: Yossi Lemel Designer: Yossi Lemel Photographer: Israel Cohen Client: Yossi Lemel

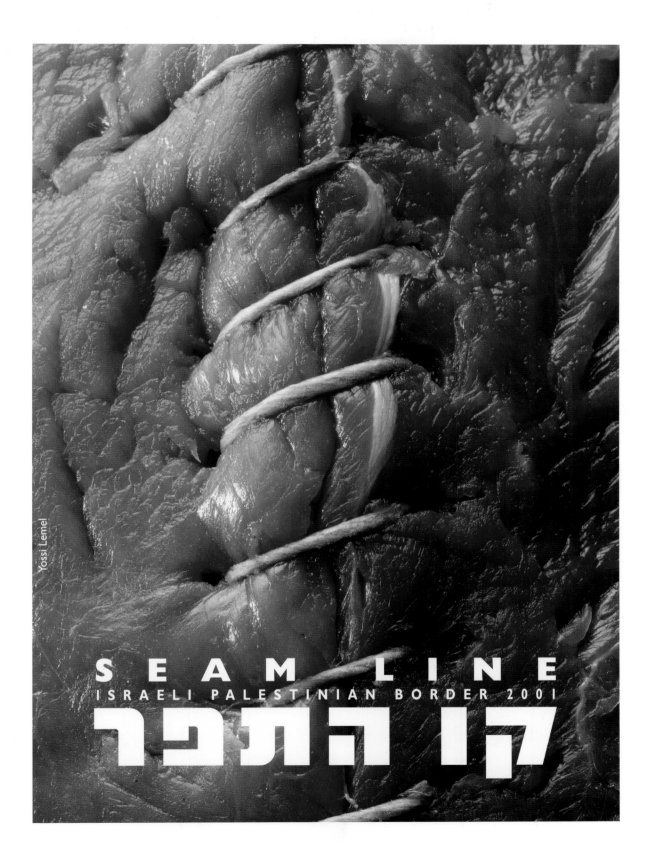

Yossi Lemel

SEAM LINE
ISRAELI PALESTINIAN BORDER 2001
קו התפר

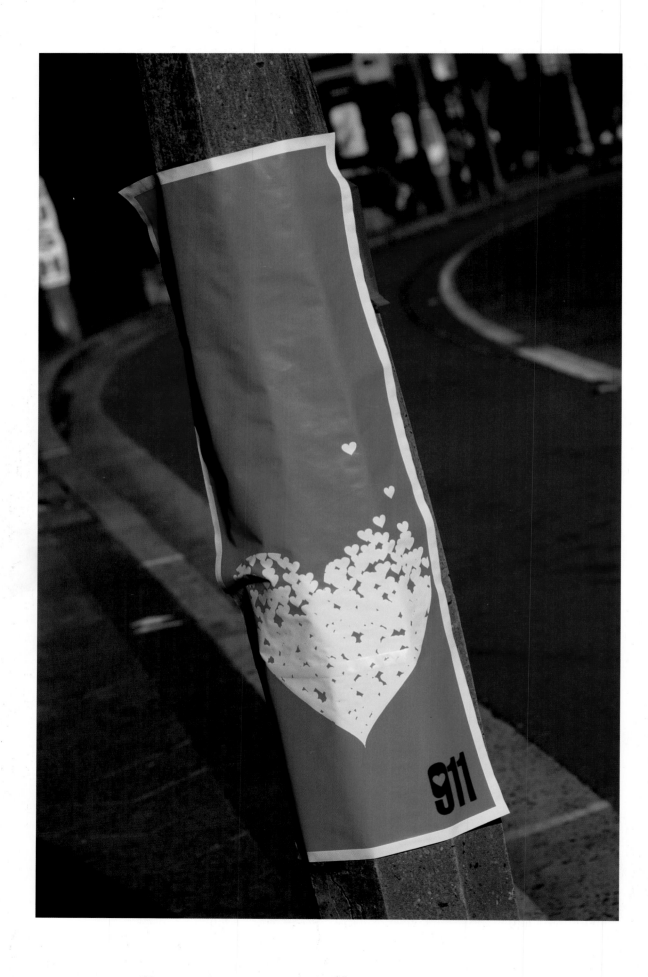

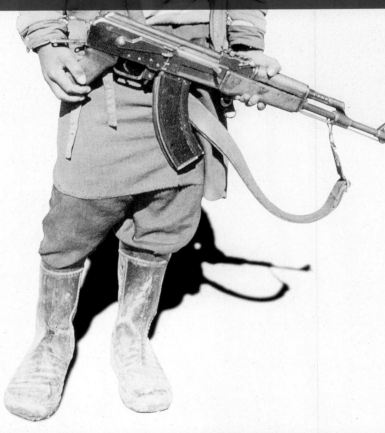

INFANTRY

**CHILDREN AT WAR:
WITNESS SPOTLIGHTS
THE TRAGEDY OF
CHILD SOLDIERS
WORLDWIDE**

WITNESS USES VIDEO
AND TECHNOLOGY
TO FIGHT FOR HUMAN
RIGHTS. WORKING IN
PARTNERSHIP WITH
ACTIVISTS AROUND
THE GLOBE, WITNESS
DOCUMENTS ABUSES
AND BRINGS THE
EVIDENCE BEFORE
COURTS, GOVERNMENTS,
THE MEDIA AND THE WORLD.

WITNESS
A PROJECT OF THE LAWYERS
COMMITTEE FOR HUMAN RIGHTS
333 SEVENTH AVENUE
13TH FLOOR, NEW YORK
N.Y. 10001 5004
TEL. 212 845 5243
FAX 212 845 5299
WEB. WWW.WITNESS.ORG
E MAIL WITNESS@LCHR.ORG

CROSS
MATRIX™

Multi-Function Pen

ATX™

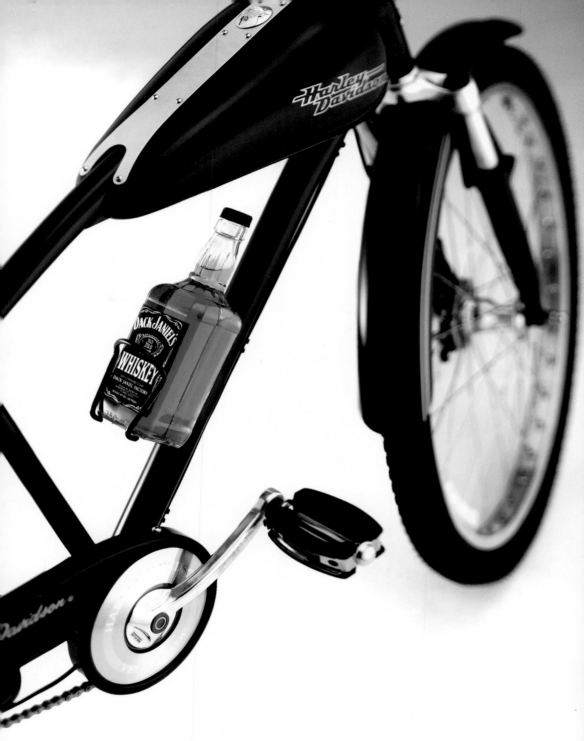

Introducing The Bicycle

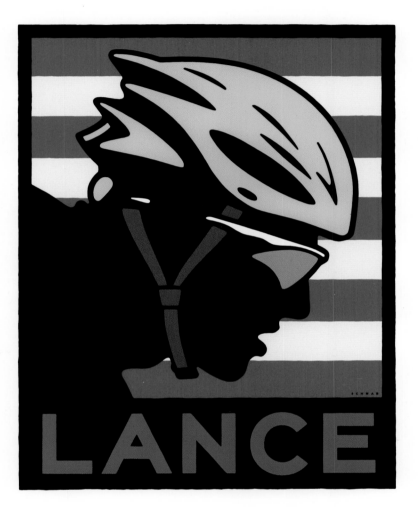

LANCE

Giro.

Design Firm: Michael Schwab Studio Art Director: Judi Oyama Designer: Michael Schwab Illustrator: Michael Schwab Client: Giro USA

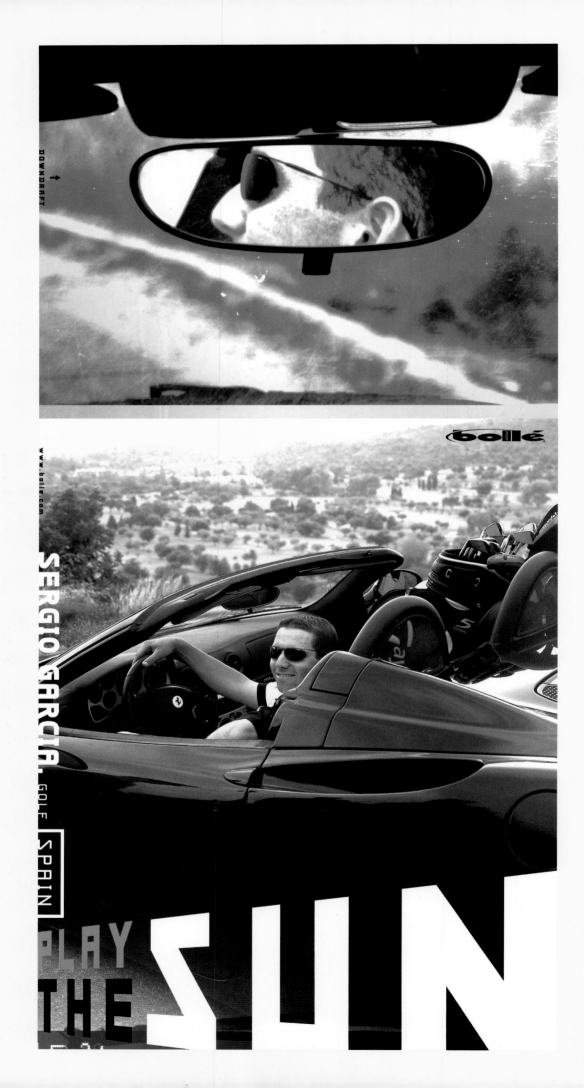

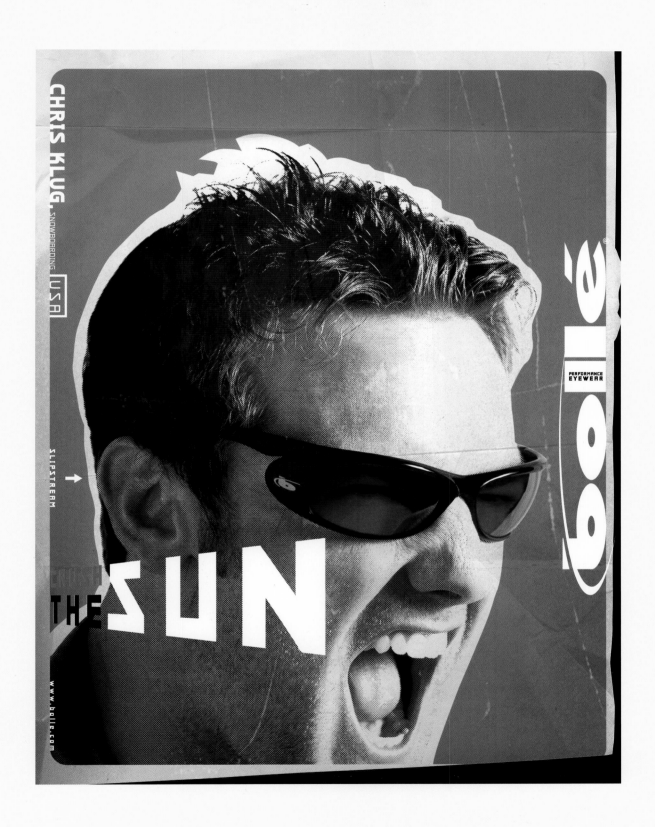

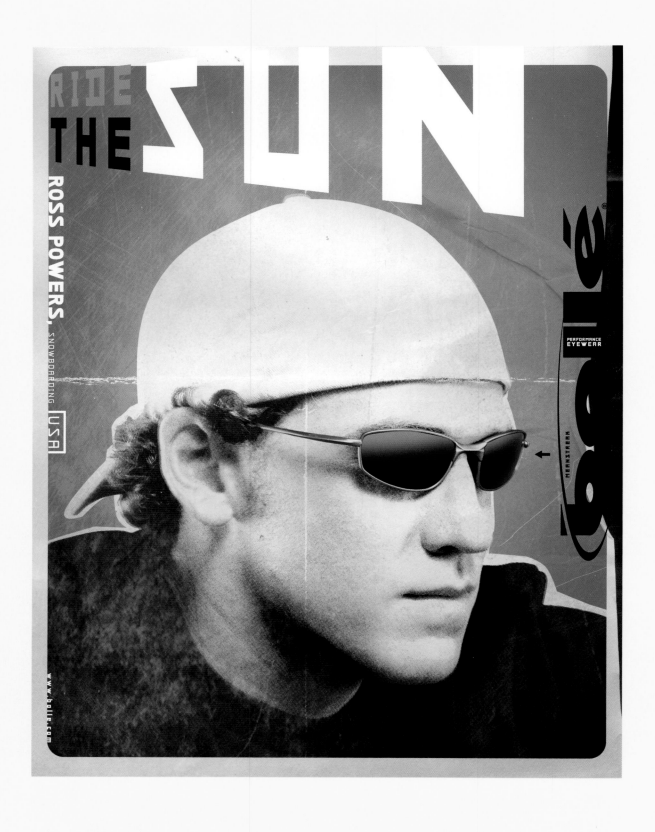

RIDE THE **SUN**

ROSS POWERS, SNOWBOARDING USA

bollé

PERFORMANCE EYEWEAR

MEANSTREAM

www.bolle.com

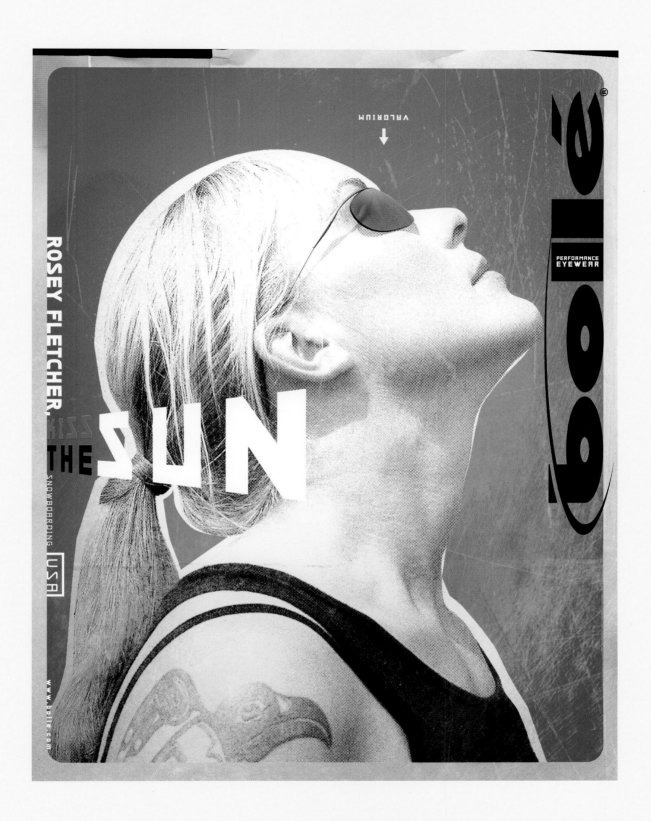

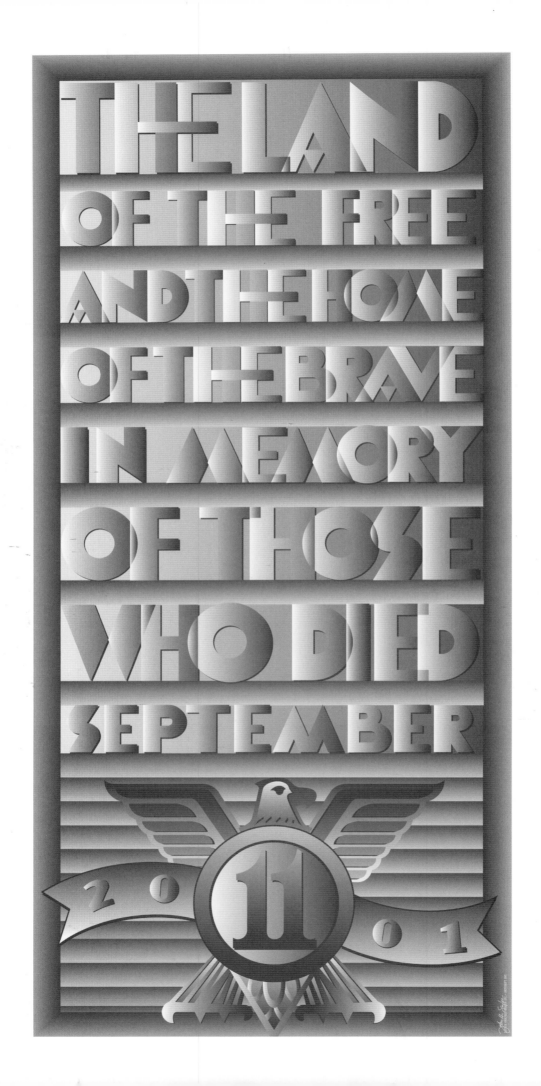

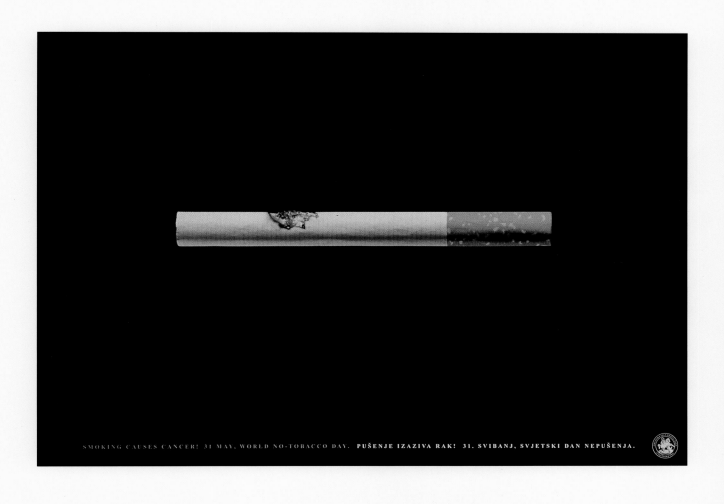

SMOKING CAUSES CANCER! 31 MAY, WORLD NO-TOBACCO DAY. PUŠENJE IZAZIVA RAK! 31. SVIBANJ, SVJETSKI DAN NEPUŠENJA.

Public Service 188,189

Client: Croatian League Against Cancer

Design Firm: Laboratorium Creative Director: Goran S. Martin Art Director: Goran S. Martin Designer: Goran S. Martin Photographer: Alan Matuka

AS LONG AS THERE ARE OLD LADIES WHO STINK AT CROSSING STREETS, WE'LL BE HERE.

CUB SCOUT ENROLLMENT IS HERE. WWW.JOINCUBS.COM

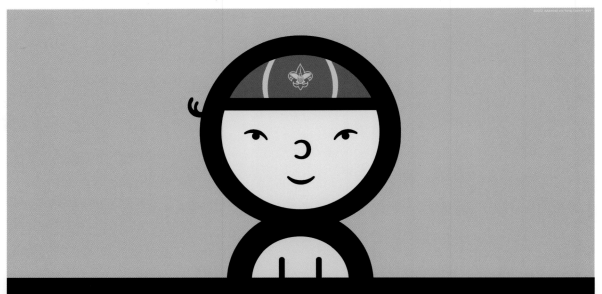

IDLE HANDS ARE TROUBLE. HANDS STUCK IN MELTED MARSHMALLOW, LESS SO.

CUB SCOUT ENROLLMENT IS HERE. WWW.JOINCUBS.COM

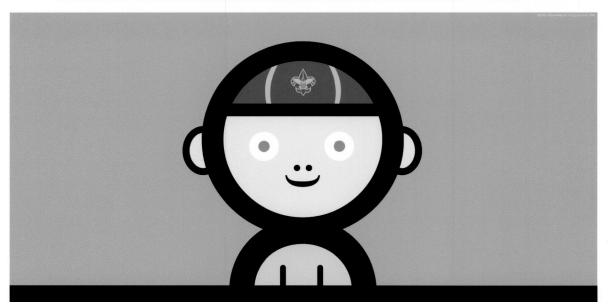

VERY FEW CRIME REPORTS START WITH "THE SUSPECT, A FORMER CUB SCOUT, WAS LAST SEEN..."

CUB SCOUT ENROLLMENT IS HERE. WWW.JOINCUBS.COM

HOW EFFECTIVE IS YOUR RAIN DANCE?
STOP PLAYING WITH FIRE COLORADO.

HATCH SHOW PRINT · NASHVILLE. TENNESSEE

Design Firm: Cultivator Advertising & Design Creative Directors: Tim Abare and Chris Beatty Art Director: Chris Beatty Copywriter: Tim Abare Client: State of Colorado Public Service 190, 191

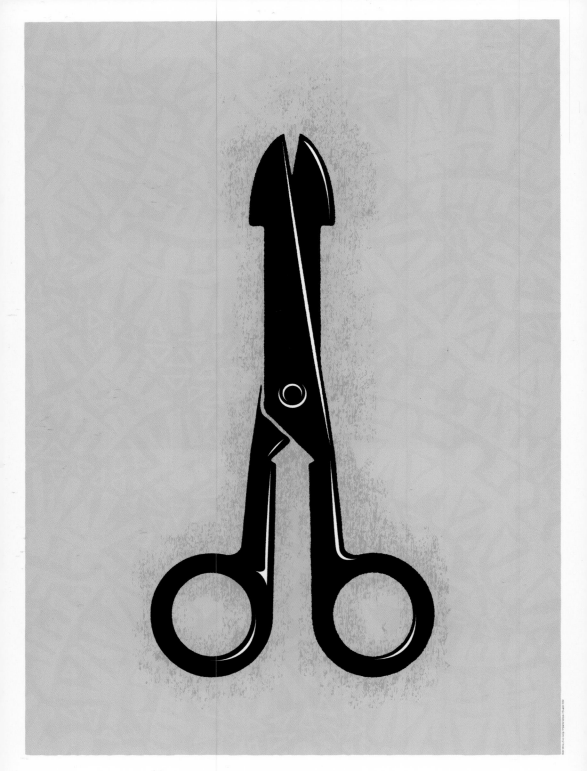

sociedad:hombre/society:man

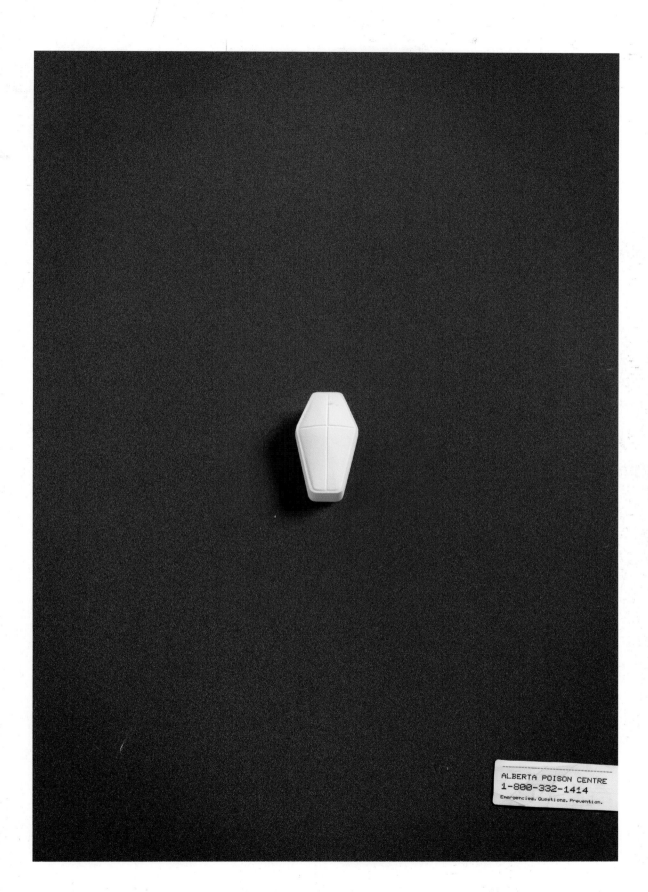

Public Service 192, 193

Design Firm: Highwood Communications Ltd Creative Director: Keli Pollock Art Director: Keli Pollock Photographer: Ian Pollock Copywriter: Ian Campbell Copywriter: Dan King Client: Calgary Health Region

Design Firm: Parable Communications Corp. Art Director: David Craib Designer: Peter Watts Photographer: Cochrane Photography Copywriter: Stiff Sentences

REMEMBER US
9/11/2001

We are the Dead. Short days ago
We lived, felt dawn, saw sunset glow,
Loved and were loved...

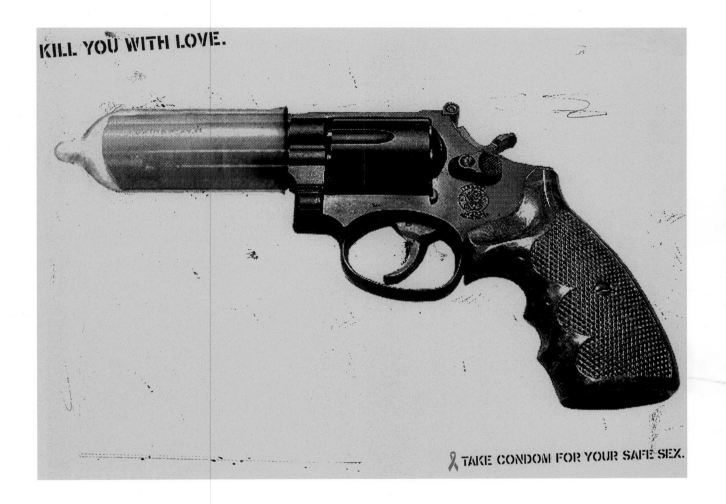

Public Service 194,195

Design Firm: Dentsu Inc. Creative Director: Shunichi Sato Art Director: Shunichi Sato Designer: Shunichi Sato Copywriter: Aoshima Miki Client: Dentsu Clinic

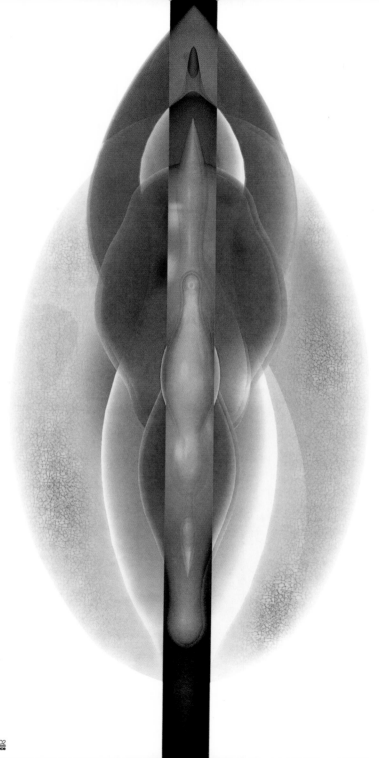

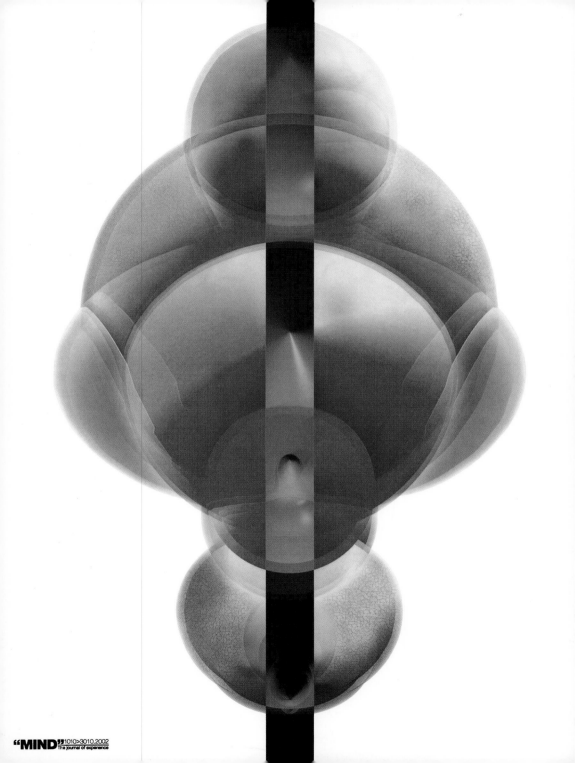

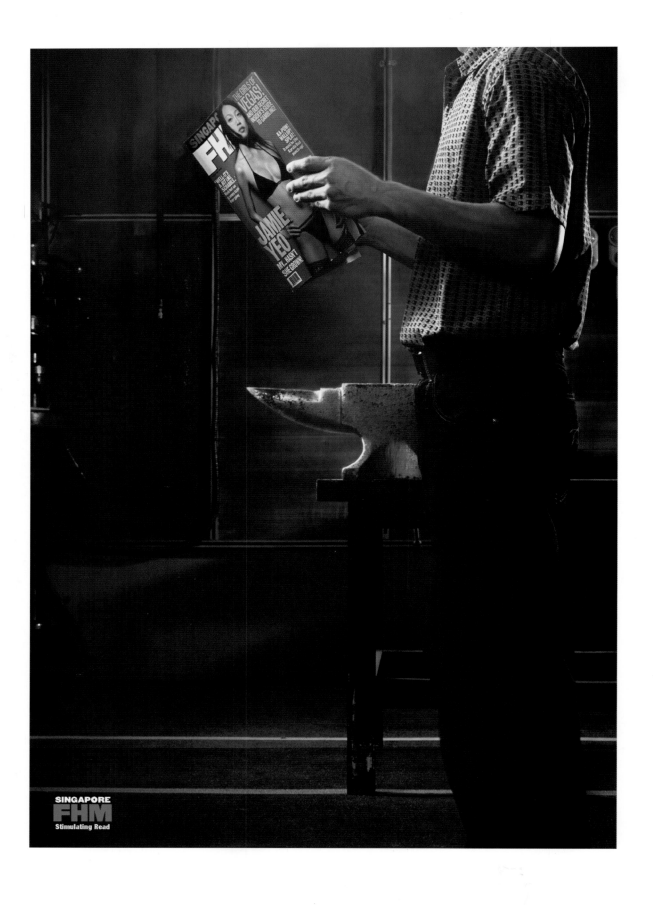

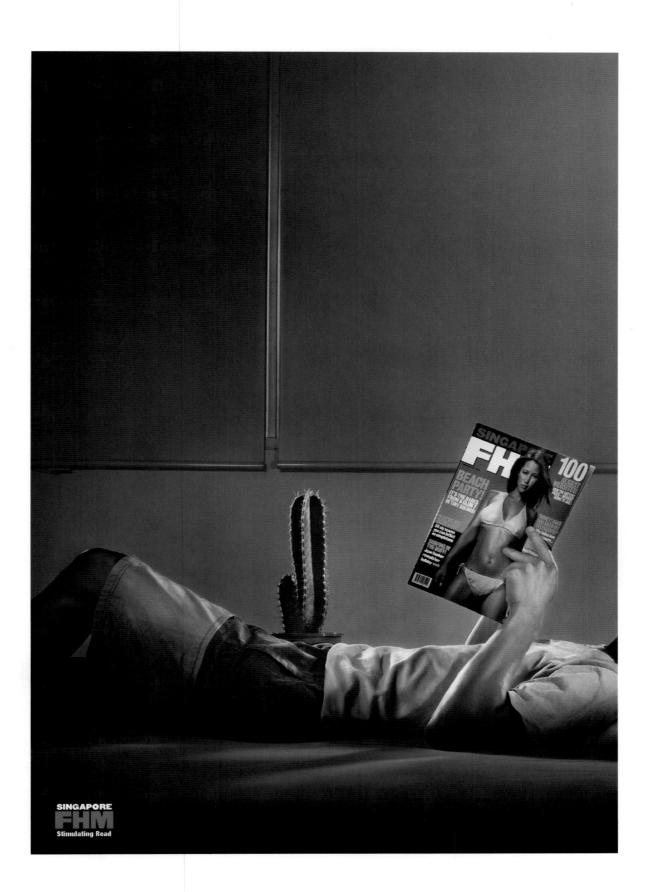

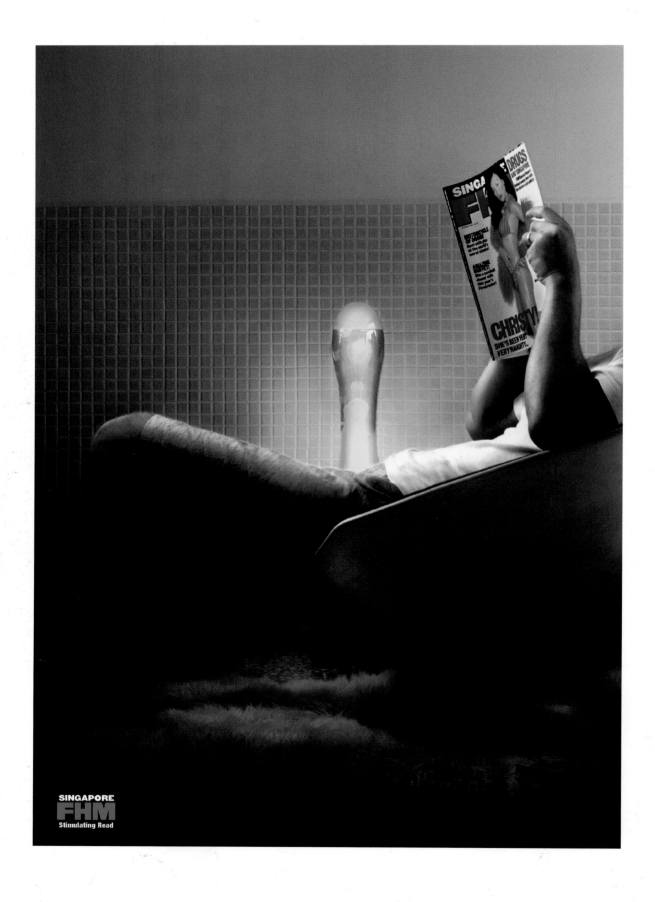

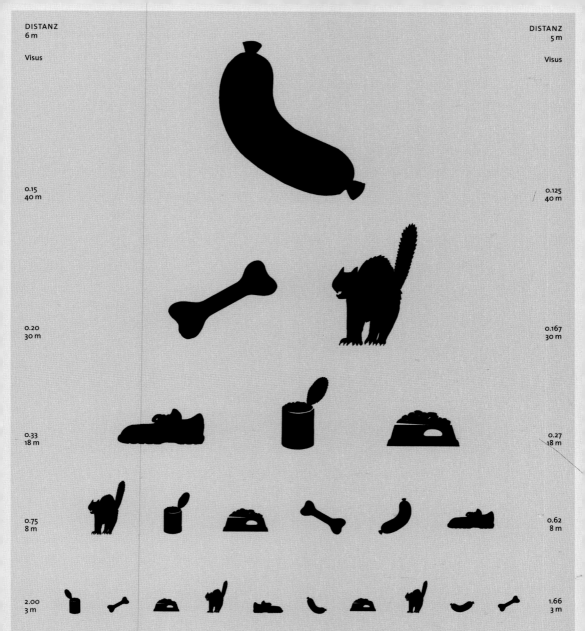

0.15
40 m

0.125
40 m

0.20
30 m

0.167
30 m

0.33
18 m

0.27
18 m

0.75
8 m

0.62
8 m

2.00
3 m

1.66
3 m

Sehtest für Vierbeiner

Mit freundlicher Empfehlung: Ein Herz für Tiere,
Europas größtes Tiermagazin.

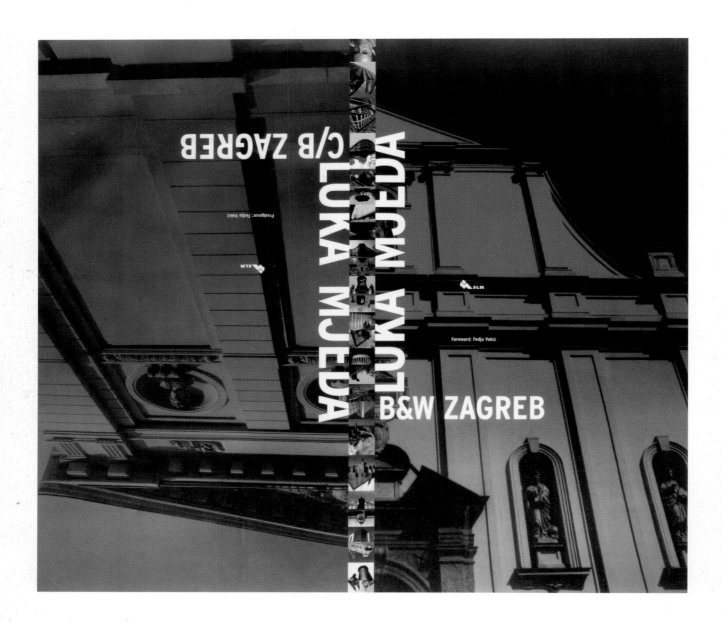

هوشنگ گلشیری

شازده احتجاب

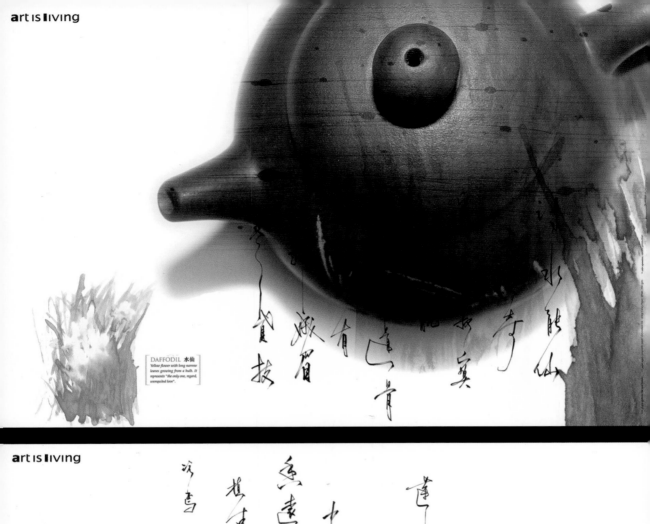

DAFFODIL 水仙

Yellow flower with long narrow leaves growing from a bulb. It represents "the only one, regard, unrequited love".

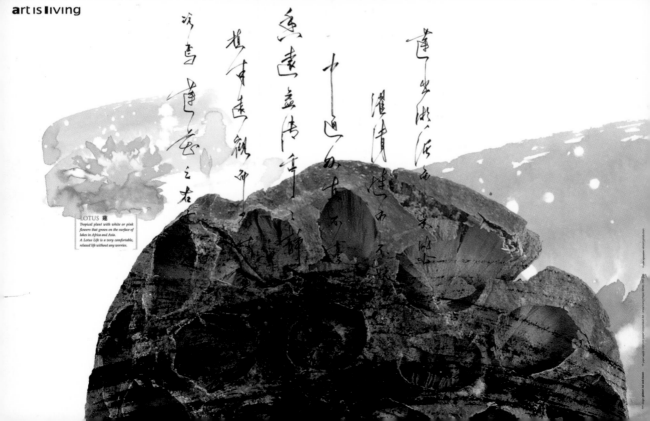

LOTUS 蓮

Tropical plant with white or pink flowers that grows on the surface of lakes in Africa and Asia. A Lotus Life is a very comfortable, relaxed life without any worries.

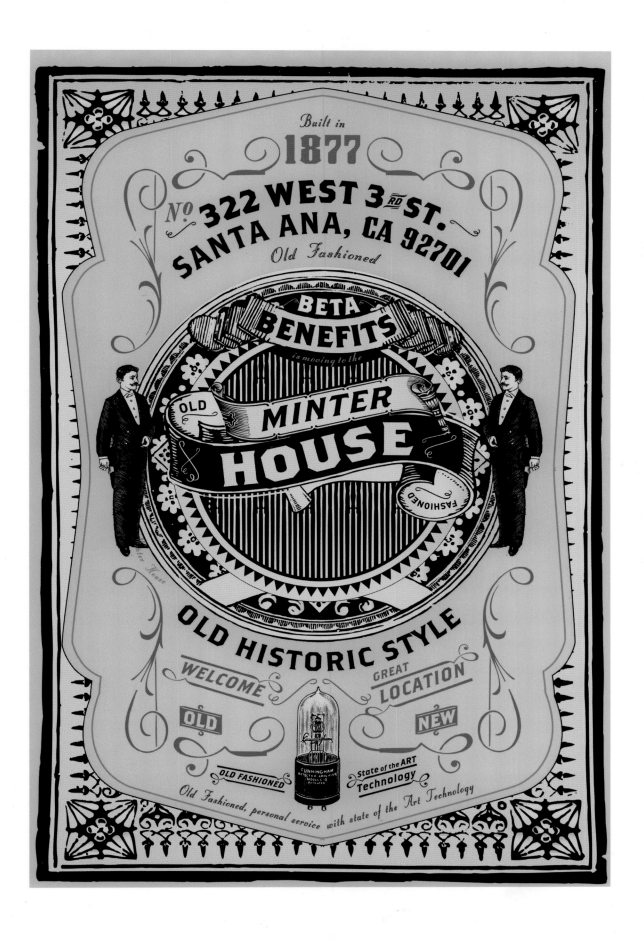

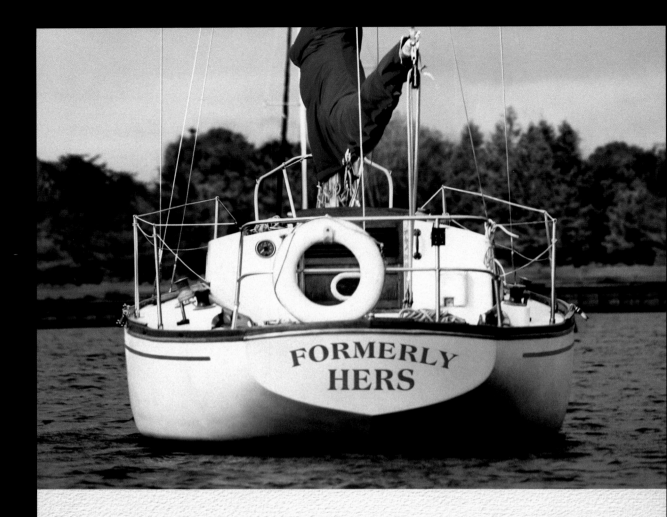

FORMERLY
HERS

Sanders, Lyn & Ragonetti Associates, Trial Lawyers

202-195 County Court Blvd. Brampton, Ontario L6W-4P7 Tel:(905)450-1711 Fax:(905)450-7066 www.slra.com

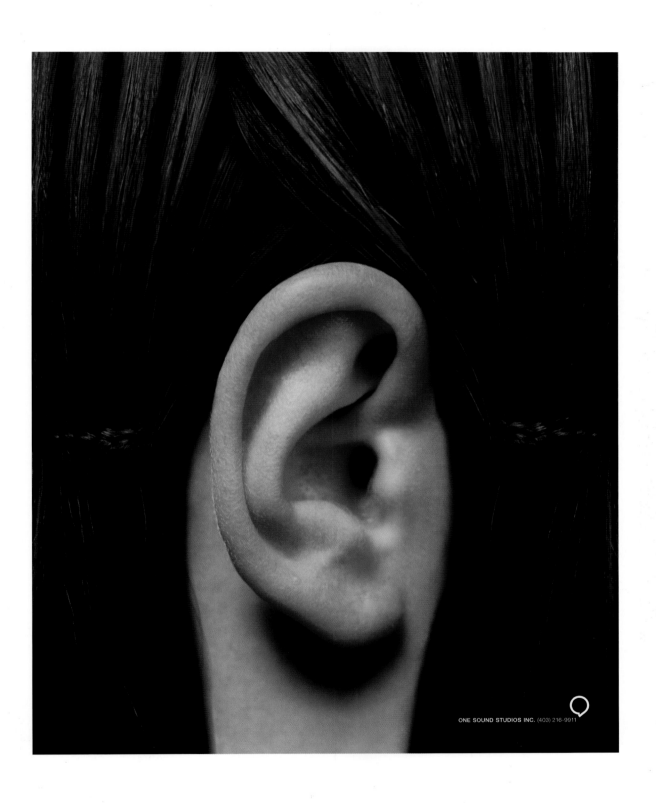

ONE SOUND STUDIOS INC. (403) 216-9911

Design Firm: Highwood Communications Ltd Creative Director: Steve Williams Art Director: Robert Sweetman Photographer: Jason Stang Illustrator: La Sagna Copywriter: Dan King Client: One Sound Studio Inc.

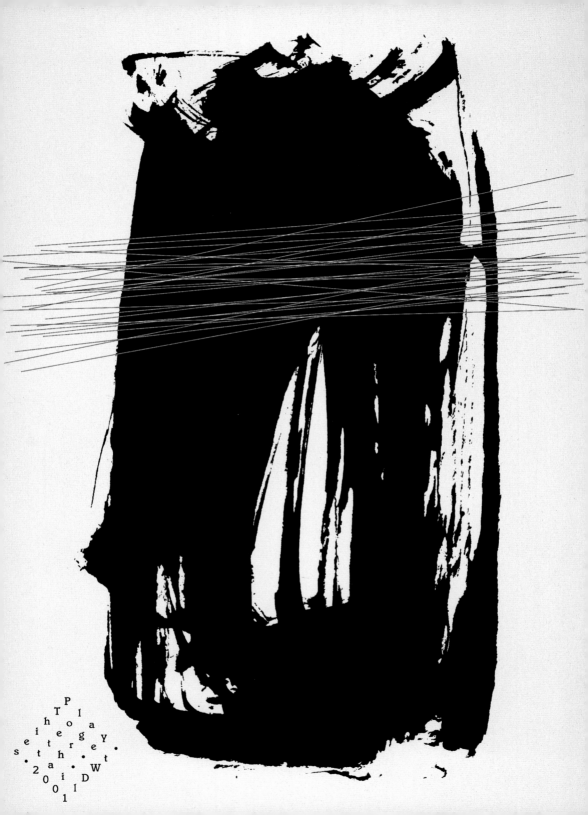

P
l
T o a
h e g Y
s e i t h r e .
. s t a i D . t
2 0 1 W
0
1

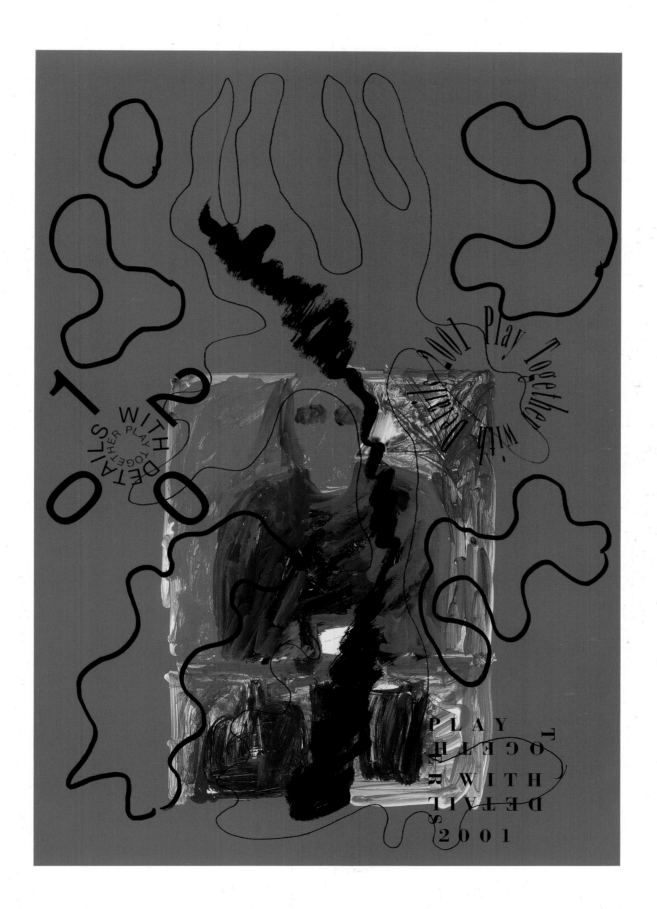

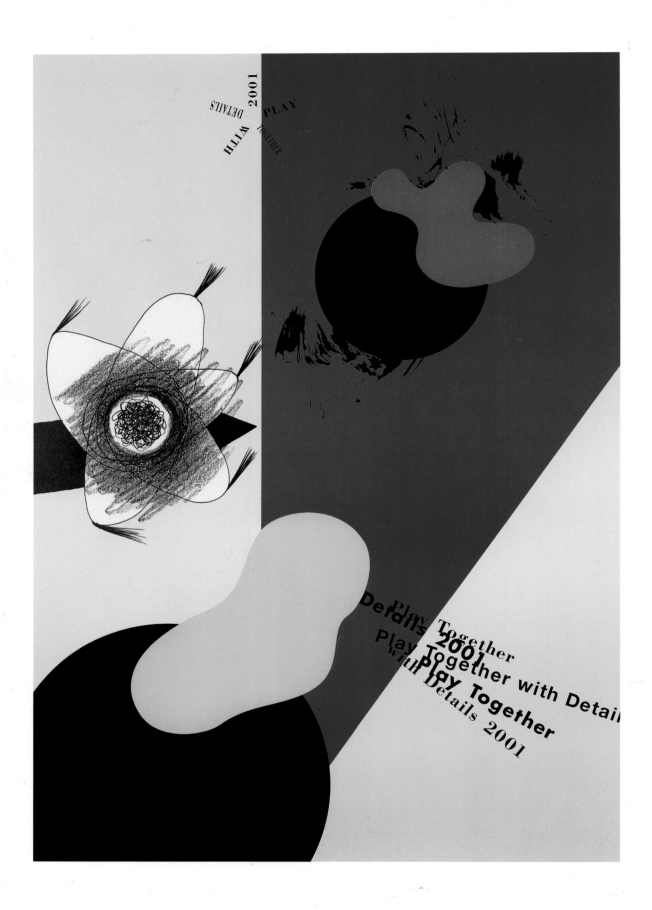

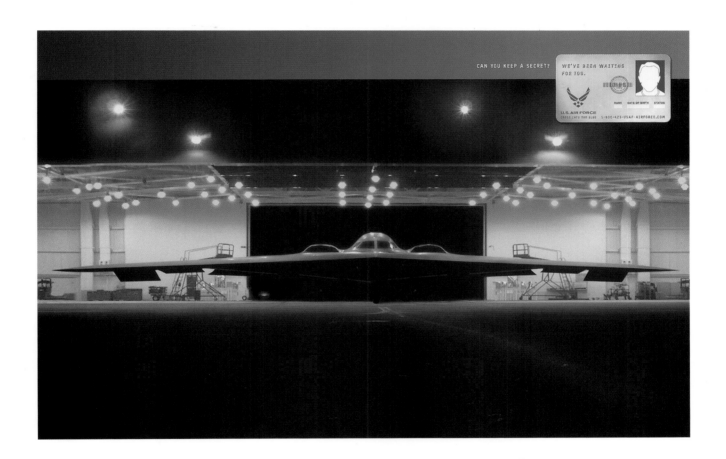

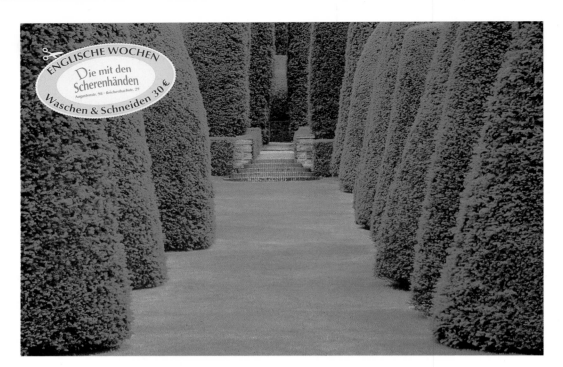

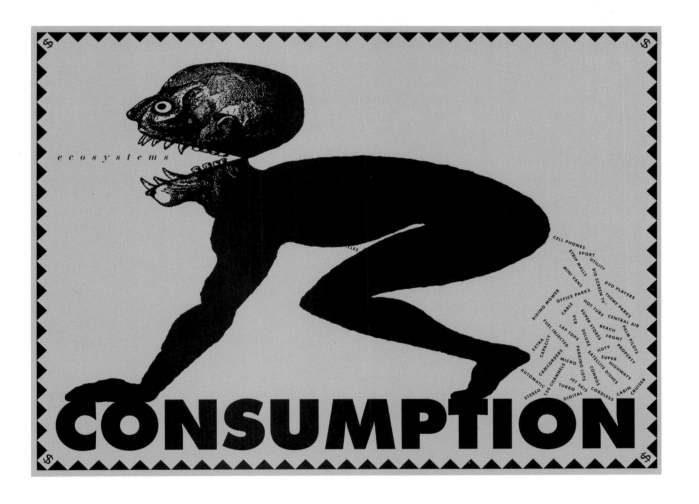

Design Firm: Scorsone/Drueding Art Directors: Joe Scoresone and Alice Drueding Designers: Joe Scoresone and Alice Drueding Copywriters: Joe Scoresone and Alice Drueding Client: Scorsone/Drueding

Social 216,217

SAN FRANCISCO

2012

THE BRIDGE TO THE FUTURE
San Francisco · U.S. Bid City · 2012 Olympic Games
DESIGN: MIN WANG / SQUARE TWO DESIGN · PRINTING: HTTPRINT / DOME PRINTING · PAPER: SAPPI · visit BASOC2012.org

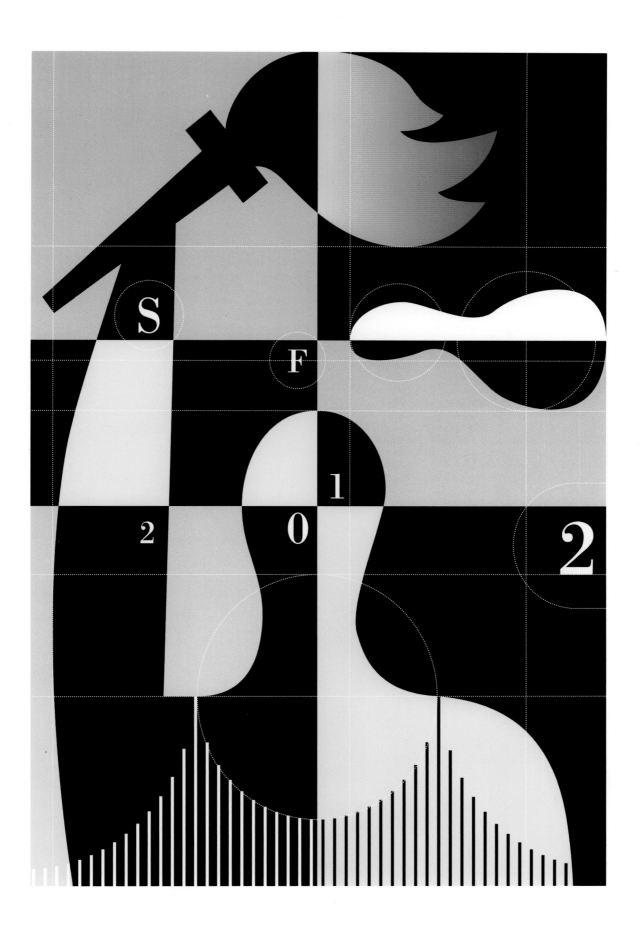

Design Firm: Vanderbyl Design Creative Director: Michael Vanderbyl Art Director: Michael Vanderbyl Designer: Michael Vanderbyl Illustrator: Michael Vanderbyl Client: Bay Area Sports Organizing Committee

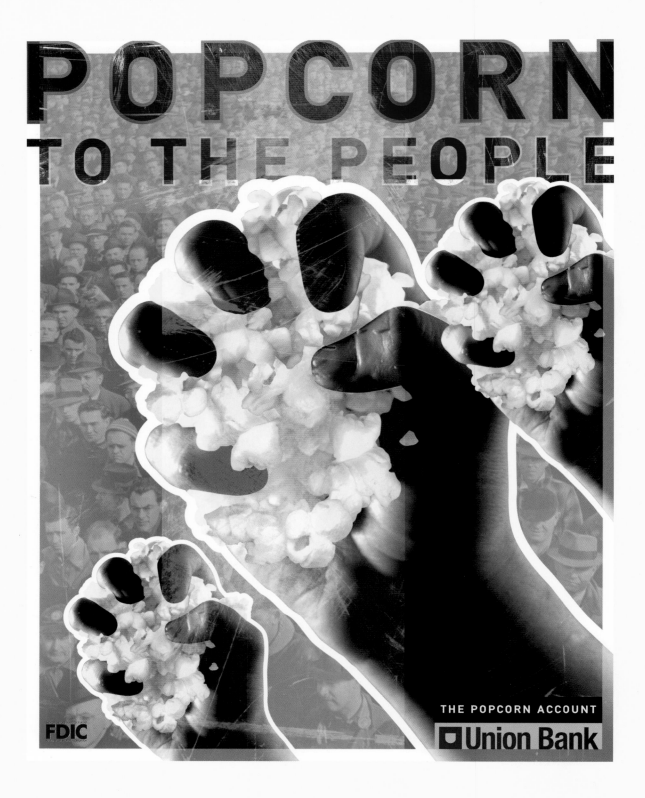

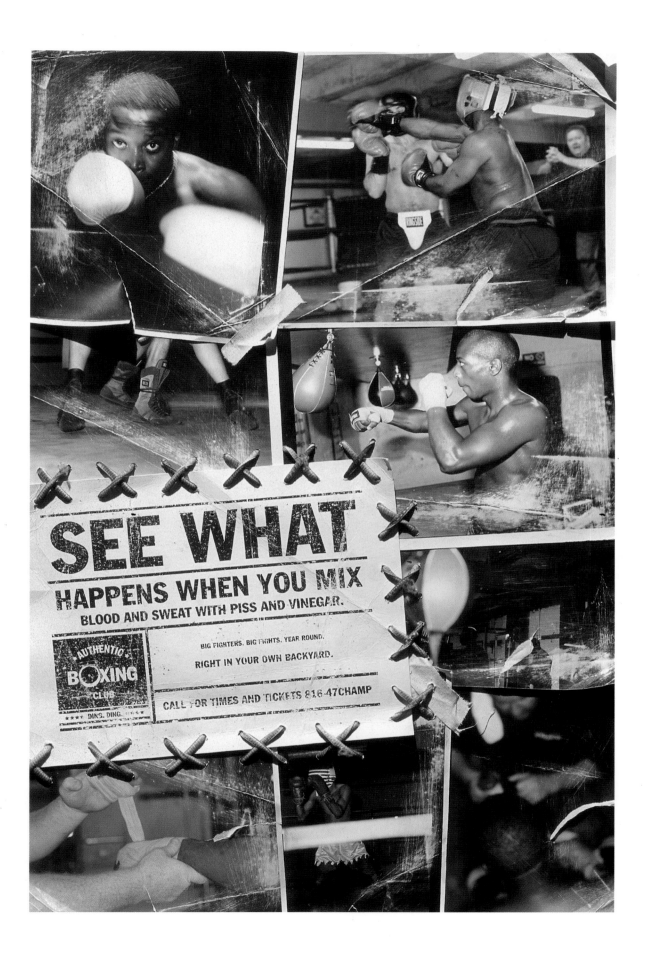

Design Firm: CHRW Advertising Creative Director: Mark Heminger Art Director: Dusty Summer Photographer: Kenny Johnson Copywriter: C. Warren Bowles Client: Authentic Boxing Club

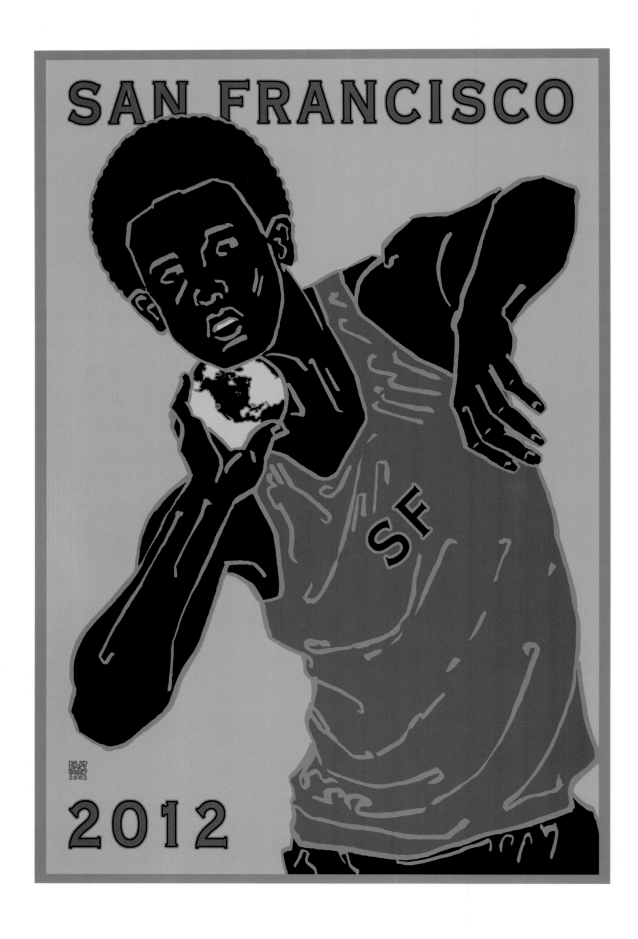

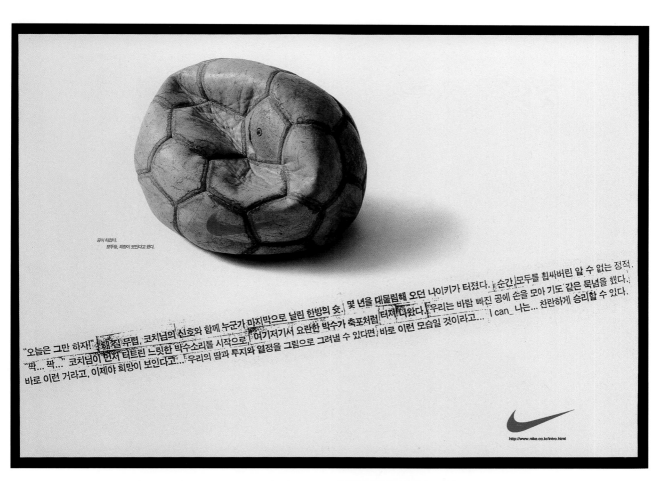

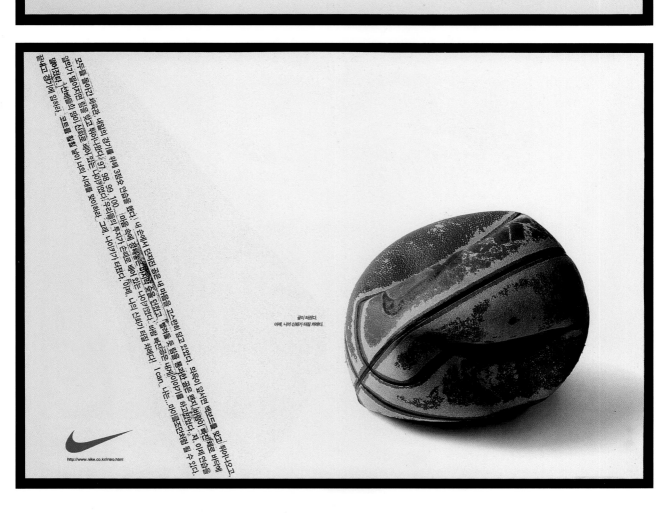

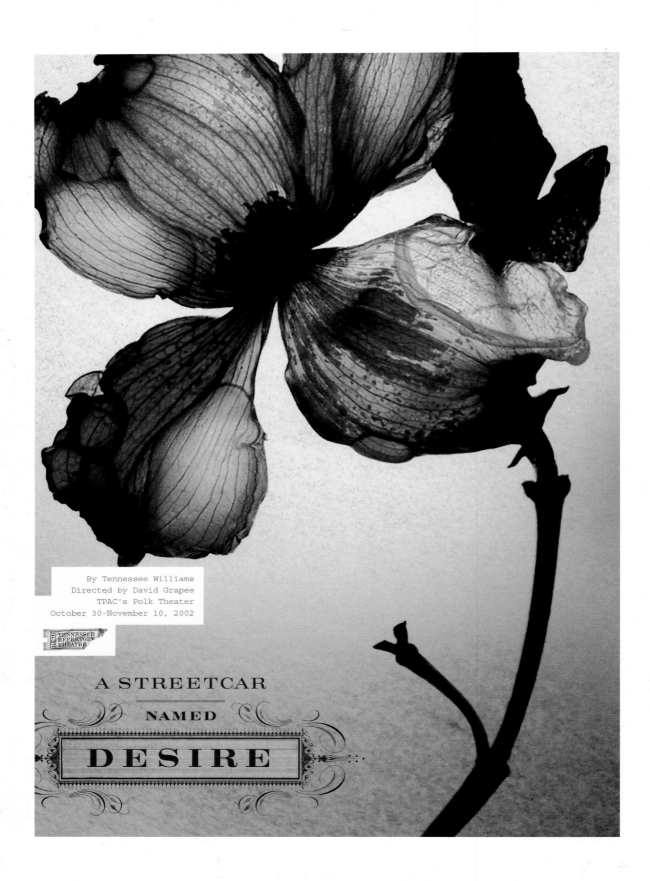

By Tennessee Williams
Directed by David Grapes
TPAC's Polk Theater
October 30-November 10, 2002

A STREETCAR
NAMED
DESIRE

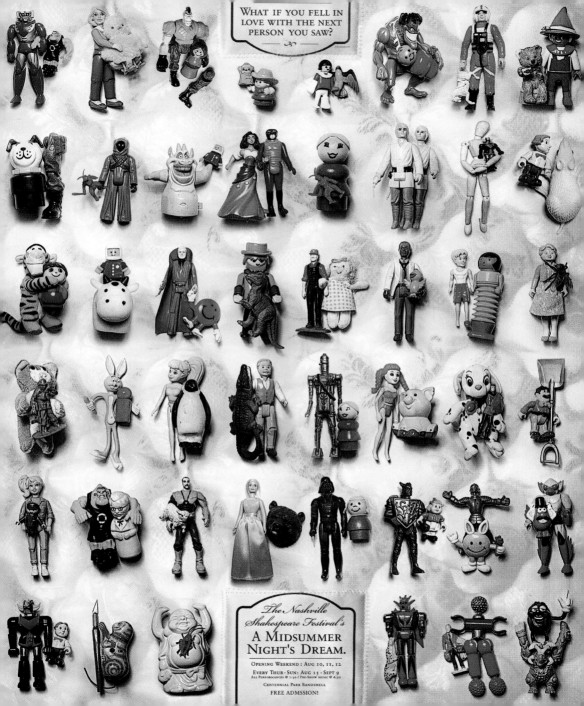

WHAT IF YOU FELL IN
LOVE WITH THE NEXT
PERSON YOU SAW?

The Nashville
Shakespeare Festival's
A MIDSUMMER
NIGHT'S DREAM.

OPENING WEEKEND : AUG 10, 11, 12
EVERY THUR·SUN: AUG 15 - SEPT 9
ALL PERFORMANCES @ 7:30 / PRE-SHOW MUSIC @ 6:30

CENTENNIAL PARK BANDSHELL
FREE ADMSSION!

ORLANDO-UCF SHAKESPEARE FESTIVAL

WILLIAM SHAKESPEARE'S 022202

HAMLET

FEB 22 – MARCH 24
PREVIEWS: FEBRUARY 20 & 21
[NEW] GOLDMAN THEATER
LOWNDES SHAKESPEARE CENTER LOCH HAVEN PARK

BOX OFFICE
[407] 447-1700 EXT 1
TICKETS: $18 TO $26
PREVIEW TICKETS $10

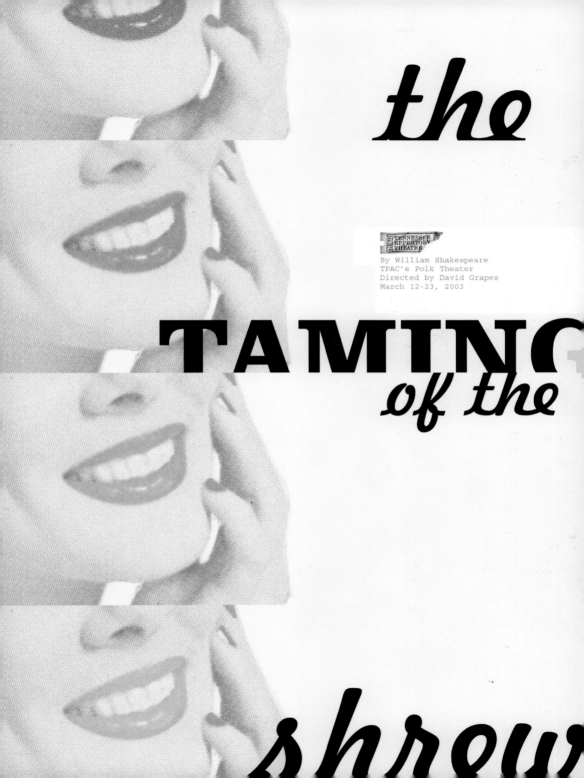

the

TAMING

of the

shrew

By William Shakespeare
TPAC's Polk Theater
Directed by David Grapes
March 12-23, 2003

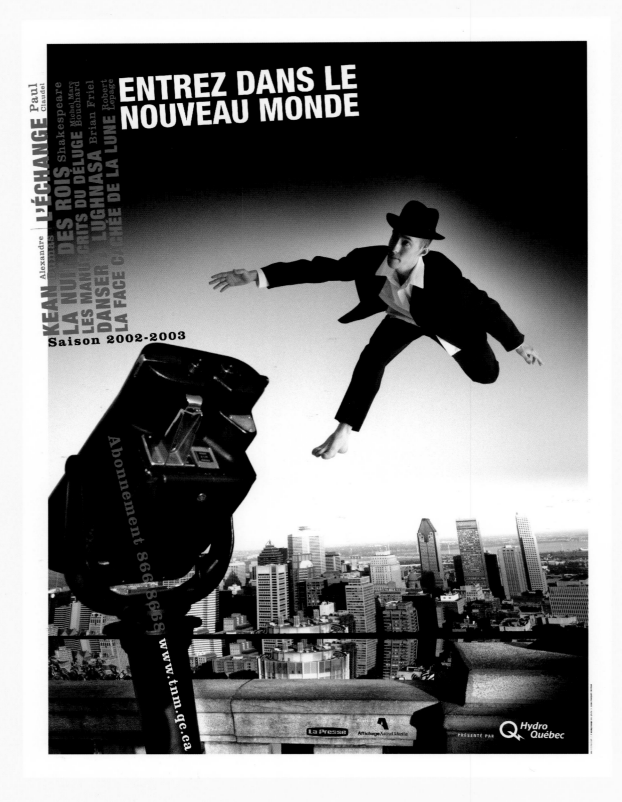

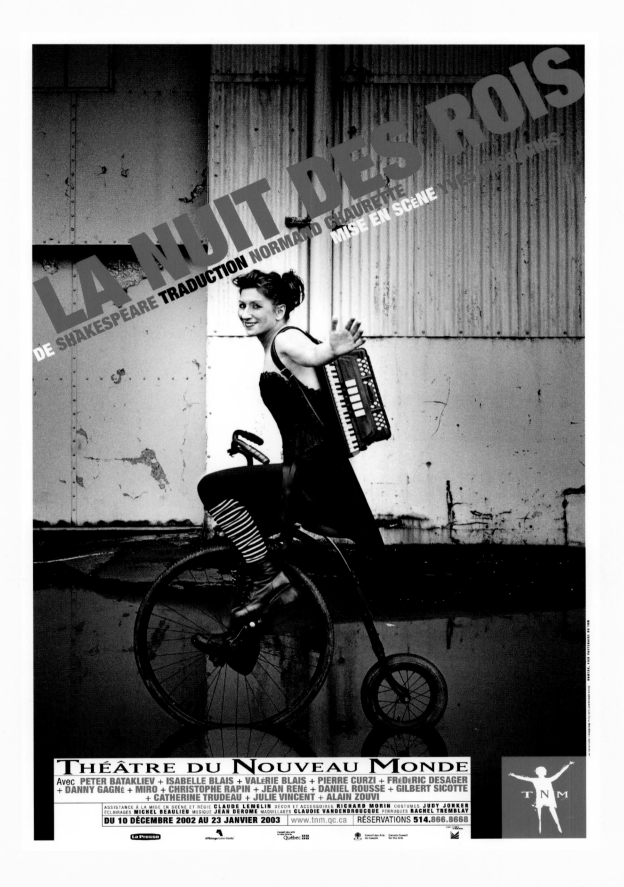

LA NUIT DES ROIS
DE SHAKESPEARE TRADUCTION NORMAND CHAURETTE MISE EN SCèNE YVES DESGAGNÉS

THÉÂTRE DU NOUVEAU MONDE
Avec PETER BATAKLIEV + ISABELLE BLAIS + VALéRIE BLAIS + PIERRE CURZI + FRéDéRIC DESAGER + DANNY GAGNé + MIRO + CHRISTOPHE RAPIN + JEAN RENé + DANIEL ROUSSE + GILBERT SICOTTE + CATHERINE TRUDEAU + JULIE VINCENT + ALAIN ZOUVI
ASSISTANCE À LA MISE EN SCÈNE ET RÉGIE CLAUDE LEMELIN DÉCOR ET ACCESSOIRES RICHARD MORIN COSTUMES JUDY JONKER ÉCLAIRAGES MICHEL BEAULIEU MUSIQUE JEAN DEROME MAQUILLAGES CLAUDIE VANDENBROUCQUE PERRUQUES RACHEL TREMBLAY
DU 10 DÉCEMBRE 2002 AU 23 JANVIER 2003 www.tnm.qc.ca RÉSERVATIONS 514.866.8668

TNM

théâtre de
QUAT'SOUS

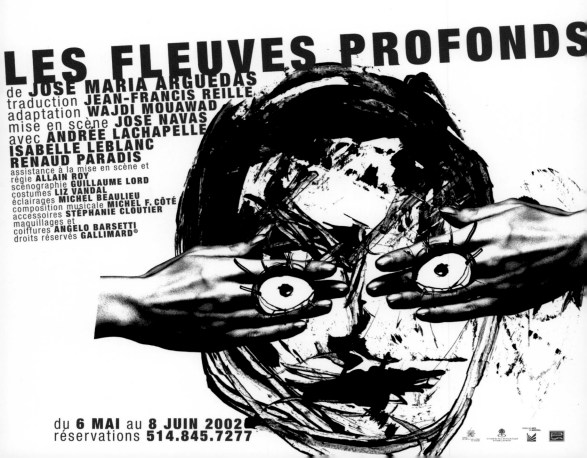

LES FLEUVES PROFONDS

de JOSE MARIA ARGUEDAS
traduction JEAN-FRANCIS REILLE
adaptation WAJDI MOUAWAD
mise en scène JOSE NAVAS
avec ANDRÉE LACHAPELLE
ISABELLE LEBLANC
RENAUD PARADIS
assistance à la mise en scène et
régie ALLAIN ROY
scénographie GUILLAUME LORD
costumes LIZ VANDAL
éclairages MICHEL BEAULIEU
composition musicale MICHEL F. CÔTÉ
accessoires STÉPHANIE CLOUTIER
maquillages et
coiffures ANGELO BARSETTI
droits réservés GALLIMARD©

du 6 MAI au 8 JUIN 2002
réservations 514.845.7277

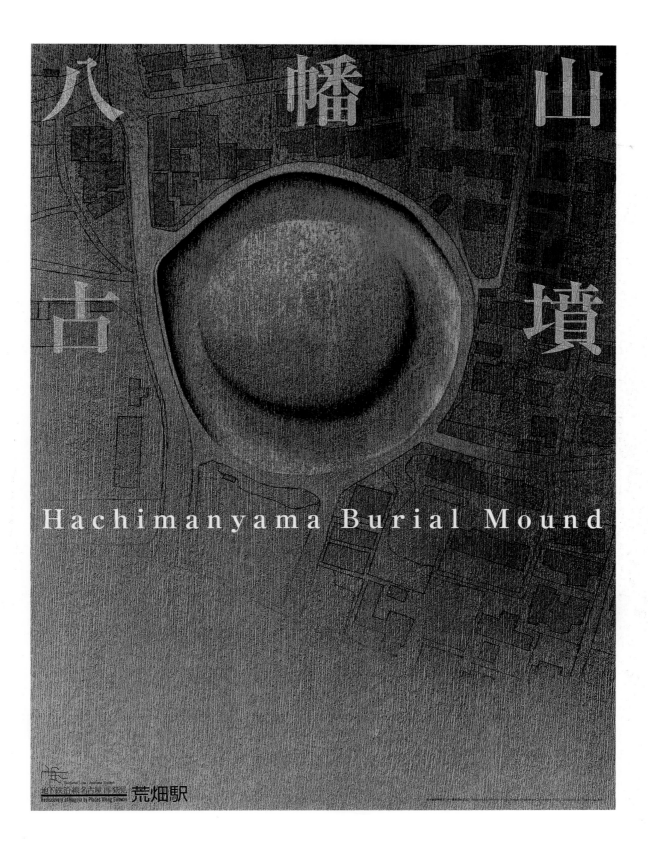

Design Firm: Toyotsuga Itoh Design Office Art Director: Toyotsugu Itoh Designer: Toyotsugu Itoh Client: Toyotsugu Itoh Illustrator: Toyotsugu Itoh Client: Nagoya Exploration Party Poster Exhibition Committee

Theater 230,231

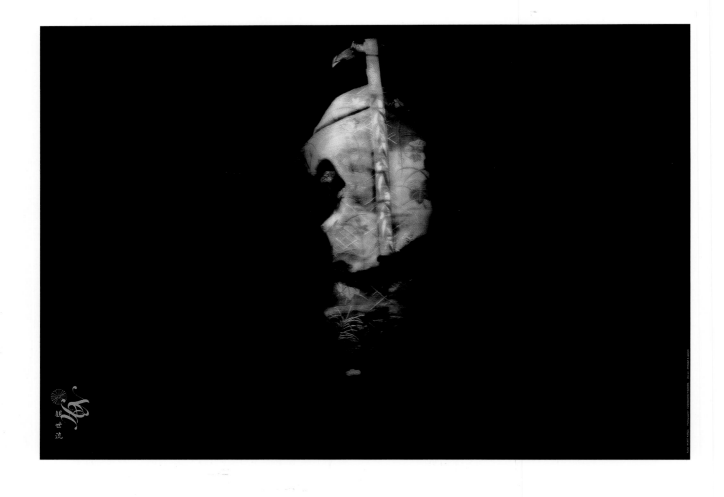

(this spread) Design Firm: Giichi Design Art Director: Giichi Designers: Mikako and Giichi Photographer: Yoshikatsu Hayashi Client: Kanze School

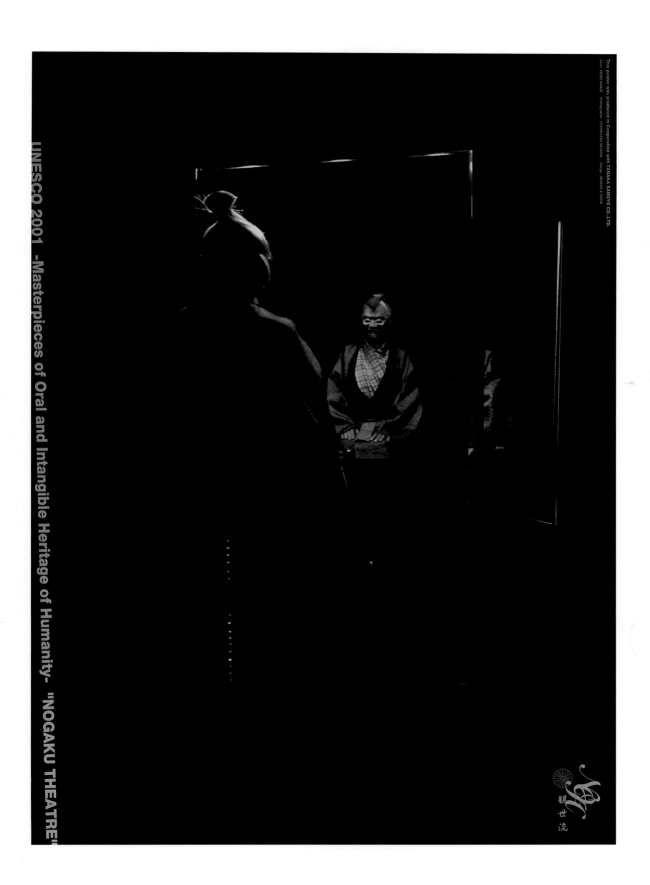

This poster was produced in Cooperation with TANAKA SANGYO CO.,LTD.

Actor: HIDEO KANZE Photographer: YOSHIKATSU HAYASHI Design: MIYAKO & GROW

UNESCO 2001 -Masterpieces of Oral and Intangible Heritage of Humanity- "NOGAKU THEATRE"

観世流

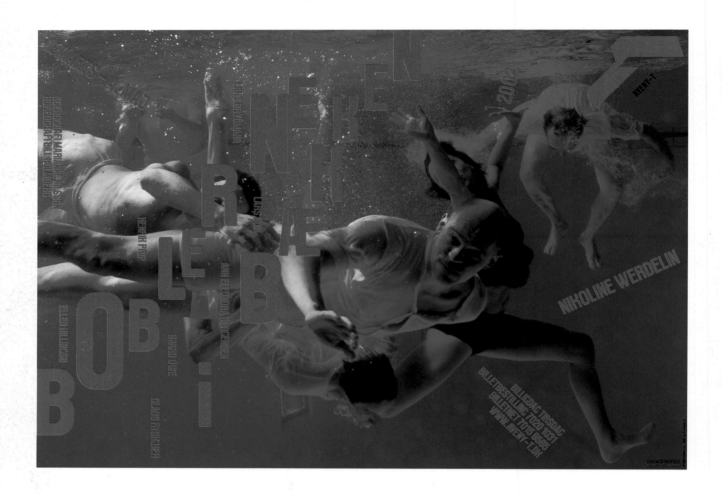

CALIFORNIA STORIES

THE CALIFORNIA COUNCIL FOR THE HUMANITIES

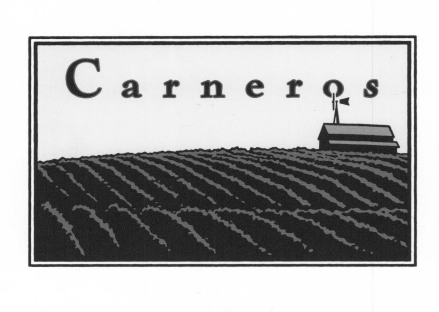

MOUNT TAMALPAIS

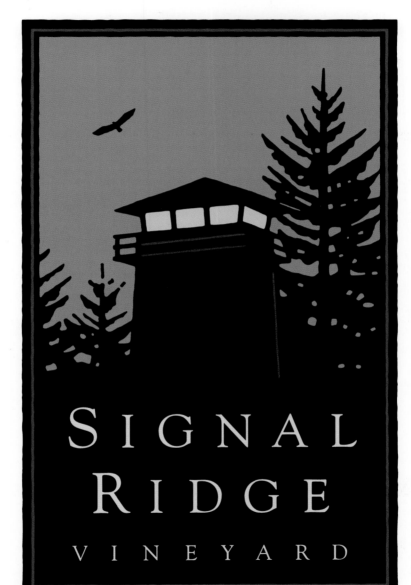

SIGNAL
RIDGE
VINEYARD

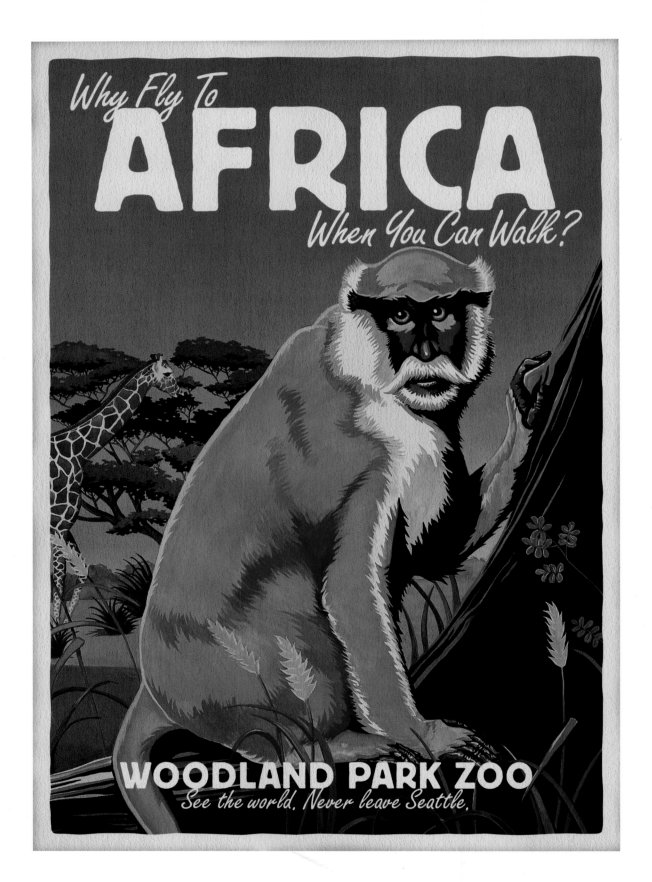

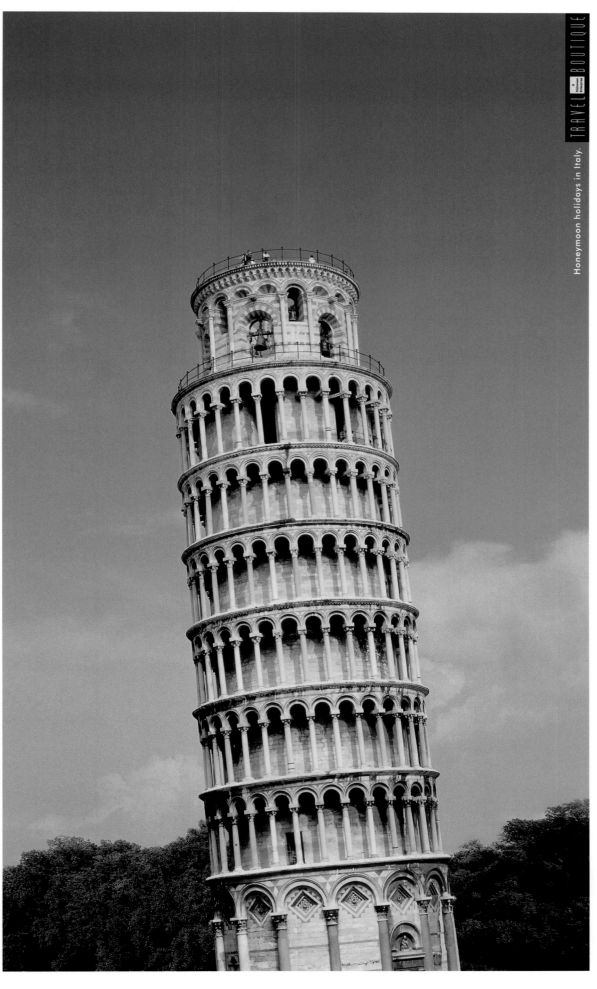

Tourism 238,239

Design Firm: Saatchi & Saatchi Creative Directors: Ramesh Ramanathan and Sean Colaso Art Director: Makarand Patil Designers: Makarand Patil and Kamal Basu Photographer: Dinodia Picture Company Illustrator: Makarand Patil Copywriter: Ramesh Ramanathan Client: Travel Boutique

HANS

A FAMILY *of* FONTS

DESIGNED *by* HANSEN SMITH

THE HANS FAMILY BEGAN WITH HANSEMI. Originally called *HanSans*, it was a font designed with some very specific goals. The basic proportions for the characters were taken from traditional Humanist faces such as *Bembo* and *Garamond*. Similarly, the proportions for the numerals were taken from the Old Style figures of the same family. With these guidlines in place this semi serif font was constructed using sharp corners, less stroke variation from thick to thin, and a subtle oblique stress. The goal was to create a modern, easily read, typeface based on the classical stylings of those cut by master craftsmen as early as 1462.

THE REMAINING FOUR MEMBERS OF THE FAMILY WERE CREATED USING THE characteristics of the original semi serif face. *HanSerif* was the first to follow. Serifs were added and proportions were modified slightly to suit the new font. The *Small Caps* were drawn next, based on the *HanSerif* capitals. The next face created was *HansItalic*. The goal was to create an italic that could be comfortably used with both the semi and the serif. The final font created was *HanSans*, a more distinctly geometric version of *HanSemi* without any taper in the stem and less variation from thick to thin.

HANS

A FAMILY *of* FONTS
DESIGNED *by* HANSEN SMITH
© 2002

a A a *a* a

A
HanSC

THE HANS FAMILY BEGAN WITH HANSEMI. Originally called *HanSans*, it was a font designed with some very specific goals. The basic proportions for the characters were taken from traditional Humanist faces such as *Bembo* and *Garamond*. Similarly, the proportions for the numerals were taken from the Old Style figures of the same family. With these guidlines in place this semi serif font was constructed using sharp corners, less stroke variation from thick to thin, and a subtle oblique stress. The goal was to create a modern, easily read, typeface based on the classical stylings of those cut by master craftsmen as early as 1462.

a
HanSemi

a
HanSans

THE REMAINING FOUR MEMBERS OF THE FAMILY WERE created using the characteristics of the original semi serif face. *HanSerif* was the first to follow. Serifs were added and proportions were modified slightly to suit the new font. The *Small Caps* were drawn next, based on the *HanSerif* capitals. The next face created was *HansItalic.* The goal was to create an italic that could be comfortably used with both the semi and the serif. The final font created was *HanSans,* a more distinctly geometric version of *HanSemi* without any taper in the stem and less variation from thick to thin.

a
HanSerif

a
HansItalic

Hans, 18 point

Hans, 8 point

THE HANS FAMILY BEGAN WITH HANSEMI. Originally called *HanSans,* it was a font designed with some very specific goals. The basic proportions for the characters were taken from traditional Humanist faces such as *Bembo* and *Garamond.* Similarly, the proportions for the numerals were taken from the Old Style figures of the same family. With these guidlines in place this semi serif font was constructed using sharp corners less stroke variation from thick to thin, and a subtle oblique stress. The goal was to create a modern, easily read, typeface based on the classical stylings of those cut by master craftsmen as early as 1462.

THE REMAINING FOUR MEMBERS OF THE FAMILY WERE created using the characteristics of the original semi serif face. *HanSerif* was the first to follow. Serifs were added and proportions were modified slightly to suit the new font. The *Small Caps* were drawn next, based on the *HanSerif* capitals. The next face created was *HansItalic.* The goal was to create an italic that could be comfortably used with both the semi and the serif. The final font created was *HanSans,* a more distinctly geometric version of *HanSemi* without any taper in the stem and less variation from thick to thin.

TYPOGRAPHY/ HENRIK KUBEL A2-GRAPHICS/SW/HK

BUCKINGHAMSHIRE CHILTERNS
UNIVERSITY COLLEGE
DEPARTMENT OF 2 DIMENSIONAL DESIGN
BA GRAPHIC DESIGN & ADVERTISING

1 DAY WORKSHOP EXPLORING THE HIDDEN
WORLD OF GRAPHIC DESIGN

EACH STUDENT IS TO INVESTIGATE A PIECE OF DESIGN
AND PRESENT THEIR FINDINGS TO THE GROUP

EACH STUDENT IS TO BRING
OPEN MIND

STUDENTS TO ATTEND
STACEY CARTER
MARK COWLAND
MATT DURBER
LISA EDWARDS

SARAH HARRIS
ELEANOR HICKS
SARAH HOBDELL
SONIA MURPHY
SARAH POWER

RICARDO ROSSETTI
TOM ROWLEY
ANNA STANDBRIDGE
ROB WHITE
BERND WUTHRICH

TEXT ON A SPINE READS WAY UP! READS WAY UP! THIS BETTER →

TYPOGRAPHY/ HENRIK KUBEL A2-GRAPHICS/SW/HK

BUCKINGHAMSHIRE CHILTERNS
UNIVERSITY COLLEGE
DEPARTMENT OF 2 DIMENSIONAL DESIGN
BA GRAPHIC DESIGN & ADVERTISING

1 DAY WORKSHOP EXPLORING THE IDEA OF DRAWING
SANS SERIF UPPERCASE LETTERS IN A SET OF
PRE-DETERMINED HEIGHTS.

THE EXERCISE ENABLES THE STUDENT TO ENGAGE
WITH THE PURE FORM AND PROPORTION OF
A SINGLE LETTER OF THE ALPHABET. THE FIRST
LETTER OF THE STUDENTS NAME IS THE LETTER
TO BE EXERCISED.

THE EXERCISE WILL TAKE THE STUDENT TO THE
NEXT STEP WHICH IS TO DRAW A SEVEN LETTER
WORD ALL IN CAPITAL LETTERS. THE FORMAT
OF THE PRESENTATION IS FREE. ATTENTION
TO CRAFT, COLOUR AND PAPER STOCK IS ESSENTIAL.
2 COLOURS ONLY. BLACK IS ONE OF THE COLOURS

EACH STUDENT IS TO BRING
AN OPEN MIND, RULERS, MARKERS AND PENCILS.

LARGE SHEETS OF WHITE OR NEWSPRINT PAPER
ARE RECOMMENDED FOR THE PREPATORY DRAWINGS.

STUDENTS TO ATTEND

MATT BROWN
AFONSO COSTA
NICKY GOVER
GENE HARNER

DAVID HIBBERD
LOUISE HUGHS
SARAH LAWMAN
LINDSAY ROBB

DAVE ROBINSON
SARAH TAYLOR
OLI THOMAS
ANDY TYE

10	20	40	80	160	320

TYPOGRAPHY/ HENRIK KUBEL A2-GRAPHICS/SW/HK

BUCKINGHAMSHIRE CHILTERNS
UNIVERSITY COLLEGE
DEPARTMENT OF 2 DIMENSIONAL DESIGN
BA GRAPHIC DESIGN & ADVERTISING

1 DAY WORKSHOP EXPLORING THE HIDDEN
WORLD OF GRAPHIC DESIGN

EACH STUDENT IS TO INVESTIGATE A PIECE OF DESIGN
AND PRESENT THEIR FINDINGS TO THE GROUP

EACH STUDENT IS TO BRING
OPEN MIND

1 DAY BRIEF SET BY NIGEL ROBINSON
IN COLLABORATION WITH HENRIK KUBEL
A2-GRAPHICS/SW/HK

BUCKINGHAMSHIRE CHILTERNS
UNIVERSITY COLLEGE
DEPARTMENT OF 2 DIMENSIONAL DESIGN
BA GRAPHIC DESIGN & ADVERTISING
SEMESTER 1 2001/2 ELECTIVE 01

PRODUCE A 3 DIMENSIONAL TYPOGRAPHIC MESSAGE.
YOU MAY WRITE OR USE AN EXISTING QUOTE
THAT IS RELEVANT TO YOUR IDEA.

EACH STUDENT IS TO DESIGN AND
PRESENT FINAL OUTCOME BY THE END
OF THE DAY.

FREE CHOICE OF MEDIA. FINAL DESIGN
MUST BE RECORDED IN A 2D FORMAT,
THIS COULD BE A SERIES OF PHOTOGRAPHS
OR DRAWINGS.

ALL STUDENTS TO ATTEND

TYPOGRAPHY / HENRIK KUBEL A2-GRAPHICS/SW/HK

BUCKINGHAMSHIRE CHILTERNS
UNIVERSITY COLLEGE
DEPARTMENT OF 2 DIMENSIONAL DESIGN
BA GRAPHIC DESIGN & ADVERTISING

TUTORIAL GROUP

IF YOUR NAME APPEARS ON THIS POSTER
YOU ARE IN MY GROUP, EVERY SECOND FRIDAY
THIS GROUP WILL MEET.

EXPECT TO SHOW AND TO DISCUSS YOUR
CURRENT PROJECT, SKETCHBOOKS AND
RESEARCH ARE VITAL.

EXPECT TO BE SET BRIEFS INVOLVING WRITING
AND THE USE OF TYPOGRAPHY. DAYTRIPS MAY OCCUR.

STUDENTS TO ATTEND

SIMON SCOTT
STEPHEN BAILEY
MANISHA PANKHANIA

LLEWELLYN ROBINSON
KRISTIAN LABAK
MIRIAM TORRELL

LAWRENCE LAMB
NEIL HARRIS
TOM DEELEE

ROBINSON LLEWELLYN NEIL HARRIS LA2 LAWRENCE STEPHEN
KRISTIAN LABAK LAMB BAILEY
TOM LEE DEE
SIMON SCOTT MIRIAM
MANISHA PANKHANIA TORRELL

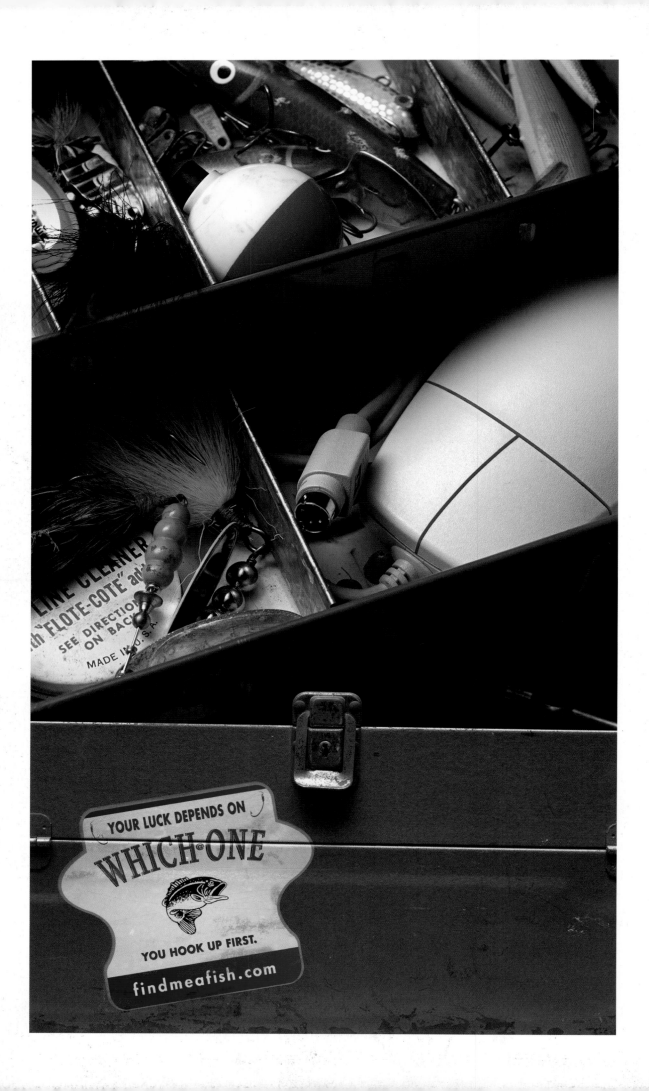

Design Firm: Noble BBDS Creative Director: Steven Wold Art Director: Tim Mikus Designer: Tim Mikus Photographer: Dave Gilo Copywriter: Steven Wold Retoucher: Scott Giannini Client: findmeafish.com

CreativeDirectorsArtDirectorsDesigners

PhotographersIllustrators

Copywriters

DesignFirms

Clients

Directory of Design Firms

50,000 Feet Inc.
3759 North Ravenswood
Suite 233
Chicago, IL 60613
Tel: 1 773 529 6760
Fax: 1 773 529 6762
www.50000feet.com

A2/Graphics/SW/HK
Unit G3 35 40 Chariotte Road
London, England EC2A 3PD
Tel: 44 207 739 4249
www.a2-graphics.co.uk

An's Design Room
Matsusiro Apt. 4, 405 Matsusiro 3 24
Tsukubasi Ibarakiken
Japan 305-0035
Tel: 81 2 9854 8300
Fax: 81 2 9854 8300

Angus Kam Design Limited
2F Kam Ping Building
95 Kings Road
Hong Kong, China
Tel: 85 22 836 3328
Fax: 85 22 904 7947

Artifacts
2503 Pine
New Orleans, LA 70125
Tel: 1 504 669 5837

Asatsu-DK Inc.
1-13-1 Tsukiji Chuo Ku
Tokyo, Japan 104-8172
Tel: 81 3 3547 2111
Fax: 81 3 3547 2894
www.adk.jp

BBDO Mexico
Guillermo Gonzalez Camarena
800-3 Col. Zedec
Santa Fe, Mexico 01210
Tel: 52 55 52671 500
Fax: 52 55 52671 576

Bozell & Jacobs
13801 Fnb Parkway
Omaha, NE 68154
Tel: 1 402 965 4300
Fax: 1 402 965 4399
www.bozelljacobs.com

BYU Publications & Graphics
218 UPB
Provo, UT
Tel: 1 801 378 4711
Fax: 1 801 422 0687
www.byu.edu

Carmichael Lynch Thorburn
800 Hennepin Avenue
Minneapolis, MN 55403
Tel: 1 612 334 6000
Fax: 1 612 334 1429
www.clynch.com

CHRW Advertising
106 West 11th Street
Suite 2220
Kansas City, MO 64105
Tel: 1 816 472 4455
Fax: 1 816 472 8855
www.chrwadvertising.com

Cole & Weber/Red Cell
308 Occidental Avenue
Seattle, WA 98104
Tel: 1 206 447 9595
Fax: 1 206 447 0640
www.coleweber.com

Communication Design 601 Bisan
403 7 Seokyo Dong Mapo Gu
Seoul, Korea 121-210
Tel: 82 2332 2601
Fax: 82 2332 2602

Cucumber
PO Box 1126 Sentrum
Bergen, Norway N-5809
Tel: 47 55 215 070
Fax: 47 55 323 112

DDB International, Ltd.
406 Tech Drive West
Menomonie, WI 54751
Tel: 1 715 235 9040
Fax: 1 715 235 9323
www.dbdintl.com

Eshareh AD
157 Khaled Eslambolie Avenue
Tehran, Iran 15168
Tel: 98 21 878 1498
Fax: 98 21 877 4145
www.eshareh.com

Fallon
50 South 6th Street, Suite 2500
Minneapolis, MN 55402
Tel: 1 612 758 2363
Fax: 1 612 758 2346
www.fallon.com

Fermination
3357 Idell Street
Los Angeles, CA 90065
Tel: 1 323 221 3761

Fons Hickmann M23
Mariannenplatz 23 Gartenhaus
Berlin, Germany 10997
Tel: 49 30 6951 8501
www.fonshickmann.de

Gollings & Pidgeon
147 Chapel Street
St. Kilda, Victoria
Australia 3182
Tel: 613 9537 0733
Fax: 613 9537 0187
www.gollingspideon.com

GSD&M
828 West 6th Street
Austin, TX 78703
Tel: 1 512 242 5800
Fax: 1 512 242 8800
www.gsdm.com

Herman Miller Inc.
855 East Main Avenue
Zeeland, MI 49464
Tel: 1 616 654 8225
Fax: 1 616 654 8210
www.hermanmiller.com

Heye
Ottobrhaching 28
Unterhaching Bavaria
Germany 82008
Tel: 49 89 665 3200
Fax: 49 89 665 32112
www.heye.de

Highwood Communications Ltd
300 1210 8th Street SW
Calgary, Alberta
Canada T2R 1L3
Tel: 1 403 244 6313
Fax: 1 403 245 4048
www.highwoodcommunications.com

IM-Lab
1F 1 1 Senri Banpaku Ku
Suita Osaka, Japan 565-0826
Tel: 81 64 864 6380
Fax: 81 64 864 6570
www.im-lab.com

João Machado Design Lda
Rua Padre Xavier Continho 125
Porto, Portugal 4150-751
Tel: 35 122 610 3778
Fax: 35 122 610 3773
www.joaomachado.com

Kenny Design Office
603 Akashi Cyo Flatts 7-20
Cyuo Ku Tokyo To
Japan 104-0044
Tel: 81 33 544 1411
Fax: 81 33 544 1412

Kinetic Singapore
2 Leng Kee Road
Thye Hong Centre
Singapore 159086
Tel: 65 6475 9377
Fax: 65 6472 5440
www.kinetic.com.sg

Laboratorium
Trecvi Vrbik 4
Zagreb, Croatia 10000
Tel: 38 5 9847 6699
Fax: 38 5 1606 1515
www.laboratorium.hr

Leslie Chan Design Co. Ltd.
4F 115 Nanking East Road Sec. 4
Taipei, Taiwan 105
Tel: 886 22 545 5435
Fax: 886 22 715 1630
www.lcdesign.com.tw

Lippa Pearce Design
358A Richmond Road
Twickenmam Middlesex
England TW1 2DU
Tel: 44 208 744 2100
Fax: 44 208 744 2770
www.lippapearce.com

Lotus Image Laboratory, Inc.
306 Bellecoline
4-5-14 Ebisu Shibuya Ku
Tokyo, Japan 150-0013
Tel: 81 35 447 1086
Fax: 81 35 447 1087

Lure Design
833 Highland Avenue
Suite 110
Orlando, FL 32803
Tel: 1 407 835 1699
Fax: 1 407 835 1698
www.luredesigninc.com

Malcolm Waddell Associates
6 Yule Avenue
Toronto, Ontario
Canada M6S 1E8
Tel: 1 416 761 1737
Fax: 1 416 761 9684

Masukomi Kikaku Co. Ltd.
Nakamura Ku Meieki
4-27-20 Mituibuill S 5F
Nagoya Aich, Japan 450-0002
Tel: 81 525 518 811
Fax: 81 525 863 344
www.masukomi.co.jp

McCann Erickson (S) Pte. Ltd.
360 Orchard Road 03 00
Singapore 238869
Tel: 65 67 37 9911
Fax: 65 67 37 1455
www.mccann.com

Milton Glaser, Inc.
207 East 32nd Street
New York, NY 10016
Tel: 1 212 889 3161
Fax: 1 212 213 4072
www.miltonglaser.com

Mirko Ilic Corp.
207 East 32nd Street
New York, NY 10016
Tel: 1 212 481 9737
Fax: 1 212 481 7088

Morla Design
463 Bryant Street
San Francisco, CA 94107
Tel: 1 415 543 6548
Fax: 1 415 543 7214
www.morladesign.com

Muller & Company
4739 Belleview
Kansas City, MO 64112
Tel: 1 816 531 1992
Fax: 1 816 531 6692
www.mullerco.com

Niklaus Troxler Design
Postfach
Willisan, Switzerland CH-6130
Tel: 41 419 702 731
Fax: 41 419 703 231
www.troxlerart.ch

Nippon Design Center Inc
Chuo Diwa Building
1-13-13 Chuo Ku
Ginza Tokyo, Japan 104-0061
Tel: 03 3567 3231
Fax: 03 3535 3569

Noble BBDS
20 West Kinzie
Suite 1400
Chicago, IL 60610
Tel: 1 312 670 2900
Fax: 1 312 670 7420
www.noble-bbds.com

Ogilvy & Mather Japan
Yebisu Garden Place Tower
26th Floor
4-20-3 Ebisu
Shibuya Ku Tokyo
Japan 150-6026
Tel: 81 35 424 3661
Fax: 81 33 448 2676
www.ogilvy.co.jp

Orangetango
4200 Boul St. Laurent 407
Montreal, Quebec
Canada H2W 2R2
Tel: 1 514 286 0022
Fax: 1 514 982 6997
www.orangetango.com

Parable Communications Corp.
352 Elgin Street
Ottawa, Ontario
Canada K2P 1M8
Tel: 1 613 236 2752
Fax: 1 613 234 9036
www.parable.ca

Pentagram
387 Tehama
San Francisco, CA 94103
Tel: 1 415 896 0499
Fax: 1 415 896 0555
www.pentagram.com

Pentagram Design Ltd.
11 Needham Road
London, United Kingdom
Tel: 44 020 7229 3477
Fax: 44 020 7727 9932
www.pentagram.co.uk

Peterson & Company
2200 North Lamar
Suite 310
Dallas, TX 75202
Tel: 1 214 954 0522
Fax: 1 214 954 1161
www.peterson.com

Reza Abedin Design Studio
41 Hediye All Shariati Avenue
Tehran, Iran 15468
Tel: 98 21 227 4299
Fax: 98 21 227 4299
www.rezaabedini.com

Richter7
280 South 400 West
Suite 200
Salt Lake City, UT 84101
Tel: 1 801 521 2903
Fax: 1 801 359 2420
www.richter7.com

Rickabaugh Graphics
384 West Johnstown Road
Gahanna, OH 43230
Tel: 1 614 337 2229
Fax: 1 614 337 2197

Saatchi & Saatchi
3501 Sepulveda
Torrance, CA 90505
Tel: 1 310 214 6206
Fax: 1 310 214 6125
www.saatchi.com

Saatchi & Saatchi India
Sitram Mills Com. Delisle Road
Mumbai, India 400011
Tel: 9122 300 0301
Fax: 9122 300 0302
www.saatchiindia.com

Saed Meshki Studio
2nd Floor 16 55th Street
Asadabadi Avenue
Tehran, Iran 1434954975
Tel: 98 2176 7472
Fax: 98 2176 7472

Sagmeister, Inc.
222 West 14th Street
New York, NY 10011
Tel: 1 212 647 1789
Fax: 1 212 647 1788

Sandstrom Design
808 SW Third Avenue 610
Portland, OR 97204
Tel: 1 503 248 9466
Fax: 1 503 227 5035
www.sandstromdesign.com

Savas Cekic Tasarim Ltd.
Havyar Sk 27 3 Cihangir
Istanbul, Turkey 80060
Tel: 90 21 2249 6918
Fax: 90 21 2245 5009
www.savascekic.com

Sayles Graphic Design
3701 Beaver Avenue
Des Moines, IA 50310
Tel: 1 515 279 2922
Fax: 1 515 279 0212
www.saylesdeign.com

Scorsone/Drueding
212 Greenwood Avenue
Jenkintown, PA 19046
Tel: 1 215 572 0782
Fax: 1 215 572 0782

Shima Design Office Inc.
Shikidai Building 18 12
Utsubo Honmachi 1 Chome Niski
Osaka, Japan 500-0004
Tel: 81 66 4418 188
Fax: 81 66 4460 625

Shin Matsunaga Design Inc.
P) Box 2595
13th Floor Tokyo Opera City Tower
Tokyo, Japan 163-1413
Tel: 81 353 530 170
Fax: 81 353 530 399

Shinnoske Inc.
2-1-8 602 Tsunigane Cho Chuo Ku
Osaka City Osaka, Japan 540-0035
Tel: 81 66 943 9077
Fax: 81 66 943 9078
www.shinn.co.jp

Slanting Rain Graphic Design
129 1\2 North 100 E
Logan, UT 84321
Tel: 1 435 753 0593
Fax: 1 435 753 0593

Sommese Design
100 Rose Drive
Port Matilda, PA 16870
Tel: 1 814 353 1951
Fax: 1 814 865 1158

Square Two Design
2325 Third Street
San Francisco, CA 94107
Tel: 1 415 437 3888
Fax: 1 415 437 3880
www.square2.com

Studio Gianni Bortolotti and C
Via Santo Stefano 59
Bologna, Italy 40125
Tel: 39 051 267 049
Fax: 39 051 274 315

Taxi
495 Wellington Street West
Suite 102
Toronto, Ontario
Canada M5V-1E9
Tel: 1 416 979 7001
Fax: 1 416 979 7626
www.taxi.ca

Th
422 3 Main Street
Franklin, TN 37064
Tel: 1 615 790 2777
Fax: 1 615 790 2377
www.thwastaken.com

Tom Fowler, Inc.
111 Westport Avenue
Norwalk, CT 06851
Tel: 1 203 845 0700
Fax: 1 203 846 6682
www.tomfowlerinc.com

Vanderbyl Design
171 Second Street
2nd Floor
San Francisco, CA 94105
Tel: 1 415 543 8447
Fax: 1 415 543 9058
www.vanderbyl.com

Voice
74 Ridgehaven Drive
Bellevue Heights
Adelaide, Australia 5050
Tel: 618 8177 2171
Fax: 618 8177 2172
www.voicedesign.net

VSA Partners
1347 South State Street
Chicago, IL 60605
Tel: 1 312 895 5080
Fax: 1 312 427 1903
www.vsapartners.com

Yossi Lemel
3 Hamelacha Street
Tel Aviv, Israel 67215
Tel: 97 27 616 707
Fax: 97 23 761 6701
www.lemel-cohen.co.il

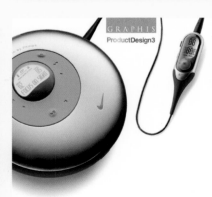

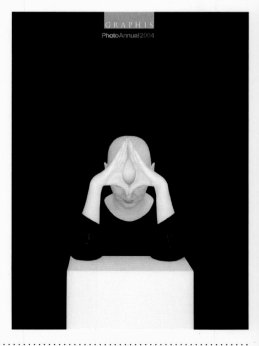

Graphis Book Order Form

DESIGN TITLES	ISBN no.	Price	Quantity	Total
Annual Reports 8	1-931241-17-1	$70.00		
Brochures 4	1-888001-51-8	$70.00		
Corporate Identity 4	1-888001-70-4	$70.00		
designing: (Chermayeff and Geismar)	1-932026-14-2	$60.00		
Design Annual 2004	1-931241-32-5	$70.00		
Design Annual 2003	1-931241-13-9	$70.00		
Exhibition: The Work of Socio X	1-931241-28-7	$45.00		
Language Culture Type (ATypI)	1-932026-01-0	$60.00		
Letterhead 5	1-888001-73-9	$70.00		
Masters of the 20th Century (ICOGRADA)	1-888001-85-2	$80.00		
New Talent Design Annual 2003	1-931241-30-9	$70.00		
New Talent Design Annual 2001	1-888001-84-4	$60.00		
Poster Annual 2003	1-931241-21-X	$70.00		
Poster Annual 2002	1-931241-06-6	$70.00		
Poster Annual 2001	1-888001-72-0	$70.00		
Product Design 3	1-931241-15-5	$70.00		
Promotion Design 2	1-931241-28-7	$70.00		
The Graphic Art of Michael Schwab	1-888001-96-8	$60.00		
The Illustrated Voice (Craig Frazier)	1-932026-08-8	$40.00		
12 Japanese Masters (Maggie Kinser Saiki)	1-931241-08-2	$60.00		
ADVERTISING TITLES				
Advertising Annual 2004	1-931241-34-1	$70.00		
Advertising Annual 2003	1-931241-14-7	$70.00		
What's a Saatchi ... ? (Tom Jordan)	1-932026-02-9	$45.00		
PHOTO TITLES				
Bird Hand Book (Victor Schrager, A.S. Byatt)	1-931241-04-X	$60.00		
Flora	1-931241-09-0	$40.00		
Jayne Hinds Bidaut: Tintypes	1-888001-79-8	$60.00		
Night Chicas (Hans Neleman)	1-932026-05-3	$50.00		
Nudes 1	3-857094-35-4	$70.00		
Nudes 1 (paperback)	0-8230-6459-X	$40.00		
Nudes 3	1-888001-66-6	$70.00		
Photo Annual 2004	1-931241-33-3	$70.00		
Photo Annual 2003	1-931241-16-3	$70.00		
Photo Annual 2002	1-931241-03-1	$70.00		
Sporting Life (Walter Iooss)	1-932026-00-2	$35.00		
OTHER GRAPHIS TITLES				
Prayers For Peace	1-932026-04-5	$15.00		
Something to be Desired (Veronique Vienne)	1-888001-76-3	$15.00		
Shipping & Handling (See Instructions on Right)				
New York State Shipments add 8.25% tax				
ORDER TOTAL				

Method of Payment: Orders payable in US dollars to Graphis

☐ AMEX ☐ Visa ☐ MC ☐ Check/Money Order Enclosed

Card # _____ Exp Date _____

Cardholder's name _____ Telephone # _____ Fax # _____

Cardholder's signature _____ Email Address _____

Ordered By:

Customer Number (found on the back cover) _____ BKST

Name		Title	
Company			
Street Address			
City	State	Zip	
Telephone #		Email Address	

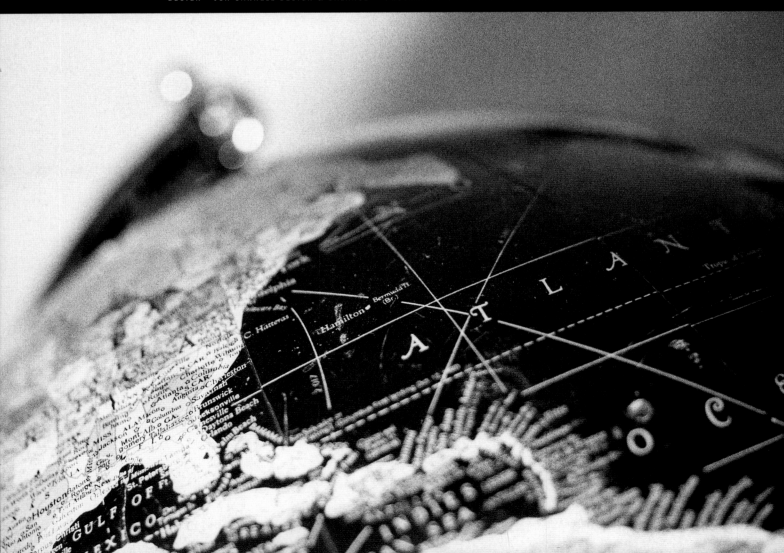

Poster Annual 2003 Graphis Mission Statement: *Graphis* is committed to presenting exceptional work in international design, advertising, illustration and photography. Since 1944, we have presented individuals and companies in the visual communications industry who have consistently demonstrated excellence and determination in overcoming economic, cultural and creative hurdles to produce true brilliance.